Richard Dadd

The Artist and the Asylum

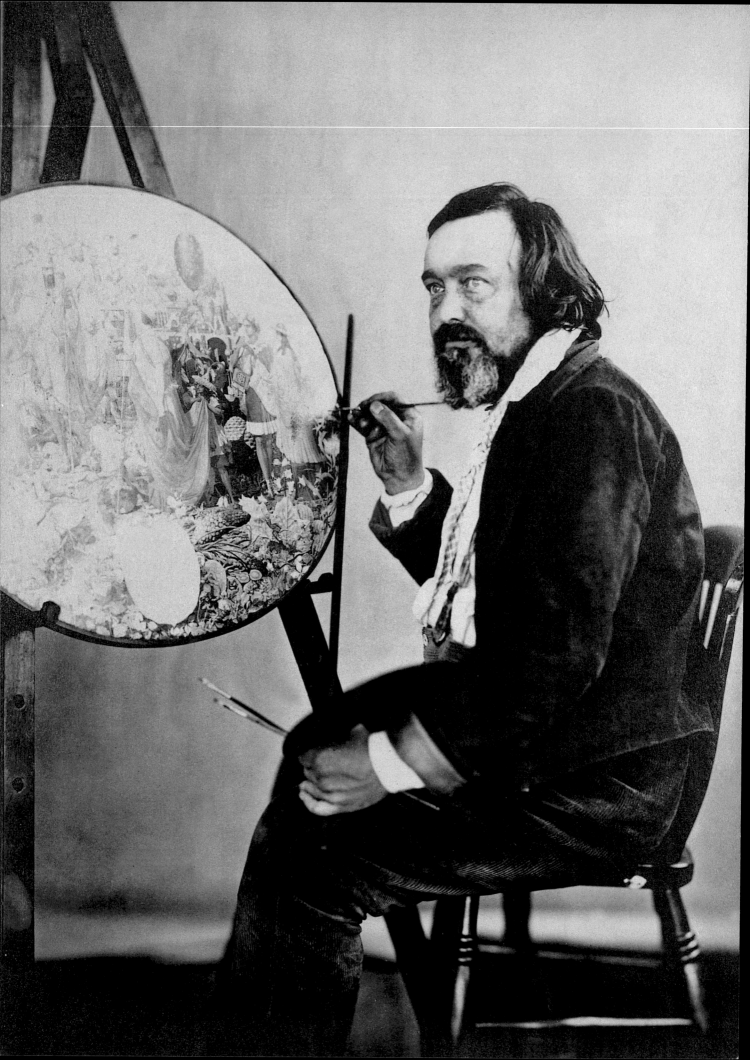

Richard Dadd

The Artist and the Asylum

Nicholas Tromans

d·a·p

p.2 and back cover
1
Portrait photograph
of Dadd by Henry
Hering, c.1857
Bethlem Royal
Hospital, London

First published 2011 by order of the
Tate Trustees
by Tate Publishing, a division of
Tate Enterprises Ltd,
Millbank, London SW1P 4RG
www.tate.org.uk/publishing

Published in North America by

D.A.P./Distributed Art Publishers Inc.
155 Sixth Avenue, 2nd Floor
New York, NY 10013

Tel:212-627-1999
Fax:212-627-9484

www.artbook.com

A CIP record for this book is available
from the Library of Congress

ISBN 978-1-935202-68-4

Designed by Atelier Works
Colour reproduction by DL Imaging
Ltd., London
Printed and bound in Hong Kong by
Printing Express

Front cover: Richard Dadd, *The Fairy
Feller's Master-Stroke* 1855–64 (detail of
fig.74)

Measurements of artworks are given in
centimetres, height before width

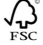

Acknowledgements
The research for this book was made
possible by the expertise and generosity
of the archivists of the Berkshire
Record Office, now custodians of the
Broadmoor Archive, and Bethlem Royal
Hospital. So my thanks go especially
to Mark Stevens at Reading and Colin
Gale at Bethlem. I have enjoyed and
benefited from conversations with other
writers on Dadd, particularly Patricia
Allderidge, Hélène Klemenz and Eleanor
Fraser Stansbie. For various problem-
solving, thanks to Martin Beisly, Judith
Bronkhurst, Julia Dudkiewicz and
Venetia Harlow: some further academic
debts are mentioned in the endnotes.
Briony Llewellyn made useful comments
on a draft of the second chapter, while
Thomas Röske (of the Prinzhorn
Collection) and Alison Smith (of Tate
Britain) read and helpfully criticised
the whole book in manuscript. Any
remaining factual inadequacies are my
responsibility alone.

Contents

Preface

Richard Dadd seems to belong to a particular historical moment, the late 1960s and early 1970s, when he was on the verge of being recruited as a heroic Victorian counter-cultural ancestor. As a patient in two of the most famous of all lunatic asylums – Bethlem and Broadmoor – he was a potential Outsider artist *avant la lettre*, a perfect case study for the anti-psychiatry movement, and an edgy corrective to the sentimental revival of all things Victorian. This process was derailed, however, by the authority of the archive. When, in 1974, the Tate Gallery mounted an exhibition of all Dadd's available work and published an accompanying exhaustive catalogue by Patricia Allderidge, interest in Dadd subsided.[1] The factual approach to Dadd's life and the appeal he had offered to fantasy and imagination did not seem to be compatible. Precious little new information on Dadd has been published since 1974.[2] On the other hand, the initiatives of Michel Foucault and others to overturn the 'humane' history of the asylum – their attempts to show how the growth of psychiatry worked to the advantage of the medical profession as much as to that of the patient – have borne decades of rich fruit despite many of the details of Foucault's pioneering work itself having to be rejected. In this case, the big ideas and the detailed research have got along much better.[3]

My aim in this book has been to return to the case of Richard Dadd with the added confidence lent by the availability today of a large and high-quality literature on the history of the asylum. I have done my best to see as much of the primary material relating to the artist as possible, and to interpret this in light of the expanded accounts now extant of psychiatry and of British art. I do not expect or intend to

revive Dadd as a hero of any kind. On the contrary, my approach has been to write about him precisely as I would write about any nineteenth-century painter. I mean that I have looked at his works and few surviving writings, at the institutions that framed his life and career, and at what other people said about him. No more than were I writing about J.M.W. Turner or Claude Monet have I pretended to know exactly what he thought and felt whilst making his pictures.

This will perhaps mean that I am guilty of what Edward Shorter complains of, in his *History of Psychiatry* (1997), as a failing of British writing in his field: that is, claiming to write about madness but in fact writing about everything but, leaving it an untouchable problem defined negatively by the more measurable surrounding phenomena of law, medicine and culture.[4] My frank response to this would be that I do not know what was wrong with Dadd. I am not qualified to judge whether a leading neuropsychiatrist is right to suggest that at the root of schizophrenic-type illnesses is damage to neuronal circuits in those parts of the brain organising perception and emotion, causing failures in the process of streaming and binding information.[5] The question of whether the study of the brain has anything to offer the history of art is today a very lively debate (a rare thing in that discipline).[6] But I am not attempting to offer a contribution to that debate. This is a history of one person's experience, insofar as I have been able to reconstruct and interpret it. I hope that, although a single case study, it will help elucidate some of the more subtle interrelationships between medicine and Victorian culture. I begin with an attempt to sketch the ideas and institutions that surrounded Dadd as he grew up in the house of his father, a high-street chemist with intellectual ambitions, in southern England in the 1830s.

1 Fairytopia

'Two Assagais, or African Spears, from Fernandez Po – Two Tarantulas – Five Chiton Shells – A Shark's Jaw.'[1] Thus Robert Dadd, Richard Dadd's father, carefully recorded one of the many gifts made to the Chatham and Rochester Philosophical and Literary Institution during 1828, its first headily optimistic year of existence. As the Institution's Curator it was his job to reflect, through the museum he set out to build, the civilised curiosity of the respectable classes of these twin Medway towns, places then much better known for their elaborate Napoleonic fortifications, massive shipyards and large numbers of members of the armed forces.

Charles Dickens had moved to Chatham as a child and his first novel, *The Pickwick Papers* (1836–7), opens with scenes set in the area in the late 1820s. Mr Pickwick's impressions of the towns were dominated by drunken soldiers and sailors, the reek of tobacco, and 'the dirt, which is [the towns'] leading characteristic'.[2] Chatham and Rochester, some thirty miles south-east of London, were functional garrison towns, tense with the threat of discipline, austere (other than for the regular spectacle of troop manoeuvres) and without the blessings of culture. But now the Institution hoped to change this situation, with its library, museum and lecture series forming a new focus of intellectual life.

Not all the local inhabitants, however, appear to have been entirely appreciative, and the early days of the Institution saw a flurry of pamphlets satirising the jumped-up aspirations of the self-appointed philosophers of the Medway. One of these, in mock-biblical tones, accused the entire project of using culture as a tool of social

distinction: 'We will shut ourselves up from the ignorant; and the vulgar shall not enter our doors. Neither shall the little tradesman find a place amongst us, nor shall the operative mechanic be of our number.'[3] Another pamphlet satirised the Institution's meetings in terms painfully close to Dickens's account of the Pickwick Club congratulating itself on having as a founder 'the man who had traced to their source the mighty ponds of Hampstead, and agitated the scientific world with his Theory of Tittlebats'.[4] This heckler took a particular tilt at Robert Dadd, well known as the chemist and druggist of Chatham High Street, but now presenting himself as the Institution's 'CURATOR, or nominal professor of Mineralogy. This is a conceited and ignorant little Cockletop of intellect', who 'may often be seen in all the chalk and gravel pits in the neighbourhood' (various laboured scatological jokes about excavating in latrines follow).[5] Robert Dadd did indeed lecture on geology at the Institution and elsewhere, specifically on the coalfields of Britain, and was a devoted fossil-hunter.[6] When he left Chatham for London in 1834, Robert donated his private collection to his museum, which already boasted – among many other things – a collection of stuffed birds of national importance as well as many man-made objects that he had classified as either 'Antiquities (belonging to the great civilisations of ancient Egypt, Greece and Rome)' or as 'Illustrations of the Manners and Customs of Different Nations' (belonging to everywhere else).

The Curator's departure was well timed, for during the later 1830s the Institution's members gradually lost interest, and it was overtaken by the newly formed local Mechanics' Institute, which had an almost identical programme of improvement but whose rules stipulated that 'Two-thirds at least of the Members shall be taken from the working Classes'. Eventually, in 1844, the entire contents of the Institution – library and museum – were sold off at an auction in Rochester at which the Mechanics' Institute were the principal buyers.[7] Robert Dadd's premature death in 1843 meant that he never knew of this tangible demonstration of how the business of culture in Britain was becoming democratised. In fact, although the sight of his collection being dispersed would have pained him, Robert would surely have approved of the political implications of the rise of the Mechanics' Institute, for he was – despite the carping of the pamphleteers – on the side of the Reform movement that had triumphed with the extension of the franchise in 1832. In that year he was recorded as Treasurer of his local Commercial and Mathematical School, an institution that was intended for the brighter children of the artisan classes, and we know that at some point he had abandoned the established Church of England in favour of the nonconformist Unitarian church, associated with a more egalitarian and inclusive form of Christianity.[8] For Robert Dadd, culture and democratic reform went hand in hand.

Richard Dadd was born in Chatham in 1817 (as it happens the year the Dickens family arrived there), one of seven children whose mother died a few days before his seventh birthday. Robert remarried, fathered two further boys, but then in 1830 became a widower for a second time.[9] By the time he had left the King's School within the precincts of Rochester Cathedral at the age of fourteen, Richard was

showing interest and talent in drawing.[10] He progressed neither to university nor apprenticeship, but instead seems to have worked on his art, presumably with a great deal of freedom until his father made the decision to leave Chatham in 1834. What his particular studies were in these years is not known, although it was later said that he was a regular visitor to Cobham Hall, the house of his local aristocrat, Earl Darnley, in Cobham Park (now a girls' school), where there was a serious collection of Old Master paintings, including such sumptuous Venetian canvases as Paolo Veronese's four *Allegories of Love* c.1575 and Jacopo Tintoretto's *Origin of the Milky Way* c.1575, and Peter Paul Rubens's extravaganza of Oriental cruelty, *Queen Tomyris Plunging the Head of Cyrus into a Vessel of Blood* c.1622–3. But the young artist's earliest work shows little trace of such muscular, baroque figures. On the contrary, it suggests some kind of training as a miniaturist, to which must surely have been added studies set by his father of the insects, skeletons and anthropological curiosities in his museum.[11]

In 1834 Robert took his children to live in the centre of London, around the corner from what was about to become Trafalgar Square, from 1837 home to a new building housing both the National Gallery and the Royal Academy of Arts. In Suffolk Street, part of John Nash's lushly stuccoed Regent Street development, Robert Dadd now lived and worked, running a gilding business and selling artists' materials.[12] The move must have been motivated in part by the family's hopes for Richard's career, but also by Robert's own second career as a museum curator, for he would now be living within yards not only of the nation's collection of Old Master paintings and of its prime art academy, but also of the British Institution in Pall Mall, an aristocratic charity devoted to maintaining the links between modern art and the great painters of the past, while the Society of British Artists (SBA) was virtually next door in Suffolk Street. If Robert Dadd had acquired a taste for culture then there was now little danger of its being frustrated.

During the later eighteenth century the British art world had become overwhelmingly centralised upon the Royal Academy. Aspiring young artists no longer underwent apprenticeships but rather sought admission to the Academy Schools, and would then proceed to try to sell to the public by displaying their work on the walls of the Academy's annual exhibition. As the art market expanded however, the Academy's monopoly was increasingly challenged. Alternative exhibition spaces were opened in the first years of the new century by the British Institution and by the watercolour specialists, and the SBA followed in 1824, aspiring simply to provide an additional opportunity for artists to sell their works. In 1836, amid the general demands for opening up state institutions that followed the great Reform Act, the Academy was made the subject of a parliamentary inquiry into its finances and administration. The SBA, meanwhile, while suffering from debts and a collapsing roof, sought to portray itself as a more modern, democratic exhibiting space, welcoming to its shows groups from London schools and charities.[13] The Society's leading figures had many connections with the mushrooming number of collectors in the Northern industrial cities and with the London theatres, where several of them worked as scene-painters. The great hit of

its first exhibition had been the biblical-scenographic *Seventh Plague of Egypt* by John Martin whose brother Jonathan designed comparably fantastic images in Bethlem Hospital, where he was committed in 1829 after having set fire to York Minster. In the early 1830s the Society's President was David Roberts, the Scottish architectural specialist and scene-painter. Roberts and Robert Dadd developed a firm friendship, no doubt beginning with the latter's practical value to the Society. The two men toured Scotland together in 1841.

Richard commenced his own professional career in the orthodox manner, entering the Academy Schools in 1837 and in the same year exhibiting for the first time, at the SBA.[14] Over the next few years the Society was Dadd's prime outlet for selling his work, but he quickly expanded as far as possible the range of other showcases for his pictures, sending to the British Institution and the Academy (from 1838 and 1839 respectively) and soon afterwards to the annual exhibitions mounted at Manchester, Liverpool and Birmingham. At first he exhibited Devon landscapes (various Dadd relations had lived in Plymouth), portraits and scenes from early English history (*King Alfred*, *King Harold* and *Queen Elgiva* all shown down on their luck). Of the few works to have survived from this period, the most strikingly advanced are the crisply executed watercolour portraits of family members: the parents of Catherine Carter, who was to marry Richard's eldest brother Robert in 1843 (1838; Bethlem Royal Hospital), his sister Maria (fig.2, overleaf) and a sheet of heads including Robert senior, several siblings and apparently a self-portrait (fig.3, overleaf).

As Dadd's career as an artist developed according to plan, he left Suffolk Street for independent lodgings, moving in 1839 to Great Queen Street and then, after a spell in Soho in 1841, to Charlotte Street north of Oxford Street in the favoured quarter of London's artists. In place of the family circle he now had his friends from the Academy, contemporaries including the future stars of Victorian genre painting William Powell Frith, John Phillip and Augustus Egg. Teaching art had never been the Academy's strong suit, and by Dadd's day there was little on offer beyond the opportunities to copy from the life model or from the Old Masters lent by collectors to the School of Painting. The academicians supervised these classes in rotation, and there were unremarkable lectures from the professors, but otherwise students were left without much guidance and so turned eagerly for support to one another and to wealthy potential patrons. Dadd and his friends clung to one another so fiercely that they became known as 'the Clique', although the only formalised activity they organised were evenings when they would gather to invent pictorial compositions from a set text. Most popular were apparently Byron and Shakespeare, authors offering real challenges to the illustrator. As was usual among informal brotherhoods of art students, the Clique made portraits of one another, Dadd representing his friends in imagined guises suited to their personalities:

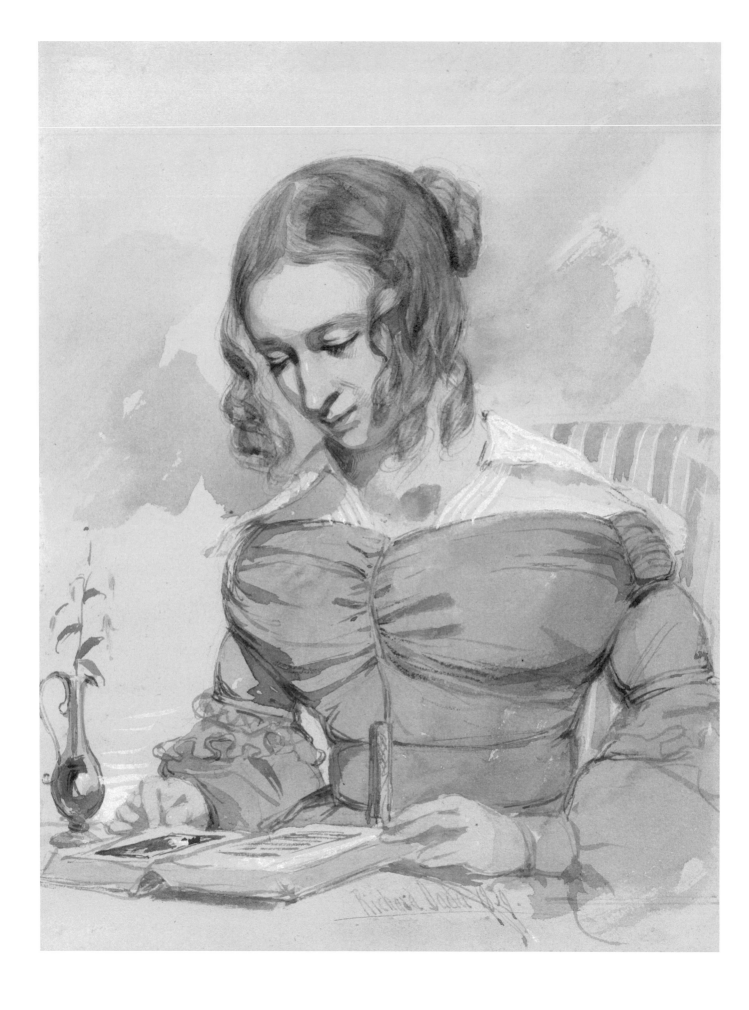

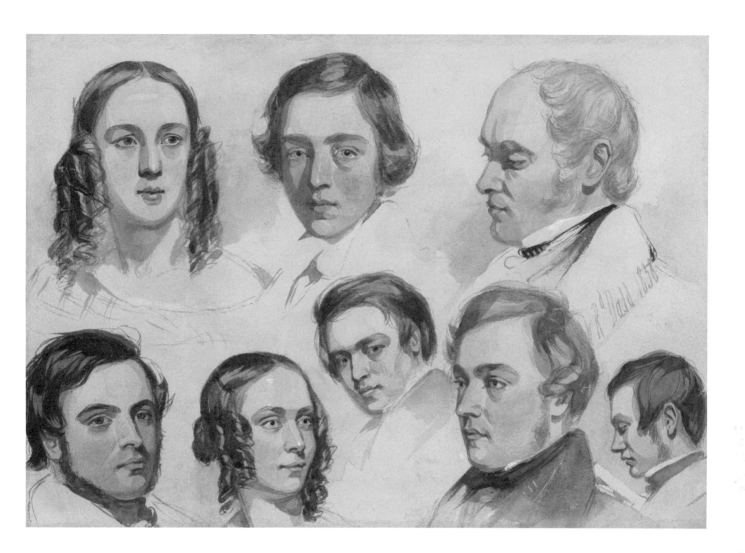

one who had an oriental look, appeared as a Pacha; another, who made verses, was shown as the Poet with 'his eye in a fine frenzy rolling'; a third, who was thin and bony, appeared as Cassius with his 'lean and hungry look', and so on until no room was left on the walls of the studio.[15]

Forming gangs such as the Clique was one way to cope with the frightening open-endedness of the young artist's choices: what should they paint and how? Making a team decision is easier. The story goes that each member elected a particular type of subject matter to follow, and that 'Dadd proposed to devote himself purely to works of imagination'.[16] As for style, the critical consensus around them was clearer in its guidance. The age of the heroic canvas – massive expanses of dark paint describing deeds of violence and magnanimity – was over. Benjamin Robert Haydon, who had proclaimed himself the heir to this tradition, was evidence of its failure, for now his career was in ruins and his bombastic work with its shameless vaunting of the artist's own genius appeared hopelessly passé. What the expanding middle-class market wanted were modest pictures, precisely executed in delicate tones, full of feeling but with the passions and the imagination firmly held within bounds. The ageing Turner, like Haydon, seemed to many a laughably expressionist romantic in a culture now acutely aware of the civic duties of public art. 'Turner was once the pride – the glory of our English school of landscape,' wrote a leading

Dadd, del.

ROBIN GOODFELLOW

From Oberon in fairye land,
 The king of ghosts and shadowes there,
Mad Robin I, at his command,
 Am sent to viewe the night-sports here.
 What revell rout
 Is kept about,
In every corner where I go,
 I will o'ersee, and merry bee,
And make good sport, with ho, ho, ho!

More swift than lightening can I flye
 About this aery welkin soone,
And, in a minutes space, descrye
 Each thinge that's done belowe the moone,
 There's not a hag
 Or ghost shall wag,
Or cry, ware Goblins! where I go;
 But Robin I their feates will spy,
And send them home, with ho, ho, ho!

Green, sc.

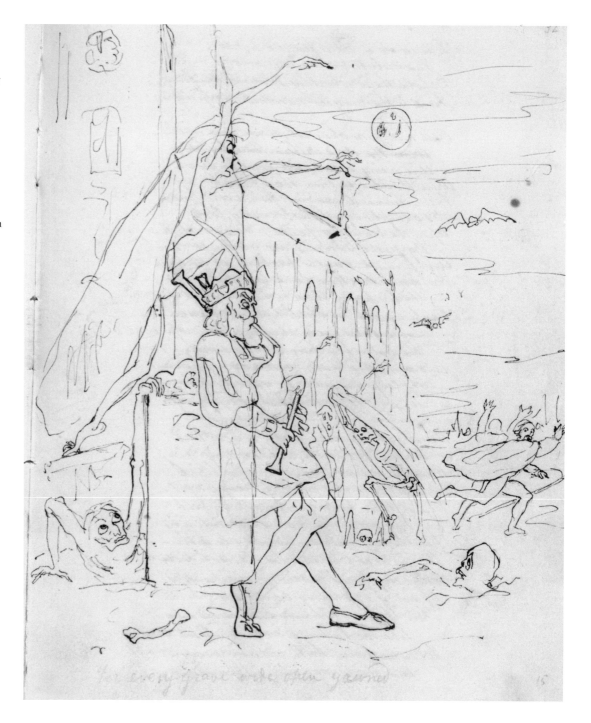

4
Robin Goodfellow
Wood engraving after
Dadd in Samuel Carter
Hall, ed., *The Book of
British Ballads*, 1842
Victoria and Albert
Museum, London

5
*Willibald Piping to
Raise the Dead* c.1840–2
Pen and ink illustration
in *Walpurgis Night*
Manuscript 20.4 x 16.5
Victoria and Albert
Museum, London

critic in 1838, 'but he, too, has turned Bedlamite ... since he has been afflicted with this incurable prismatic madness'.[17] The appropriate models for modern British art, according to the critics, now included the pictures of the Irishmen William Mulready and Daniel Maclise, and the German school of art, in which were combined a rigorous draughtsmanship and a healthily national romanticism.[18] As the British, too, looked back in their own art history for national inspiration, interest in William Hogarth's Modern Moral Subjects was revived, albeit after a thorough editing of some of his earthier humour.[19]

By the early 1840s, while continuing to send work in to the public exhibitions, Dadd was exploring alternatives to this too often humiliating annual ritual. Following his fascination with the most imaginative of literary classics, he

experienced with book illustration, with a domestic decorative scheme using literary subjects, and even collaborating with a poet to produce a unique illustrated manuscript. In 1842 the art publisher Samuel Carter Hall brought out *The Book of British Ballads*, an anthology of verse illustrated with borders and vignettes designed by young artists including Dadd. Hall was a central figure in the early Victorian art world, the editor of the monthly *Art-Union* (later the *Art Journal*) and the ubiquitous upholder of the modern aesthetic values of Britishness and passion filtered through sentiment.[20] Dadd's contribution to the *Ballads* comprised the four decorated pages of the poem 'Robin Goodfellow' (fig.4, previous page), sometimes attributed to Ben Jonson, in which the tricksy Puck, or Robin Goodfellow, of fairy lore sings of his maddening but essentially harmless misdemeanours. Dadd's work is elegantly light and as playful as Robin himself, although we can imagine the tasteful Hall raising an eyebrow at the little goblin impaled on one of the letters of the poem's title.

6
Emblem of the Wiltshire Friendly Society c.1840–2
Engraving after Dadd
Society of Antiquaries, London

7
Self-Portrait 1841
Etching 13.3 x 11.4
Bethlem Royal Hospital, London

The Book of British Ballads was dedicated by Hall to King Ludwig I of Bavaria, and was deliberately intended as a British rival to the great illustrated edition of the medieval German epic *Nibelungenlied* published in Leipzig in 1840. Before the *Ballads* appeared, Dadd had it seems already attempted his own response to German literary art, illustrating a manuscript of three poems, apparently written by H.G. Adams, a newspaper editor, apothecary and amateur poet who was a Kentish friend of the Dadds. 'Walpurgis Night', the first of the three pieces is, as Allderidge noted, a sort of cross between Johann Wolfgang von Goethe's tragedy *Faust* (1808–32) and Byron's dramatic poem *Manfred* (1817).[21] A prince, Henrick, practising alchemy in pursuit of the *elixir vitae*, becomes 'too presumptuous, yearning after vain/ Delusions, things which are not'. Caught in a storm on a mountain on Walpurgis Night – that is, the old Midsummer Night, the last night of April, when witches and spirits were supposed to congregate – Henrick is lured to his death by the Devil in the form of an owl. The poem concludes by describing the strangely unconcerned reaction of his parents to the news. 'The Piper of Neisse' (fig.5, previous page), which follows, has a similarly supernatural theme but a happier ending. In brief, Willibald the piper has his revenge upon the town's despotic mayor, in whose jail he has perished, by appearing as a ghost to raise his fellow dead and kill off the local maidens with his playing; whereupon the mayor relents and allows his daughter to marry Willibald's adopted son Wido, a painter, who creates a now lost masterpiece illustrating the story. The manuscript ends with a brief version of the story of 'The Devil's Bridge', in which the Devil is tricked out

R.Dadd se ipse fecit.
.1841.

of the human soul he had expected to obtain in return for building a bridge for some Swiss mountain villagers.

Many of the illustrations clearly echo the line manner of the German painter and draughtsman Moritz Retzsch, whose illustrations to *Faust* first appeared in 1816 and were republished in London in the 1830s. Retzsch was admired in Britain as a kind of modern-day saint of art, retired and unworldly, tracing chastely outlined visions of classic literature. Dadd was only one of many British artists to be inspired by his *Outlines to Shakespeare*, which appeared from 1828. Maclise stole from them directly, and as late as 1849 John Everett Millais borrowed from them the idea of Ferdinand – in *The Tempest* – being lured by Ariel in the form of a sort of halo of

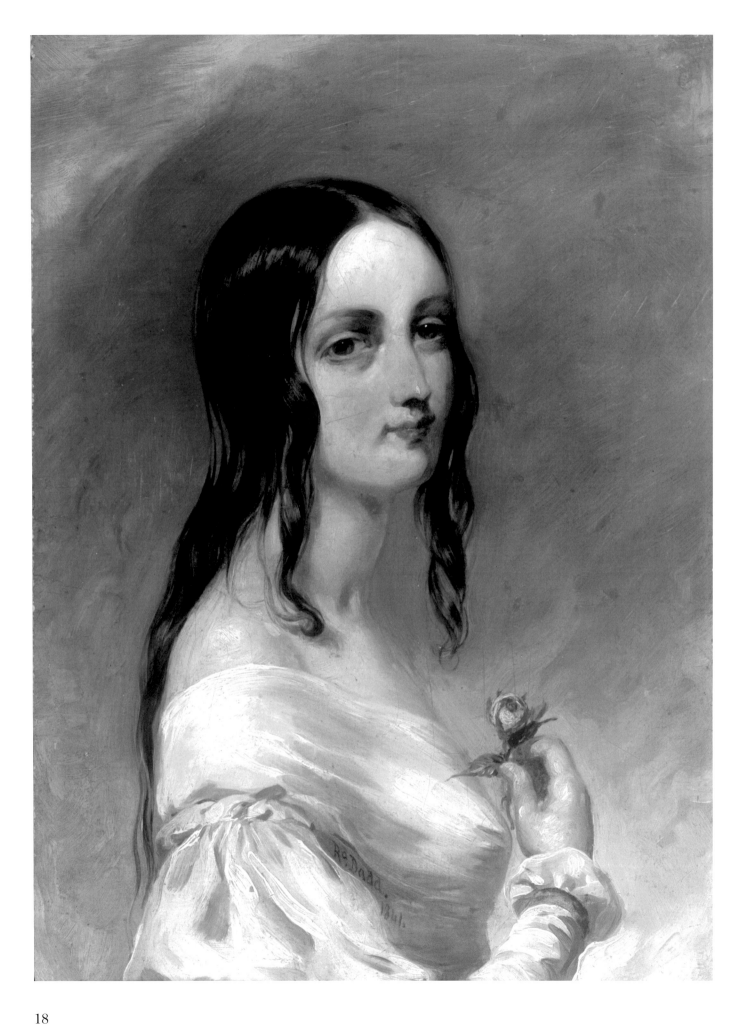

18

bat-like creatures. Dadd's drawings for 'The Piper of Neisse', however, are more nervous and lively in execution, suggesting some impatience with the static Retzsch manner that developed as he worked through the manuscript.

Perhaps the most ambitious alternative that Dadd found to the public exhibition was the commission he received from Henry, Lord Foley, to paint a series of decorative panels for one of the grander rooms in his London house in Grosvenor Square. Sadly no images of this scheme have ever been located, but the subjects are described as having been taken from Byron's *Manfred* and Torquato Tasso's sixteenth-century Crusader epic, *Jerusalem Delivered*.[22] *Manfred* is a dramatic poem recounting the eponymous noble hero's longing for oblivion to escape a terrible guilt.[23] Living in isolation in the Alps, Manfred is determined to perish without succumbing to the appeals of either Demons, 'the Destinies' or the Church, in a morbid quest for total existential authenticity that he ultimately achieves. In the same year as *Manfred*, Byron published *The Lament of Tasso*, in which the great Renaissance poet bitterly denounces those who have shut him in a madhouse – where 'each is tortured in his separate hell/ For we are crowded in our solitudes' – for having presumed to declare his love for Leonora d'Este, sister of the Duke of Ferrara. For Byron, then, this 'romantic' Tasso was kindred to Manfred, another noble mind whose dangerous personality led to calamities that destroyed his life but never his spirit. Quite how Dadd managed to accommodate such themes in the decorative panelling of the early eighteenth-century aristocratic interior of Lord Foley's house remains an unanswered question.

The young Dadd gave the impression of absolute self-possession, so confident in his talent that he could afford to seem not to require the protection of his superiors. As Adams put it in a panegyric to his friend of about 1839, 'within thee burns the fire/ Of genius, and no grovelling thoughts are thine;/ ... thou dost worship, not at Mammon's shrine'.[24] Others repeatedly referred to him as noble and gentlemanly, one of nature's aristocrats.[25] We can see evidence of his passion for self-sufficiency in Dadd's leading role within the Clique, and in the reports of his chairing meetings in 1841 to establish a new independent exhibiting society (although this came to nothing).[26] Perhaps we can also see it in his acceptance, around the same time, of a commission to design the emblem for the Wiltshire Friendly Society (fig.6, previous page), one of those mutual health-insurance schemes established by networks of working families as an alternative to the vagaries of charity.

As Dadd launched himself into the London art world, the professional persona he projected was thus clearly marked. He announced a dangerous Byronic mode in his taste, but one thoroughly composed within a decorative aesthetic – a sort of gothic rococo. This fitted with a clever commercial positioning of himself as a kind of independent for hire – a romantic champion of self-sufficiency with the charm and manners to do business with any potential patron. The Byronic aspect to his persona was thoroughly tempered by a responsible clubbability. Hence the suitability for Dadd of the themes of *apparent* madness that Byron so melodramatically describes. Neither Manfred nor Tasso – nor Dadd's Henrick –

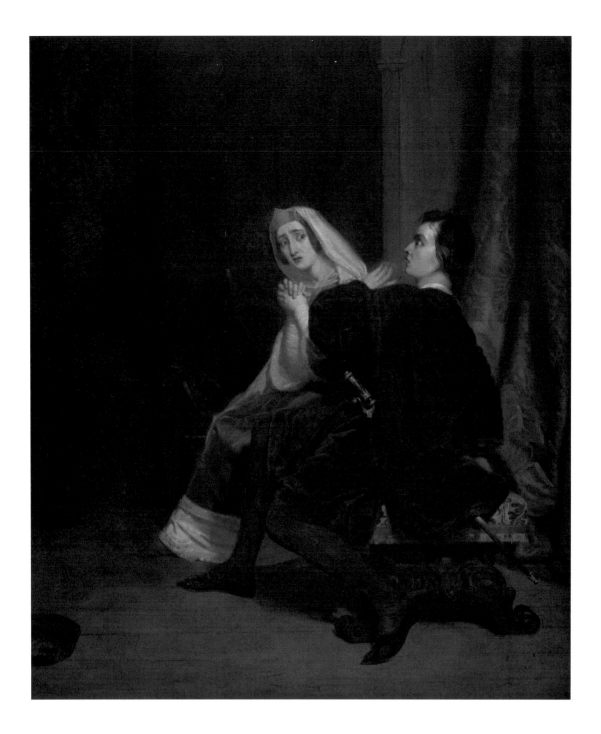

was truly mad, any more than were Don Quixote or John Keats in the flights of their fancy (the sources for other pictures by Dadd of the period). These were all figures whose inner visions were of complete consistency but who nevertheless appeared deranged to other, lesser creatures, producing a highly marketable kind of psychological snobbery.

Since the eighteenth century, imaginative literary British painting had included, at its extreme point, the world of fairies. Thoroughly documented in poetry and legend, this alternative little universe, never too far from the realms of delusion, was the ultimate challenge for an artist eager to demonstrate a distinguished sensibility. Frith declared himself horrified when he discovered that Robert Huskisson, one of the leading fairy painters of the 1840s, spoke with a strong

Midlands accent. This reaction suggests the snobbery of the Clique, but Frith had another cause to resent Huskisson's success: some of his best pictures were plagiarised from Dadd's three great fairy subjects of the early 1840s – the paintings by which the general public were primarily to know him for the rest of his life.[27]

If fairies were always an elusive subject for artists to capture, then the ultimate challenge for a literary painter was to invent visual translations of the fairy images to be found in Shakespeare. *A Midsummer Night's Dream* is entirely about the confrontation of the human and fairy worlds, while Ariel and other spirits appear in *The Tempest* and, in a single extraordinary speech in *Romeo and Juliet*, Mercutio describes the deeds of Queen Mab. Dadd used all three texts as points of departure for his own original fairy iconography, but this was in turn part of his larger interest in Shakespeare, whose works his father probably introduced him to early in life (Dadd's younger brother George was said to be able to recite whole plays from memory). At the London exhibitions in 1840 Dadd showed scenes from *As You Like It* (untraced) and *Hamlet* (fig.9: the scene where the prince's mother declares, 'Alas! he's mad!' as her son appears to address an invisible ghost), and then in 1841 a picture with at least the title borrowed from the opening scene of *The Merchant of Venice* ('*When I speak let no dog bark*'; untraced). Meanwhile the enigmatic *Young Lady Holding a Rose* 1841 (fig.8, previous page), with its suggestion of Ophelia, is perhaps one of Dadd's portraits in character.

By the 1840s, fairyland was whatever you wanted it to be. Any precise or authoritative taxonomy of the inhabitants of the fairy realm of folklore had evaporated in the process of its translation into modern art and literature. Its essence nevertheless remained that of a world within a world – an apparently entirely autonomous microcosm that always existed, however, in relation to, or alongside, everyday human life, and whose miniaturism only signified by comparison with the human scale. This structural constant within fairyland allowed it to suggest a range of alternative quasi-human realms. It had, for example, an erotic mode, 'the quaint pornography of never-never land', as Angela Carter put it in her radio play about Dadd, with skimpily dressed little fairies displaying skins of a pure yet impenetrable surface (Susan Stewart's words).[28] Later in the Victorian century, fairy painting evolved into something like an allegory of modern natural history, its precise rendering of a microscopic register hinting at the beautiful but cruel and obscure processes of generation.[29] But there was perhaps also the capacity of fairyland to stand for a *better* world, a little commonwealth where things could be different, such as that imagined by Gonzalo on arriving on Prospero's island in *The Tempest*, or as actually attempted by such utopian industrialists of Dadd's time as Robert Owen.

While these were some of the abstract echoes that helped sustain the allure of fairyland for the Victorians, a more immediately concrete prompt for Dadd's Shakespearean sprites was, naturally enough, the theatre. His *Hamlet* 1840 shows the most famous Shakespearean double-act of the age, Charles Kean and Ellen Tree, who performed together at the Haymarket Theatre in 1840 and were married

10
Titania Sleeping 1841
Oil on canvas
64.8 x 77.5
Musée du Louvre, Paris

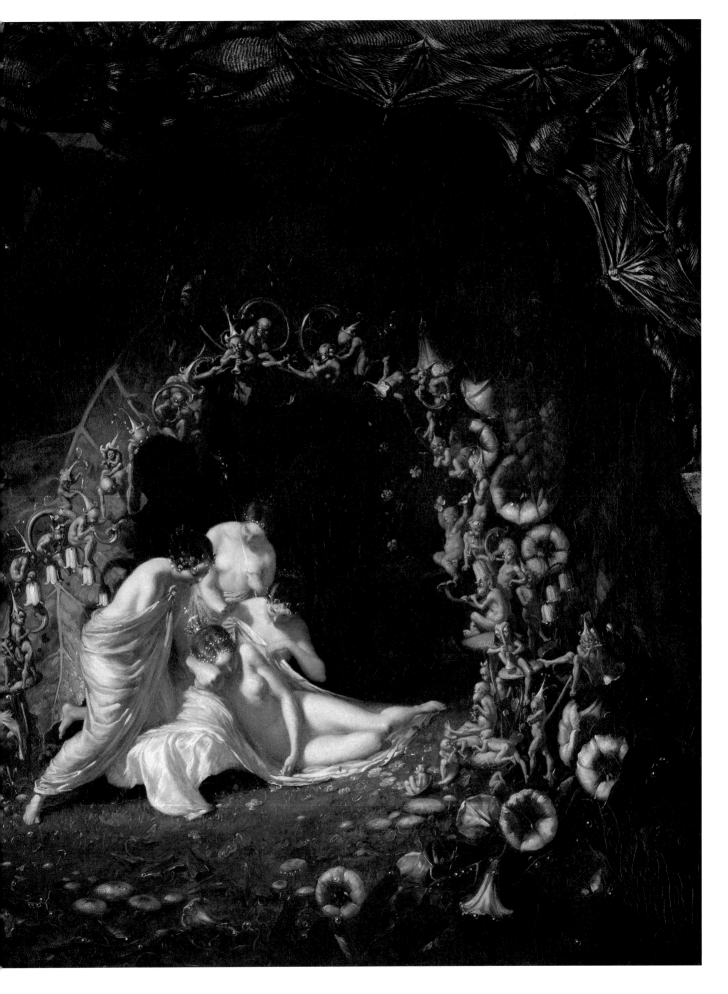

in 1842. And I suggest that Dadd went on to conceive his fairy subjects illustrating *A Midsummer Night's Dream* in 1841 (see fig.10, previous page) and *The Tempest* in 1842 (fig.15, p.32) as interpretations to rival two celebrated new productions staged at Covent Garden. Each of these plays had for generations been considered unperformable: as William Hazlitt had complained earlier in the century, they delighted when read but disappointed when staged.[30] Indeed neither drama *was* staged other than in entirely mangled versions between the Restoration and Dadd's day, when William Macready revived *The Tempest* (1838) and Eliza Vestris the *Dream* (1840) in more or less the form in which Shakespeare had written them. Both these productions were massively ambitious visual spectacles. Macready's scene-painter, Charles Marshall, was felt to have succeeded in conjuring up a convincing enchanted island, around which the female Ariel (Priscilla Horton) flew on wires. Reviewing *The Tempest* in the *Examiner*, John Forster (who much later, as one of the Commissioners in Lunacy, acquired watercolours by Dadd) declared that the new production 'carries poetical and pictorial illustration as far as they will go'.[31] But the *Dream* of a couple of years later seemed to go even further. Also boasting an actress in one of the leading male parts (Vestris herself appearing as Oberon, King of the Fairies), this production featured scrolling panoramic backdrops that represented the setting and rising of the sun, various characters ascending and descending upon risers and through traps, as well as the glorious music of Felix Mendelssohn. The final scene in Theseus's palace, in which 'fairies crowded in every part, gliding along galleries, ascending and descending steps, soaring in the air with blue and yellow torches which produce a curious light, is' – wrote *The Times* – 'one of the most beautiful and highly wrought fairy scenes ever introduced on the stage'.[32] For painters aspiring to depict the fairy world, the bar had just been significantly raised by the London theatre. Dadd responded with the masterpieces of his early career.[33]

Titania Sleeping was accepted by the Academy for exhibition in 1841 and was accompanied in that year's catalogue by a brief quotation from Oberon's speech in Act 1, Scene 2 of *A Midsummer Night's Dream*, beginning 'I know a bank where the wild thyme blows' in which he plots revenge upon his disobedient queen: he will rub a potion into her sleeping eyes that will cause her to fall in love, on waking, with the first creature she sees. Controversially, Vestris had this speech set to music to create a sentimental duet that she herself, as Oberon, sang (presumably with Puck), leading the young Queen Victoria to complain in her diary of the show's weakness being its 'stupid duets and songs'.[34] So perhaps Dadd deliberately chose this weak point of the production with which to enter into competition. On a modest scale, he painted a naked Titania falling asleep to the lullabies of her fairies as Oberon lurks in the shadows of the leafy bower ready to strike. Their song is accompanied by a miniature orchestra of undetermined little beings (goblins?), twined around the arch of convolvulus and blowing instruments, some of which consist of parts of the trumpet-shaped flowers or of the players' own anatomy. A mixed company of nude dancers spin away to the left, while the whole scene is framed above by a stylised series of bats – inspired by Titania's account of her followers' bullying of the natural world: 'Some war with reremice [i.e. bats] for their leathern wings,/ To make my small elves coats' (Act 2, Scene 2).

11
Daniel Maclise
The Disenchantment of Bottom 1832
Oil on canvas
127 x 101.6
Wadsworth
Athenaeum Museum
of Art, Hartford CT

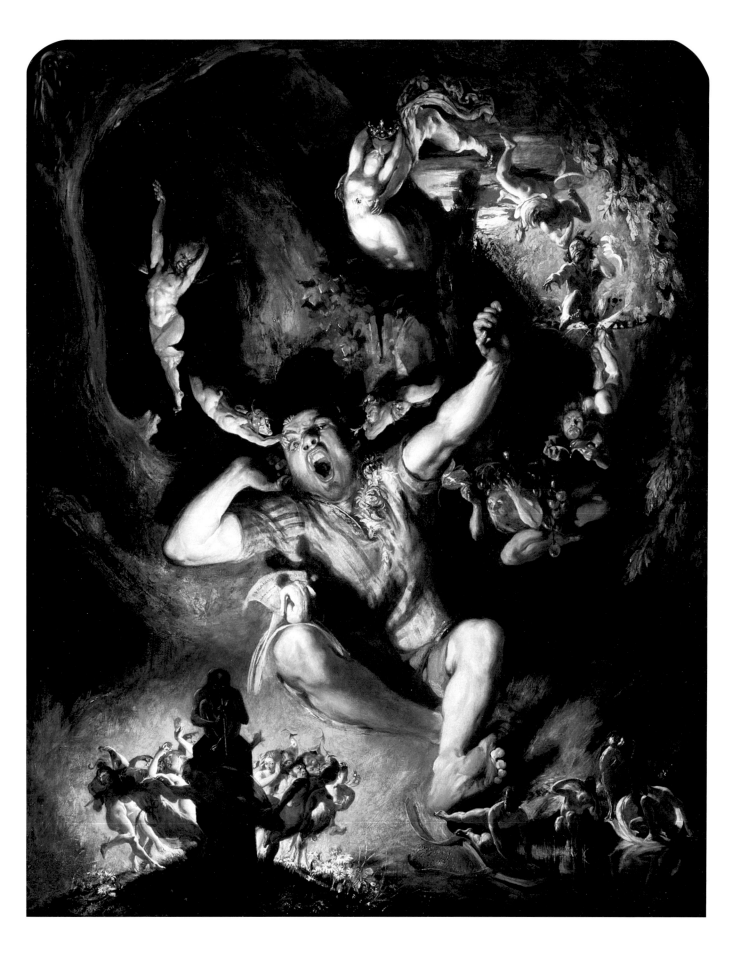

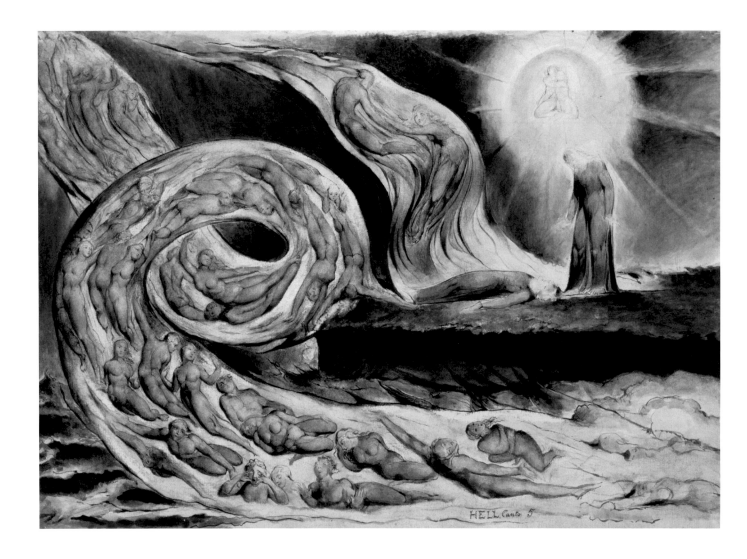

The composition is very lucidly articulated, almost geometrical, based on
a receding spiral. The idea of the circuit of miniaturised creatures has been
borrowed from Maclise (fig.11, previous page), while the overall structure
resembles nothing so much as one of William Blake's last works illustrating Dante's
Divine Comedy, The Circle of the Lustful 1824/7 (fig.12). Dadd's is certainly a sexy
Shakespearean invention, as emphasised by the admiring critics who felt the need
to insist that the picture was in fact thoroughly chaste.[35] Possibly Dadd was again
being competitive with the theatre here, as Macready had famously chastened
Covent Garden in the 1830s by expelling prostitutes from its public areas. Fleshly
pleasures make their return in *Titania Sleeping*.

The fate of the picture at the Academy was mixed. The critics who took notice
of it were impressed, but its attraction was partly that of the underdog in that it
had been very badly placed, hung near the floor and therefore easy to overlook.
It was not bought by a collector but instead by an art dealer, Henry Farrer of
Wardour Street, who chose *Titania* as part of his prize that year in London's new
art lottery, the Art Union (it was part of the same enterprise as the journal of the
same name).[36] This was in effect a middle-class collectors' 'trade' union or friendly
society. Members bought tickets allowing a few winners each year to purchase their
choice of modern art from the London exhibitions. Dadd must have admired the

independence of the venture but might perhaps have preferred a more glamorous owner for his picture.

Presumably it was with the same prize money that Farrer also acquired Dadd's *Puck* (fig.13), shown at the Society of British Artists in 1841. The picture comes from the same world as *Titania* with its abandoned revellers, botanic architecture and geometrically tidy composition, here conceived as a liquid globe backlit by a crescent moon. This all complements the text from Act 2, Scene 1 of *A Midsummer Night's Dream* that Dadd had printed in the catalogue:

> I do wander every where
> Swifter than the moon's sphere,
> And I serve the fairy queen,
> To dew her orbs upon the green.

But these lines belong to Titania's first fairy, not Oberon's servant Puck, and indeed form part of the stand-off between the King and Queen and their entourages. Evidently Dadd was more interested in emulating Shakespeare's conceptual playfulness than in illustrating a specific text. The circular image is cornered by four male nudes resembling river gods, echoes of the figures that might have elaborated an old astrological chart. The ethereal lighting perhaps resembles theatrical limelight (said to have been the invention of Marshall of Covent Garden), but might equally be seen as recalling an engraver's work table, upon which light from a bright lamp would be refracted through a glass globe filled with water (Dadd was himself working with engravers around this time in connection with his image of Puck for *The British Book of Ballads*). Puck himself (or Robin Goodfellow) is based on Joshua Reynolds's putto characterisation of several decades earlier, although his appearance as a baby may echo some of the other folklore around Puck, for instance the Kentish version of his career according to which a male fairy took a fancy to a human girl, and 'every night would he with other fayries come to the house, and there dance in her chamber'. She in due course gives birth to a beautiful baby boy, destined to become the famous tormentor of the false and idle.[37] Dadd's Puck is crowned with a chandelier of purple convolvulus. Just conceivably he was making reference to the folk tradition of the seeds of certain convolvuli having hallucinogenic properties (a tradition subsequently confirmed by chemists and embraced by recreational drug users of the 1970s, for whom Morning Glory seeds were a cheap alternative to LSD). Meanwhile, the earliest first-hand account of a magic mushroom trip dates from 1837.[38] With its giddying medley of sources, Dadd's *Puck* placed its author beyond the role of illustrator or even interpreter. Where precisely that left him was a question that worried some of his admirers. Hall, writing in his *Art-Union*, was equivocal: 'Mr Dadd is on the right road to fame; he must, however, beware; and stop short of the boundaries which divide the imagination from the absurd.'[39]

There are various references to other, minor fairy subjects of this period, now not easy to put into clear order. One of the few known today, *A Fairy – Sunset* c.1841–2

13
Puck 1841
Oil on canvas
59.2 x 59.2
Harris Museum and
Art Gallery, Preston

(fig.14), is an oval composition showing a single female fairy in the guise of a Crouching Venus, relating to the speech of the fairy in Act 2, Scene 1 of the *Dream*, from which Dadd had quoted when exhibiting his *Puck*: 'I must go seek some dew-drops here,/ And hang a pearl in every cowslip's ear.'[40] Among the lost fairy pictures there appears to have been one major work, *Fairies Assembling at Sunset to Hold their Revels*, exhibited at Manchester in 1841, which we can only suppose was closely related to the last fairy subject that Dadd sent for exhibition, *Come Unto These Yellow Sands* 1842 (fig.15, overleaf).[41] In the Academy catalogue of 1842 there was again, as in the case of *Puck*, no title, only these lines from Act 1, Scene 2 of *The Tempest*:

> Come unto these yellow sands,
> And then take hands,
> Curt'sied when you have, and kissed
> (The wild waves whist).
> Foot it featly here and there,
> And sweet sprites the burden bear.

This rather confused text, over which editors of Shakespeare have worried at length, is part of the song with which the 'airy spirit' Ariel lures the shipwrecked prince Ferdinand to his master Prospero. Evidently this is not what Dadd has represented, and indeed when the picture was sent up to the Liverpool exhibition in 1843, Dadd added to the quotation a title – *Fairies Holding their Revels on the Sea Shore at Night* – which seems to take the image further away from *The Tempest* and back towards the *Dream* in Act 2, Scene 1 of which, during her row with Oberon, Titania suggests this peace offering: 'If you will patiently dance in our round/ And see our moonlight revels, go with us.' Indeed, if we identify the regal female figure at the apex of Dadd's composition as the Queen of the Fairies, then the subject seems to relate best to the earlier part of this same exchange in which Titania explains why she refuses to render up the Indian page whom Oberon so covets:

> Set your heart at rest:
> The fairy land buys not the child of me.
> His mother was a votress of my order;
> And in the spiced Indian air, by night,
> Full often hath she gossip'd by my side;
> And sat with me on Neptune's yellow sands,
> Marking th'embarked traders on the flood:
> When we have laugh'd to see the sails conceive
> And grow big-bellied with the wanton wind;
> Which she, with pretty and swimming gait
> Following (her womb then rich with my young squire),
> Would imitate, and sail upon the land
> To fetch me trifles, and return again
> As from a voyage rich with merchandise.[42]

14
A Fairy – Sunset
c.1841–2
Oil on canvas
60.6 x 50.8
Private collection

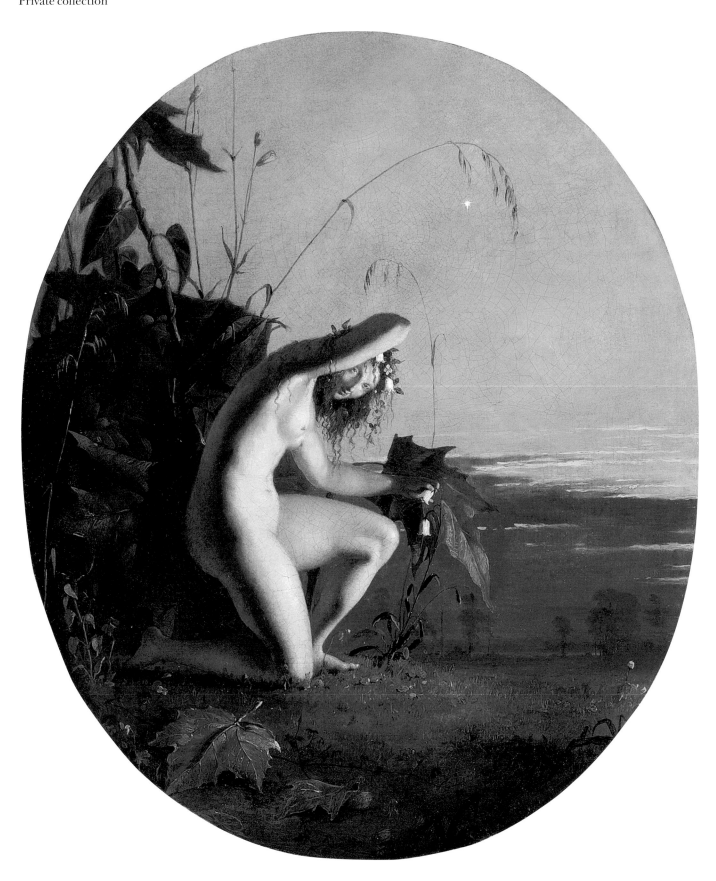

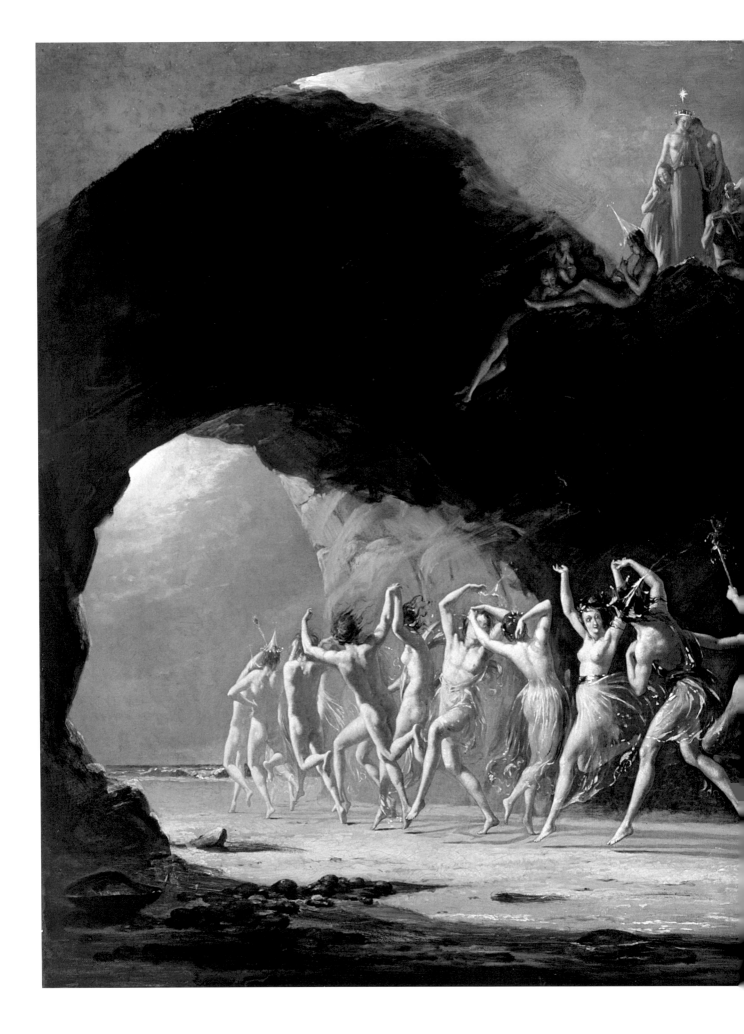

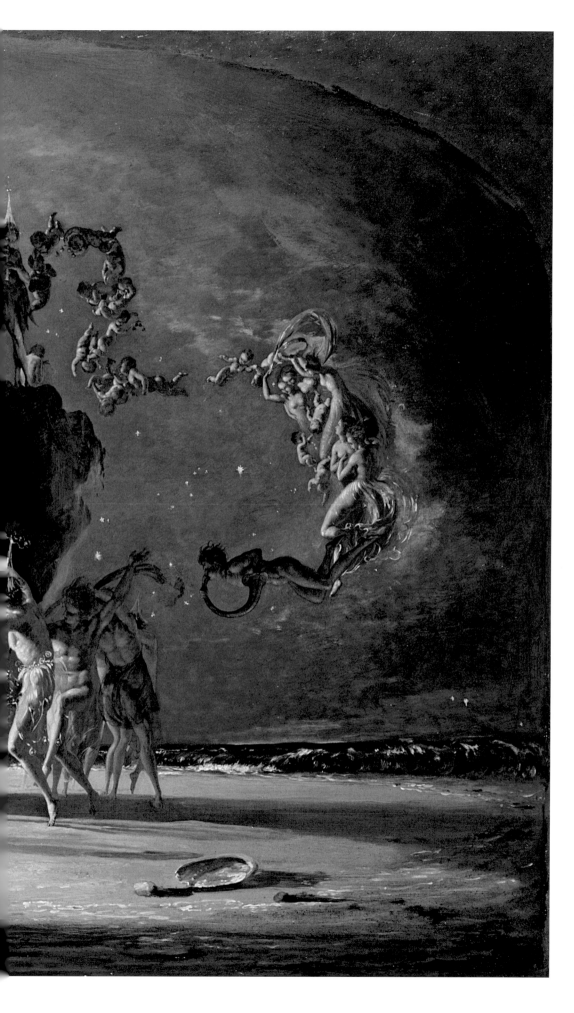

15
Come Unto These Yellow Sands 1842
Oil on canvas
55.3 x 77.5
Private collection

On the sands the dancing fairies move jerkily in a half-circle. One of the exhibition reviewers found them too 'spicular' and perhaps here again Dadd was vying with the theatre, for the romantic ballet of the 1830s had introduced the vogue for fay or elfin ballerinas skitting across the stage on their points.[43] Linking the Queen above with the dancers below is the dynamic double loop of musical figures, now more elegant and less grotesque than the comparable characters in *Titania Sleeping*. If not quite so beautiful as that painting, *Come Unto These Yellow Sands* nevertheless seems to capture much of Shakespeare's pivoting between the sublime and the sexual, the natural and the fantastic. The *Art-Union* decided that it 'approaches more nearly the essence of the poet than any other illustrations we have seen', and that it was 'fraught with that part of painting which cannot be taught – in short, the artist must be some kind of a cousin of the muse Thalia' (the muse of comedy and of idyllic poetry).[44] Those who hung the pictures at the Academy cannot have agreed, as the painting was, like *Titania* before it, placed at shin level, 'where the mere crowd of gazers would pass it by unnoticed'.[45] Just possibly, however, the academicians may have intended this position to be suited to the fairy world – lost to inattentive sight in the undergrowth.

Dadd's trio of fairy pictures shown at the London exhibitions in 1841–2 brought him valuable critical recognition but not much money. None of them was engraved at this time, one reason being that they all left London, entering relatively obscure collections. Indeed there is a distinct and intriguing pattern to the collecting of Dadd's earliest paintings. Their owners tended to be from the manufacturing cities of the Midlands and the North, men with strong local profiles but in no way members of the country's elites of power, money or taste. They were rather, perhaps, men who wished to distinguish themselves among their industrialist peers through a controlled flash of Byronic danger or fairy magic. Thus *Titania* went from Farrer's stock up to Leeds and then to the collection of the Manchester mill-owner Samuel Ashton.[46] *Puck* went to Stoke (midway between Birmingham and Manchester), to the earthenware manufacturer Charles Meigh, and afterwards to Thomas Birchall of Preston.[47] *Come Unto These Yellow Sands* found a more genteel home with Patrick Dudgeon, the antiquarian and mineralogist of Cargen, Dumfriesshire.[48] But by quite a large margin, Dadd's most devoted, and most obscure, collector was Richard Gibson Reeves, a merchant of Birmingham, the city that stood for cheap and cheerful mass production, and for uncompromising democratic politics.[49] In the sale that followed Reeves's death in 1864 there was an entire section devoted to Dadd's works, including the *Hamlet*, several of the Clique portraits, the original drawings for the Foley decorations and a large and expensive fairy subject that must have been the now missing *Fairies Assembling at Sunset*.[50]

Dadd's works of fantasy and imagination had thus found their most welcoming home in Britain's headquarters of radical politics. The Birmingham Political Union had led the popular agitation for Reform in the early 1830s and during the following decade the city became a centre of Chartism, the campaign to achieve the complete restructuring of Britain's political system. Dadd's career was now, in 1842,

to be pulled in new directions in the wake of the turbulence of this potentially revolutionary movement.

Chartism alternately fascinated and terrified the intellectual classes. When, they worried, would democracy darken into mob rule? The answer appeared to come when dramatic events overtook the South Wales coal and iron town of Newport in 1839. A politically confident local working population, frustrated at the 'sell-out' of the 1832 Reform Act, had turned Newport into a centre of Chartism to rival even Birmingham. John Frost emerged as the most determined local leader, coming to prominence after getting himself elected mayor in 1836–7. Frost and the other Chartist leaders took an extreme dislike to the man who succeeded as mayor in 1838, the local solicitor Thomas Phillips. Phillips had been a moderate Reformer himself, but as a supporter of the Anglican Church and the fundamental rights of the Establishment in general, he was just the kind of liberal whom the radicals saw as their worst enemy.[51] The Chartists vowed they would string him up from the nearest lamppost once his rule was overthrown, which seemed about to happen when in November 1839 a virtual army of thousands of working people entered Newport demanding the release of some arrested Chartists.[52] Fire was opened between them and Phillips and the soldiers who had come to his aid. Some twenty people lost their lives, while Phillips himself received a couple of wounds in the arm and groin. The confrontation ended with the dispersal of the Chartists and the arrest of their leaders.

Such was the sense of relief among the ruling elite that all protocol was cast aside and Phillips, although a commoner, was swept into a private audience with the Queen at Windsor and awarded a knighthood. Now a public figure, he took to his new role of seigneur with gusto, deciding that the carnage at Newport was ultimately the result of a breakdown in paternalism: 'This antagonism originated, as great social evils ever do, in the neglect of duty by the master, or ruling class.'[53] In 1842, prior to establishing himself as a lawyer in London, Phillips embarked upon a very grand tour that was designed to allow him to see as much of European and Near Eastern cultural history as was humanly possible within a few months. Imagining that a gentleman tourist needed an artist-companion to record the sights (in fact an already old-fashioned idea), Phillips turned for advice to David Roberts, the country's best-known Orientalist painter, whose scenes of ancient Egypt and the Holy Land had been highlights of the Academy shows since 1840. Roberts was delighted to be able to recommend the brilliant son of his friend Robert Dadd, a young man not only of talent but also of good breeding. A dose of drawing real buildings and people might do him no harm after inventing all those fairies.

2 Orientalist and Assassin

Dadd became part of British art's Orientalist moment of the 1840s. Propelled by steam power and attracted by the Ottoman Empire's reform programme that included a new openness to Europeans, from the late 1830s painters began to make tours of the Eastern Mediterranean in unprecedented numbers. David Roberts led the way in 1838–9 with a tour de force of industrious sketching in Palestine and Egypt. He was away only eleven months, but in that time garnered enough pictorial material with which to produce paintings of Eastern architecture for the rest of his career. David Wilkie and the watercolour specialist John Frederick Lewis were both in Constantinople (as most Europeans still referred to Istanbul) in 1840. Wilkie went on to the Holy Land, intending to paint scenes from the life of Christ, but died on the way home the following year. Lewis meanwhile took up residence in Cairo, where he remained a full decade before returning to London in triumph as the undisputed master of lushly detailed, apparently truthfully rendered pictures of Oriental life.[1] Younger than any of these members of the elite of artistic society, Dadd's venture was nonetheless more old-fashioned in that it was not self-financed. He travelled as the companion-draughtsman to a gentleman tourist, Sir Thomas Phillips, a role more common in the eighteenth century before the evolution of exhibition culture had made possible the independence of an artist's travels by providing a selling space for the resulting products.

The precise details of the arrangement between the two travellers remain unclear. So determined was each of them to play the gentleman that money matters were apparently scarcely discussed. But essentially Dadd was expected to make drawings

London

Paris

Venice
Bologna
Florence

Rome Istanbul/Constantinople
Naples

Corfu
Delphi Smyrna
Athens

Beirut Damascus

Jerusalem

Alexandria

Cairo

Thebes/Karnak

16
Map showing some of
the principal locations
visited by Dadd in
1842–3

of the places they visited, which Phillips would keep, in return for all the artist's expenses being covered. Very likely Phillips had intended to write a travel book – just the kind of project suited to a socially ambitious man of energy such as himself. This would explain the interest in accumulating a body of illustrations, and also the long and detailed letters that Phillips wrote to his brother in London at regular stages during his tour, potentially constituting a rough draft of a travelogue sent home in instalments for safekeeping.[2]

The world through which Phillips and Dadd travelled between July 1842 and May 1843 was that of the traditional grand tour of Italy and Greece, now extended thanks to steam travel into the Ottoman world of Turkey, Egypt and 'Syria' (the modern-day Arab countries west of Iraq). For educated European travellers, the Eastern Mediterranean was a region comprising bewilderingly complex layers of their own cultural history, layers with which it seemed difficult to engage simultaneously. There were the classical remains and the geography of Homer's epics, the locations of the first Christian churches and Paul's journeys, and then the relics of the Crusaders. The nineteenth century introduced the Byronic mode of Orientalism, fraught with sexualised violence fantasised against backdrops of romantically revived national cultures. And following Byron's championing of Greek independence against Turkey, there now evolved, especially in Britain, a more earnest rhetoric pondering the future of the territories still shakily retained by the ailing Ottoman Empire. Which of the European powers were to hold sway in the future in the lands of the Pharaohs, in Palestine where Jewish culture had never

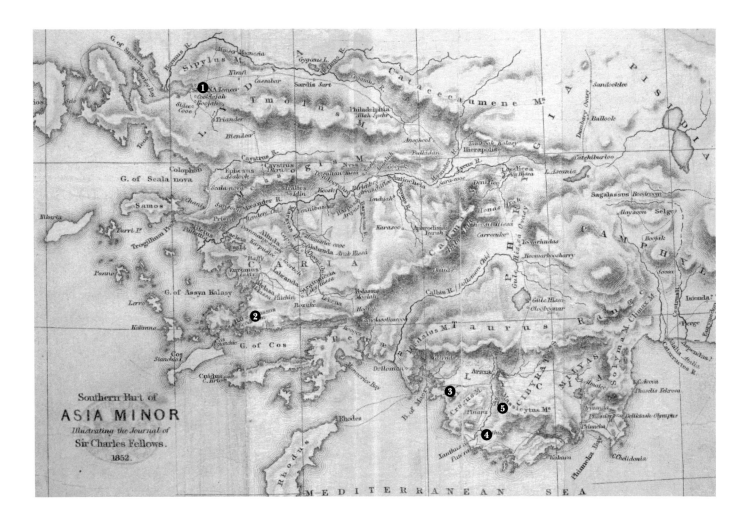

given up its presence, or indeed in the Ottoman capital itself, Constantinople, which the British feared was in the sights of the Russian Empire's military planners? But, as things turned out, precious few of these historical and political questions had the chance really to work their way into the experience of our travellers. The reason was simple: they were too busy travelling.

A memoir of Dadd's employer published after his death recalled that 'In person Sir Thomas Phillips was of medium size, with a well-made and compact frame, indicating great strength and power of endurance. His presence had an air of command.'[3] He certainly turned out to be a ferocious tourist, exhausting his younger companion in a whistle-stop clockwise trajectory around the Mediterranean, stopping only when forced to do so by the demands of quarantine or – more rarely – the irresistible attractions of such metropolises of culture as Constantinople or Thebes. The keynotes of Dadd's experience were to be elation at the wondrous places he saw, alternating with frustration at not having time to draw them properly. The tour lasted ten months, about the same period Roberts had spent abroad four years earlier. But although Dadd saw many more places than Roberts had done, from what we know of the work he was able to bring back, he returned with much less in the way of useful sketches that might easily be translated into oil paintings for exhibition. Dadd was working mainly in small sketchbooks, of which only two are known to survive. One, now in the archives of Bethlem Hospital, has been only partially used and contains scrappy sketches and notes

17
Map of south-west Turkey (ancient Caria and Lycia) from Charles Fellows, *Travels and Researches in Asia Minor* (1852) showing some of the sites visited by Dadd:
1 Smyrna (Izmir)
2 Halicarnassus (Bodrum)
3 Macri (Fethiye)
4 Xanthos
5 Tlos
British Library, London

18
Map of Syria Ancient and Modern by James Wyld (1840) showing some of the places visited by Dadd:
1 Tripoli
2 Baalbek
3 Beirut
4 Damascus
5 Dor (Tantura)
6 Jerusalem
7 Ein Gedi
Royal Geographical Society, London

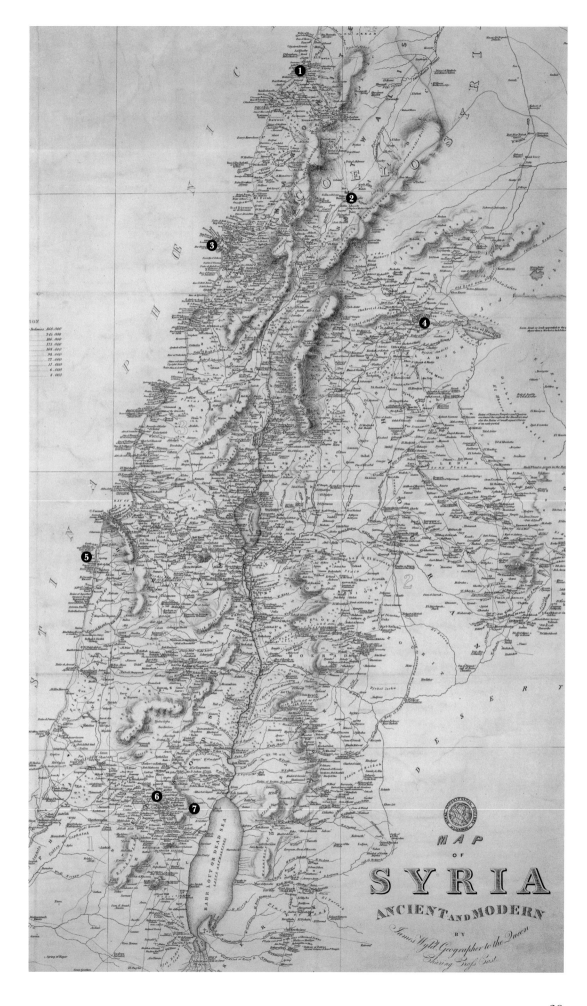

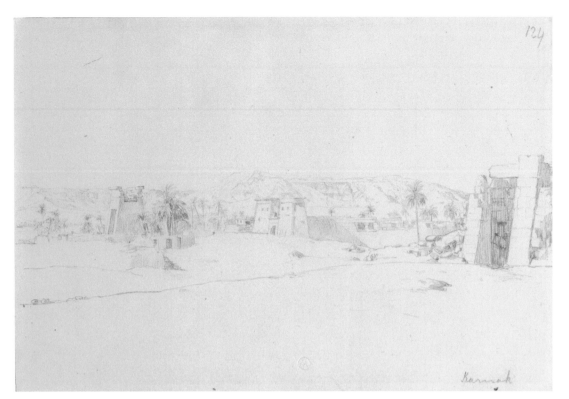

19, 20
Pages from Dadd's
Middle-Eastern
Sketchbook, 1842–3
(above) *General view of
Karnak*
(below) *Group of male
figures at Damascus*
Victoria and Albert
Museum, London

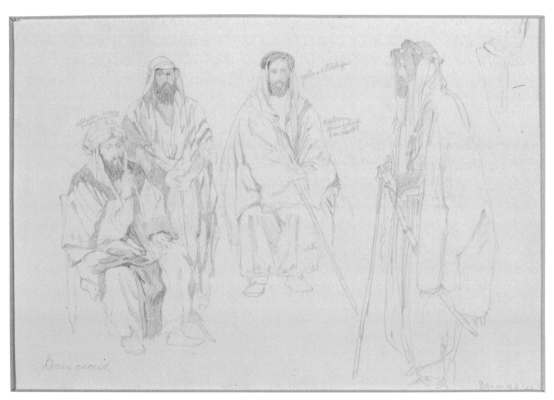

dating largely from the spring of 1843 when Dadd and Phillips were in Italy.
The other, in the Victoria and Albert Museum, is full of material from the eastern
core of the journey. Measuring just 14 by 20 centimetres, Dadd crammed this
sketchbook with a multitude of pencil studies, executed in a delicate, taut line,
and so densely packed into the little pages that they can appear like hieroglyphics.[4]
On rare occasions he was able to set down full-page mini-panoramic landscapes
(fig.19) or an elaborate figure study (fig.20). But otherwise the V&A sketchbook

is testimony to the difficulties of which Dadd regularly complained in finding opportunities to sketch, and the 'impossibility' of being in one place long enough to use colours to complete watercolours.[5] Its principal contents are fragments of costume, architecture and landscape, with colour names written in for future reference. Dadd did however manage to make some more elaborate pencil drawings on independent sheets, and may even have after all succeeded in executing a small number of finished watercolours while abroad. There was also at least one further sketchbook, still sadly untraced, which Dadd used on his travels and retained for the rest of his life as a source of Oriental subject matter. Possibly this was larger than the two that are known, and contained more fully worked landscape compositions, the V&A sketchbook being used concurrently for quicker, slighter work.[6]

What did the Orient mean for artists? Roberts was seen to have pioneered a kind of Orientalist realism, bringing home for the first time, like a natural historian, authentic and accurate visual reports of the appearance of the great sites and cities of the Near East. For Lewis, Wilkie and the artists who followed them later in the century such as the Pre-Raphaelite William Holman Hunt, this appeal to the authenticity of vision was central. The myths of exploration, with challenging climates and reluctant natives, informed these travellers' heroic notion of the artist's gaze being extended against the odds into uncharted territory. Key to this conception of the Orientalist painter's expedition was the physicality of looking. The artist was supposed to endure bodily danger to capture his image, and the people being looked at were supposed actively to resist that capture. The gaze needed to be flexed against its resistant target, and Eastern populations were cast in this latter role, especially Muslims, whose theological strictures against the use of certain imagery were exaggerated by Westerners into a decided iconophobia (Islam per se often played little or no further role in travellers' thinking).

This very physical interpretation of looking – the body being fully implicated in the job of sketching – appears in Dadd's letters home the moment he crossed the most narrowly defined boundary of the traditional European grand tour. Setting out via Ostend in July 1842, the tourists made their way to Italy via Belgium and Switzerland. Dadd was presumably still adjusting himself to his employer's pace, as no drawings survive from this first phase. They were five days in Venice in August before visiting Bologna and then embarking at Ancona for Greece. A brief pause at Corfu was the cue for the onset of Dadd's Orientalism:

> On landing we at once entered upon a scene of a description that baffles me. It seemed a large assortment or menagerie of pompous ruffians, splendid savages, grubby finery, wild costume, long matted hair, dark complexions, and noisy shopkeepers, styed in filth, all their [shirts] looking like makeshifts: these mixed with English, soldiers and civilians, Italians, donkeys, mules, and strange half-naked children, quite bewildered me, and I knew not which to look at first. Upon recovering I pulled out my sketch-book to secure some reminiscences of costume, and immediately I was surrounded by the

whole market. I never saw such an assemblage of deliciously villainous faces: they grinned, glowered, and exhibited every variety of curiosity. Oh, such expression on such heads! is enough to turn the brain of an artist. Having sketched what I desired, I moved off only to be followed by a troop of boys and men about fifty or sixty in number, and I in modesty dived into all sorts of miserable alleys and back ways to avoid them; but alas! I might as well have tried to get rid of my own shadow. All my efforts could secure me but little of what I saw, as the moment I began sketching some kind body would inform the person, and raise his curiosity to see his picture. Some looked at me with great suspicion, whilst others examined me as a species of curiosity, and – but I must wait my return to inform you of more.[7]

As a young artist with no pretensions to political or other useful information, Dadd has little or nothing to say about the social and economic realities of the places he visits. Instead he resorts immediately to the most basic trope of Orientalist travel writing, a bathos predicated on the tragicomic differences supposed to exist between the ancient dignity of the names of the sites and the ordinary ugliness of modern life now being carried on there. This was his reaction to the sacred spring at Delphi, once home to the oracle of Apollo but now to shouting washerwomen. Thus a sense of belatedness, so typical of the Oriental traveller, established itself from the outset in Dadd's mind: he had come too late to see anything truly magnificent.[8]

There was then a week spent touring the antiquities of the Peloponnese, visiting Argos, Tiryns and Mycenae where Dadd was able to make quick sketches of the so-called Tomb of Agamemnon (leader of the Greek expedition against Troy) and the Lion Gate, the latter only very recently excavated and restored (V&A sketchbook: S.266–7). But by the time he and Phillips paused for a week in Athens at the beginning of September, the artist was feeling exasperated. Both men now had the chance to write letters home, Phillips reporting genially of Dadd that he was 'obliging, good tempered, sufficiently informed on general subjects to make an agreeable companion, possesses considerable knowledge of art & loses no opportunity to improve himself'.[9] But Dadd's letter from Athens to Roberts suggests he felt he had been *too* obliging: 'Hitherto we have travelled with the greatest rapidity so that the number of sketches I have made is but few and those are mere scrawls in a sketch book.' Apologising for his negative tone, Dadd adds, 'I must trust that you will excuse this, as one excuses a safety-valve in a steam-engine'.[10] On 9 September Dadd and Phillips crossed the Aegean to Smyrna (Turkish Izmir) and then took a steamer up to Constantinople.

Now they were in the real Orient, the capital of the shrinking Ottoman Empire, the most architecturally beautiful and politically important city on their itinerary. Even Phillips felt he had to devote a fortnight to the place, although the surviving references to these weeks are scant. In Dadd's sketchbook are drawings of the city's famous skyline, of its scarcely less celebrated slave market, and of that other staple of the tourist's Constantinople, the lodge of some whirling dervishes (S.91–2,

21
Page from Dadd's
Middle-Eastern
Sketchbook, 1842–3
Letter writer
Victoria and Albert
Museum, London

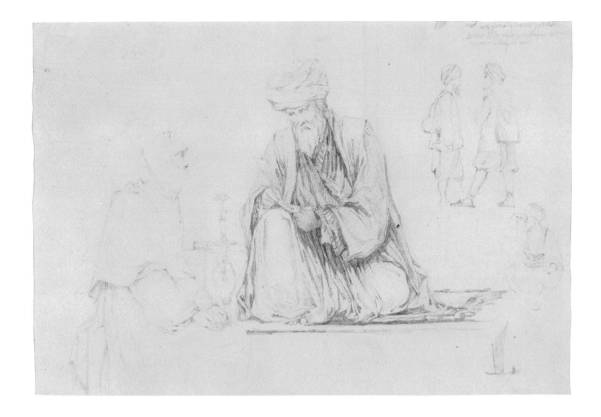

98). Constantinople also inspired several of the most elaborate figure studies in the sketchbook: men in kalpaks (high-crowned caps), veiled women and even something approaching a genre scene – a professional letter-writer taking dictation in a city street, a subject already becoming a favourite among European artist-travellers to Constantinople (fig.21). These visual notations are all we have to interpret Dadd's reactions to the Ottoman capital. He is not known to have taken an interest in the Tanzimat reforms taking place there at the time, or in the keen debates that exercised politicians everywhere over the future of territories, in the Balkans and Palestine especially, that the Ottomans seemed unlikely to be able to maintain. What is also missing, more strikingly, is any reference, visual or verbal, to the harem, the female-only world that for Westerners so often defined their fantasy of the Orient.[11]

After Constantinople came the least predictable leg of the tour. Dadd and Phillips spent most of October in Asia Minor, exploring classical ruins along the south-western coast of Turkey. Around the former ancient states of Caria and Lycia lay the remains of cities on the edge of Greek civilisation (Anatolia means orient in Greek), places where Persian influence had produced hybrid languages and architecture at once familiar and exotic to the European tourist and archaeologist, for whom this region had recently become exciting new hunting ground. The British archaeologist Charles Fellows was now a literary celebrity following his explorations of Lycia and account of its 'lost' capital of Xanthos in particular. He supervised the carrying off of its sculpture to the British Museum in a series of expeditions in the 1840s. The great sport of travellers here was to match the remains with places described in classical literature, an exercise in ignoring the intervening two thousand years, similar to the way in which tourists in Palestine

often sought to make sense of their surroundings with the help of the Bible alone.[12] Meanwhile, the basic surveying of the coast of modern Caria and Lycia had yet to be satisfactorily completed, and the Royal Navy's Hydrographic Survey was busy working on this task in the area.

Phillips and Dadd set out from Smyrna at the beginning of October and travelled on a south-eastern route intended to take them down to Xanthos and to include the other major archaeological sites recently or presently being investigated. The regime was again brutal, as Phillips insisted on as many as twelve hours a day in the saddle. But, although Dadd declared the whole of Asia Minor to be 'one vast ruin', this did not stop him enjoying this stage more than any other of the tour.[13] The rugged, sometimes spectacular landscape, poetic ruins and nomadic people moved him intensely, and by now he had learned to be philosophical regarding the impossibility of capturing their appearances: 'A thousand things to arrest the attention, and which all seemed to slip away from me as if unreal – as if they were the pageants of a dream, rather than a substantial reality; and yet I do not think that I am much to be blamed, for a body can't very well sketch riding on horseback.'[14]

Via Ephesus they arrived at the ruins of Magnesia, where they found the French archaeologist Charles Texier hard at work removing a huge second-century BC frieze from the Temple of Artemis Leukophryene. Now to be seen in the Louvre (it is the largest sculptural ensemble housed there), the frieze represents an amazonomachy, a battle between Greeks and the Amazons, the legendary warrior women of Asia Minor. Symbolising the weird and foreign alien to the Greek mind, the imagery of the Amazons, specifically this disturbing, woman-bashing iconography of the amazonomachy, recurred repeatedly through this part of Dadd's travels.[15] There was an especially celebrated version of the theme at the travellers' next key destination, the Mausoleum of Halicarnassus. From Mylasa (modern Milas), the former capital of Caria, Dadd and his companion headed south to Bodrum on the coast, site of this fabled tomb-temple erected by the widow of Mausolus, an independent King of Caria in the fourth century BC. Along with the Temple of Artemis at Ephesus it had been one of the Seven Wonders of the ancient world. By the time of Dadd's visit it had virtually disappeared, its surviving sculptures installed in the nearby castle of St Peter, built by the Knights of St John around 1500, to which access was seldom granted by the local Ottoman governor. The British were nevertheless intent on capturing these prizes eventually, and Dadd was set to make formal drawings of those few sculptures that could be seen from the outside of the castle (fig.22) – parts of the amazonomachy frieze representing the expedition of Heracles and Theseus into Asia Minor to attack the Amazons in their home town of Themiskyra on the Black Sea coast (the frieze also appears in the sketchbook: S.274). Dadd's drawings were sent to Stratford Canning, the British Ambassador at Constantinople, along with a report by Phillips. But this effort turned out to be only one skirmish in the diplomatic battle to secure the marbles of Halicarnassus, which were eventually removed to the British Museum in 1846.[16]

44

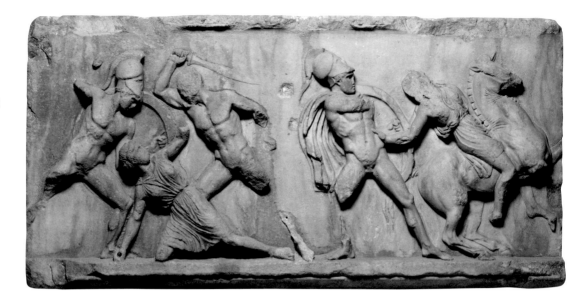

22
*Greeks and Amazons
Fighting*
Part of the frieze from
the Mausoleum at
Halicarnassus, c.350BC
British Museum,
London

Dadd had nothing to say about the harem; nor, in his surviving letters at least, does he rehearse any of the familiar received wisdom of the tourist about the inferior position of women in Oriental society. His Orientalist fantasy of gender seems to have worked in the reverse sense to the norm. Dadd's travels in Asia Minor were haunted by images of Amazons, ferocious and totally independent of men, while among the actual present population he was repeatedly struck by the physical prowess of the women. He seems to have had a particular attraction to the sight of women carrying heavy water vessels, and when he witnessed a large number of people descending from the mountains to change abode for the season, he recorded his admiration of the 'lusty women' who 'were stoutly trudging their way'.[17] The women of the region, he felt, walked with simple dignity, without the mincing mannerisms of spoiled young English ladies – 'such a gait as a rational creature should use'.[18] Had things turned out differently Dadd might have become one of those renegade commentators on Oriental manners, such as Lady Mary Wortley Montagu in the eighteenth century or Wilfrid Scawen Blunt later in the nineteenth, who saw there a corrective to the corrupting arrangements of society in Europe.

From Bodrum the travellers took a boat along the Gulf of Kos to make faster progress east into Lycia, visiting Dalaman and the port of Macri (modern Fethiye, ancient Telmessos) before heading inland to see one of the great sights of Lycia, the citadel of Tlos. A great crag of rock honeycombed with carved tombs in classical architectural forms, Tlos offered sublime views towards the mountain ranges – including the snow-capped Massicytus – that surrounded it. Then it was back south to Xanthos, the recently revealed ancient city of such fierce independence that its citizens had twice committed mass suicide rather than submit to either the Persians or later the Romans. Now it was the culminating point of Phillips' and Dadd's tour of Asia Minor. They arrived to find the removal to London of the sculptures of Xanthos suspended between campaigns. The first shipload had departed in March, and the job was resumed late in 1843. Dadd and Phillips were therefore among the first tourists at the site, but also among

23
Page from Dadd's
Middle-Eastern
Sketchbook, 1842–3
*Rock Tombs Cut into
Hillside in Lycia*
Victoria and Albert
Museum, London

the last people to see a substantial number of the sculptures still in place. Dadd made some sketches of the tombs (S.275–9), but must have been aware of the amateurism of his efforts in comparison with the highly focused work going on in the area to produce a thorough survey of Lycia.

The travellers had apparently met up at some point with Lieutenant Thomas Spratt, the indefatigable naval surveyor of HMS *Beacon*, the principal ship of the Mediterranean Hydrographic Survey that had supported Fellows's Xanthos campaign earlier in the year.[19] A colleague of Spratt's on the *Beacon*, Richard Hoskyn, had recently made a careful survey of the coast of Lycia, published by the Royal Geographical Society in 1842, and also in this year Spratt had made his own tour of the ancient cities of Lycia in the company of the brilliant young naturalist Edward Forbes and a prominent amateur artist, E.T. Daniell of Norwich.[20] The three of them intended to combine their different descriptive skills to produce a new kind of unified visual account of Lycia, and although this was frustrated by the illness and death of Daniell during the work, the book published in 1847 by the two survivors of the expedition is illustrated with wonderfully detailed plans and maps. There was a strong sense of competition about such projects. The Navy survey was of course connected with possible future military requirements, but the artists also had an eye on one another.[21] When the Bristol painter William Müller turned up at Xanthos late in 1843 he was given the cold shoulder by Fellows's own resident draughtsman George Scharf, but was nevertheless only prevented by his early death from publishing a portfolio of prints after the drawings he managed to make. Lycia does not seem to have been a very lucky place for British artists. Comparing his own cursory sketches with the work of the surveyors and archaeologists, Dadd can surely only have mentally retreated to the reassuring thought that he was after all a *painter* – an artist of poetry and the imagination. Any Oriental scenes he might paint after his return would not aspire to contend with such scientific accuracy.

The next key landmark in the tour was to be Jerusalem, the city holy to Jews, Muslims and Christians, although in keeping with the secular, archaeological tenor of the venture, this was essentially a staging post on the way to Egypt. From Xanthos, Dadd and Phillips returned to Macri via Pinara, admiring at both these places the characteristic Lycian tomb-temples carved into the rocky hillsides in such numbers that they appeared like some miracle of nature (fig.23). Having awaited a steamer at Rhodes, they touched at Cyprus before arriving at Beirut on 28 October. In the Lebanon their pace returned to its frantic norm as they went first north to visit Tripoli (Trablous), then inland to the convent of St Anthony and the ancient cedars, and then south to the epic Roman remains at Baalbek, site of a cult of sun-worship at a crossroads of the great trading routes (S.155, 157).

Baalbek had become one of Roberts's favourite Oriental subjects following his visit there in May 1839. For many years he returned to the subject, executing his increasingly fantastic versions on a huge scale. Dadd was especially aware of Roberts as his forebear now, and wrote to him in London describing the way he saw the sights of Lebanon through his memories of Roberts's pictures. One of

the last things Dadd had seen on the older artist's easel had been the Temple of the Sun at Baalbek, and at Tripoli, so he claimed, he had enjoyed the memory of Roberts's images of the place as much as the actual landscape itself. This appears a conventional picturesque homage – territory being aesthetically appropriated through a chain of artistic friendships – but, as in Lycia, Dadd must again have felt how ill equipped he was to compete with artists with technical specialities, such as Roberts's expertise in evoking architectural grandeur. It has even been suggested that Dadd came to develop a kind of Oedipal horror at the traces he encountered of his predecessor.[22] Certainly the vicarious presence of Roberts in the Orient must have exacerbated the sense of belatedness that, we have noted, the Orient seemed to engender in Western travellers, which worked against the traditional picturesque pleasures of finding echoes of friends on one's path.

The travellers remained five days at Damascus in early November, and it seems that here Dadd managed to settle himself long enough to make some unusually careful studies in the sketchbook (fig.20, p.40) and even apparently to complete a watercolour of the Great Mosque which is dated 1842 (private collection). This was achieved despite his work being interrupted when he tried to sketch in the streets, and even being pelted with husks of corn, as Dadd claimed he was.[23] He also found time at Damascus to write a letter to Roberts, which included some more than usually poetic passages, such as a description of the deep blue sky of the East, 'where seems to be written in brightest colours the symbol of eternity'.[24] Dadd admitted he was not at all sure what he really meant by this and, as he and Phillips entered the Holy Land, there is no evidence that he was especially interested in the specifically Christian resonances of the place. Rather, as they worked their way towards Jerusalem, it was again the image of strong women that captivated him. On the coast at Dor (Tantura), between Haifa and Caesarea, they seem to have encountered a caravan pausing to stock up with water from a spring; at least later, back in London, Dadd painted such a scene (fig.32, pp.62–3). With Mount Carmel forming a backdrop, the picture echoes Dadd's words in a letter to his friend William Frith: 'The water-carriers (women) are very capital subjects for the brush; and they rush along with great celerity under pitchers of no small size,' while the men, so far as he could observe, sat and watched.[25]

Dadd and Phillips entered Jerusalem on 20 November. More than ever, for a devout British Christian, the 1840s should have been a thrilling time to be in the Holy City. The year before their arrival, a Protestant bishopric had been established there and a church to house him (Christ Church) was under construction. Evangelicals, consuls and travellers all talked mistily about the restoration of Israel under British protection, and archaeological work on the Temple Mount – site of the remains of the Jewish Temple and of the Muslim Dome of the Rock and al-Aqsa Mosque – had recently been pioneered by Frederick Catherwood. That Dadd was not entirely impervious to this aura of anticipation is shown by his stunning watercolour of the Temple Mount (or Haram al-Sharif) from the north, in which the Dome of the Rock and al-Aqsa are represented on either side of the thirteenth-century Ghawanima minaret (fig.31, pp.58–9).

24
Page from Dadd's
Middle-Eastern
Sketchbook, 1842–3
Jerusalem: View over the
Temple Mount
Victoria and Albert
Museum, London

The forms of the architecture and the planes on which they stand seem to vibrate in sympathy with the powerful sunset colour-chords of complementary blue and orange. The result resembles Samuel Palmer in his visionary days, and can be seen perhaps as part of Dadd's poetic answer to the question of what sort of imagery was left to him as an imaginative artist without specialist knowledge of history, theology or architecture.

The Jerusalem watercolour was most likely completed back in London, the artist using as his model a drawing in the sketchbook (fig.24), for there turned out to be insufficient time to linger even in Jerusalem. The very day after their arrival, Dadd and Phillips joined a party of British naval officers and midshipmen from the *Hecate* and the *Vernon* to ride out to the Dead Sea, east of the city.[26] Dadd recounted to Frith a story of their being intercepted at Jericho by a party of local villagers who requested the usual fee for passing travellers: Dadd makes the usual tourist's jokes at their expense. The fee paid, some of the villagers escorted the Europeans the rest of their journey to the shore of the Dead Sea, where they encamped and waited for the moon to rise, to give enough light by which to ride back towards Jerusalem through the surreally lush rockscape of Ein Gedi as far as the Greek Orthodox monastery of Mar Saba, where they stayed the night. The plan was that, after Jerusalem, Phillips and Dadd would trek south overland into Egypt, but a shortcut was now made available courtesy of the crew of the *Hecate*, a recently launched armed wooden paddle steamer made in Dadd's native Chatham, who offered them a passage from Jaffa to Alexandria. Hence the otherwise inexplicable omission from the itinerary of the fabulous city of Petra, entirely and miraculously carved out of the pink rock of the landscape, an epic version of the picturesque rock tombs of Lycia and another of Roberts's favourite themes.

25, 26
Pages from Dadd's
Middle-Eastern
Sketchbook, 1842–3
(above) *Interior of
Sultan Hasan, Cairo*
(below) *View over Cairo
with the Mosque of Sultan
Hasan*
Victoria and Albert
Museum, London

Thanks to the *Hecate*, Dadd had leisure to write the letter to Frith which the latter published in the final volume of his memoirs in 1888. The letter is very different from those to Roberts. It is witty, punning, straining in its efforts to entertain: 'I shall never be jealous of you now, for I've got open my mind, yes, opened my mind, and mind what I say, it's uncommon good soil, so soil not your lips by the traduction or reduction of my induction in this matter.' Dadd is able to celebrate his sense of liberation from the responsibility of caring about the particulars of place names and such details – not something he was likely to do in a letter to the

academic topographer Roberts. Satirising a conventional tourist's letter, Dadd affects to begin dutifully to recount details of the picturesque bazaars of Syria, but then interrupts himself – 'especially one near (I don't know where, nor do I care, nor do you care, for you would be as wise as ever did I know and tell)'.[27] Inevitably the passage that stands out most (not least because Frith printed it in italics lest any of his readers should miss it) is this confession:

> At times the excitement of these scenes has been enough to turn the brain of an ordinary weak-minded person like myself, and often I have lain down at night with my imagination so full of vagaries that I have really and truly doubted of my own sanity. The heat of the day, perhaps, contributed somewhat to this, or the motion of riding is also another reason for this unusual activity of fancy.[28]

The greatest set piece of the tour was to be the Nile cruise. Phillips and Dadd were to spend several weeks, in December and January 1843, travelling up (i.e. south) and then back down the river to see the awesome remains of ancient Egypt. But there were obstacles after their arrival at Alexandria. First there was quarantine, a full week of it at the end of November and beginning of December; then a stint in the city itself, where an English banker was able to show off the latest prints after Roberts's views of Egypt and the Holy Land; then forty miles along the Mahmoudia Canal to the Nile at Atfeh, a steamer to Bulak and a final leg by donkey into Cairo. Phillips promptly set about buying equipment for their Nile expedition, leaving Dadd to explore this most magnificent of Arab cities. The superciliousness, and even disgust, with which he had reacted to some of the earlier parts of the tour were now gone, and the inability to sketch attributed no longer to the speed of travel but to the artist's own over-excitement:

> For my part I walked about the streets with my eyes and mouth wide open, swallowing, with insatiable appetite the everlasting succession of picturesque characters. I had the most unaccountable impulses, that would not let me stop to sketch, but were constantly prompting me on, to drink in, with greedy enjoyment, the stream of new sensations.[29]

There are however several studies of elegant Cairene architecture in the V&A sketchbook, including a general view of the city from the citadel, dominated by the massive structure of the mosque of Sultan Hasan (fig.26), and another drawing of the dramatic courtyard of the same building, with its forest of hanging lamps made denser still by Dadd's later incongruous addition of several little Nile boats (fig.25).

For European travellers Cairo held little of the political fascination of Constantinople or Jerusalem. Its status was effectively settled as a virtually independent pashalic technically within the Ottoman Empire but under the de facto financial and technological tutelage of the European powers. Cairo and the Nile were places for pleasure and for archaeology, not fantasies of new world

orders. Dadd was soon encountering the treasure-hunting European historians of pharaonic Egypt, whose discoveries were gradually to displace Islamic Cairo from the European mental image of the country. At Giza, site of the Pyramids and the Sphinx, he came across the recently established Prussian expedition, led by K.R. Lepsius and including the British architect-archaeologists Joseph Bonomi and James William Wild. Lepsius was working on a unified chronology of ancient civilisations, determined to bring together ancient Egyptian and Old Testament narratives. Among the key benchmarks in this process of co-ordination was the career of Moses who, when in Egypt, had been a priest of Osiris.[30]

Meanwhile, Phillips had succeeded in borrowing a boat from the British consul at Cairo. Small but well made, it was crewed by twelve oarsmen as well as four further men, one of whom had the role of entertaining the others with improvised songs (the boat may well be the one shown in S.200). The Nile trip had a simple enough plan: they were to go up the river some 400 miles as far as the great city of Thebes, site of the temple complex of Karnak and the royal burial ground of the Valley of the Kings, and then travel back again. They paused at other sites – including Antinoe, Asyut and Dendera – only so long as necessary to explore them efficiently before returning to the boat. The voyage dragged. There are plenty of drawings from these weeks in the sketchbook but, given the nondescript scenery available during most of the expedition, they are dull. Only Thebes itself, where the travellers remained an entire week in January, inspired more interesting work, including a general view of Karnak (fig.19, p.40) resembling a miniaturised picture by Roberts, to whom Dadd wrote saying he had recognised there the location of several of the older artist's views and had even found his name carved – twice – into one of the propyla of the Great Hall. Dadd must again have felt how small and belated were any efforts he might make in precise topographical study. He was nevertheless greatly moved by the survival of these vast remains, the Great Hall with its 80-foot (25-metre) tall columns aweing him with 'the idea of immense size and eternal strength'.[31]

The price for this week of amazement at Thebes was the dreary journey back. Sir Thomas entertained himself by trying to shoot animals with the gun he is shown holding in one of Dadd's two portraits of his employer. In the standing portrait he is wearing a sort of Arab dress (fig.28, overleaf) and in the reclining image he is shown as a Turkish gentleman, presumably in Constantinople (fig.27).[32] Dadd may have worked on these during the Nile expedition, when he would have had all too much time to observe his companion. In the evenings they 'either read or wrote or drew', leading 'such a mode of life, [that] one gladly catches at anything that will elicit a new idea'. Dadd and Phillips must have spent many hours discussing the architecture and history they were exploring, not least the bewildering religion of the ancient Egyptians, with its shape-shifting gods who were able to morph into one another or into different divine combinations, allowing the renegade monotheist pharaoh of the 18th Dynasty, Amenhotep IV (who took the name Akhenaten and was one of the builders of Karnak), to meld the sun-god Ra and the sky-god Horus into the universal deity Aten, the sun-disc.

27
Thomas Phillips
Reclining in Turkish
Costume 1842–3
Watercolour on paper
17.8 x 25.4
Bethlem Royal
Hospital, London

Eventually, by the last week of January 1843, they were back in Cairo, where Phillips met the reclusive watercolourist J.F. Lewis, who had been living in the city since 1841. Curiously, Phillips did not think fit to include Dadd in the visit. 'I saw Lewis at Cairo but was not introduced to him,' as Dadd reported to Roberts. 'Sir Thomas who called on him says he is painting for the Exhibition and has several very nice sketches, he told him he had accumulated enough to last him for the rest of his life and that he meant shortly to return and settle, and reap the harvest of his labours.'[33] As he himself began the journey homewards, Dadd must have asked himself what rewards he would be able to reap from his own far less focused labours. He certainly seemed to be in a melancholic state on the way back to Europe. At Alexandria he and Phillips boarded HMS *Medea*, the ship that brought the Xanthos marbles to Britain, for a six-day passage to Malta, during which, Dadd confessed, he suffered from 'nervous depression'.[34] Their detention at Malta for no less than three weeks of quarantine cannot have improved his mental state.

The last leg of the great tour undertaken by Phillips and Dadd was to be its most conventional – Naples and Rome. The partially filled sketchbook that survives from this period (now at Bethlem) has been used to make notes of pictures and places seen. Dadd seems to have been fascinated by the devotional art of Italy, finding a Jusepe de Ribera *Pietà* to be 'full of intense expression', and copying down the head of Christ from an *Ecce Homo*. By the time they had reached Rome, in April,

Dadd had apparently started to become outspoken on the subject of religion. Phillips wrote home worriedly that his companion would give way to 'violence of expression' and become excited if religion, politics or the condition of the local population were under discussion.[35] He would compare the effects of Christianity negatively with those of paganism, claimed he was being watched, and believed that someone was attempting to injure his health. This sense of threat that Dadd now felt, coupled with an apparent turning against Christianity, led him to feel compelled to attack Pope Gregory XVI during a public appearance. But the pontiff, himself obsessed with the threat to the Church and State from secret societies of revolutionaries and freemasons, was apparently too well protected and Dadd thought better of it.[36] Years later, there were stories that Dadd had begun seeing the Devil in different guises, once in the form of 'an old English lady in a lavender-silk dress, looking at the pictures' in the Vatican galleries.[37]

Dadd's behaviour became erratic enough to cause Phillips concern for his own safety, but they continued on together homewards. At Florence, Dadd wrote down ever more intensely observed descriptions of the expressions of figures in the famous Old Masters there. His attention was especially caught by Salvator Rosa's melodramatic *Conspiracy of Catiline* in the Pitti Palace, in which furious aristocratic plotters seal an oath to rebel against the Roman Republic. Dadd noted that the central figure seemed to possess 'demoniacal' horns because of the way another man's fingers appeared behind his head, while the older man turning away from the scene 'has a calm expression like that of a man who has rather been forced into this conspiracy by the wrongs inflicted on him than impelled by the violence of his own passions'.[38] Eventually, in Paris in May, Dadd precipitately abandoned his employer and took the fastest (and most expensive) possible route back to England, 'posting' from one fresh horse to another.[39] With this sudden flight Dadd's great Oriental tour ended, and he himself temporarily disappeared from his own narrative, at least in terms of the written word. For the time being, his friends must recount the story, and those friends were confused and frightened.

Upon his arrival in London at the end of May, Dadd's behaviour caused people to fear he had fallen ill with sunstroke. During the summer of 1843 rumours even spread that he had become insane. Yet the incidents that provoked the rumours were minor, and few enough for no urgent action to be initiated by anyone. Aware of the impression he was making with his occasional talk of diabolic possession, Dadd warily controlled his conversation:

> Soon after his return from the East, indeed, he said to a dear and intimate friend, that although many fiends had been about him on his voyage home, the Great Fiend of all he had as yet never seen, but gave a frightful intimation that he [Dadd] was looking for him. His insane thoughts, however, were communicated to very few. He became far more reserved than he used to be; yet manifested a degree of shrewdness and sharpness about little things utterly foreign to his former character.[40]

28
Thomas Phillips Standing in Arab Costume 1842–3
Watercolour on paper
24.1 x 16.5
Bethlem Royal
Hospital, London

Mutual suspicion set in between Dadd and his fellow artists. While his friends watched for signs of the alleged madness, his own fixed idea became, understandably, 'that he was being watched'.[41] The loyal Frith kept in close contact, without (so he claimed much later) noticing anything very unsettling. But others came to fear him.[42]

In these tense circumstances Dadd set to work to make finished pictures from the sketches he had made abroad. No doubt he felt he had some catching up to do and wanted to get his name re-established in the art world. He even decided to rush to complete and submit before the deadline a huge drawing – *St George and the Dragon* – for the competition being held to select decorations for the new Houses of Parliament.[43] Living apparently on a diet of eggs and ale,[44] Dadd started making watercolours including the view over the Temple Mount, compilations of studies of heads (fig.29) and the beautiful miniature-style *Bearded Man with a Pipe* (fig.30) with his chibouk and strangely knowing look. When it came to selecting a subject fit for a large oil with which to relaunch his exhibiting career, Dadd chose the female water-carriers by whom he been so taken, showing a caravan halted at the spring at Tantura (fig.32, pp.62–3). Employing a frieze-like composition suggesting the memory of some of the classical sculpture he had studied abroad, Dadd sent the five-foot (1.5m) canvas to the annual Liverpool exhibition (being too late for that year's Academy show), where it was shown as *Group of Water Carriers*,

29
Portrait Studies of Figures in Eastern Dress 1842–3
Watercolour on paper
18 x 25.5
Winchester College

30
Bearded Man with a Pipe 1842–3
Watercolour on paper
25 x 19.7
Fine Arts Museums of San Francisco

Overleaf
31
Jerusalem from the House of Herod 1842–3
Watercolour on paper
16 x 25.5
The Pierpont Morgan Library, New York

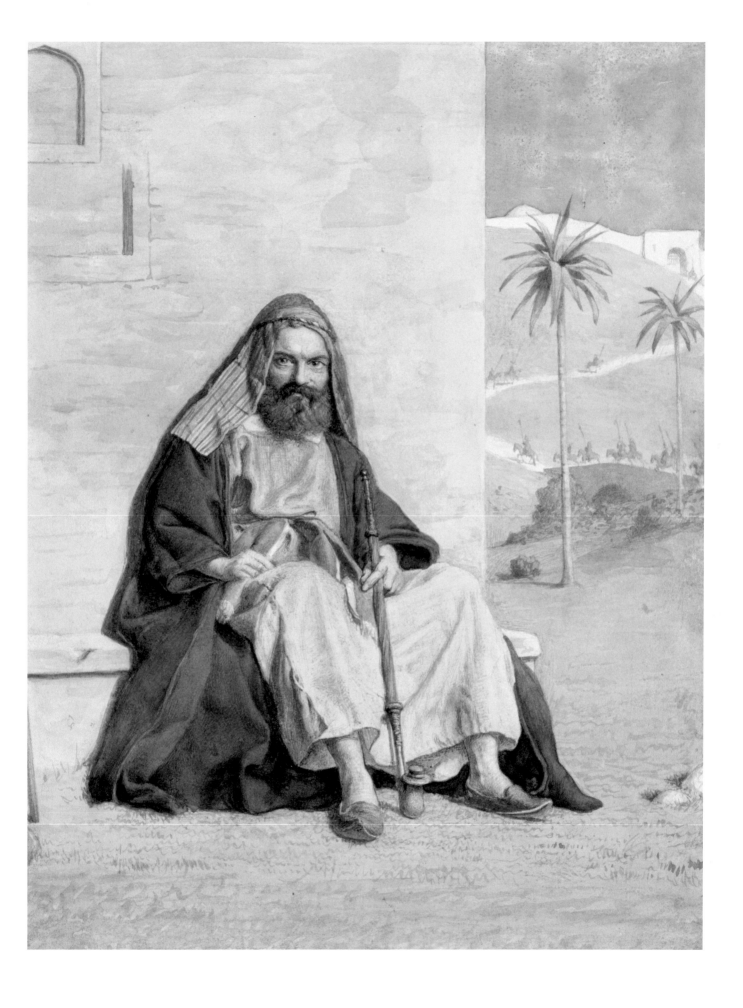

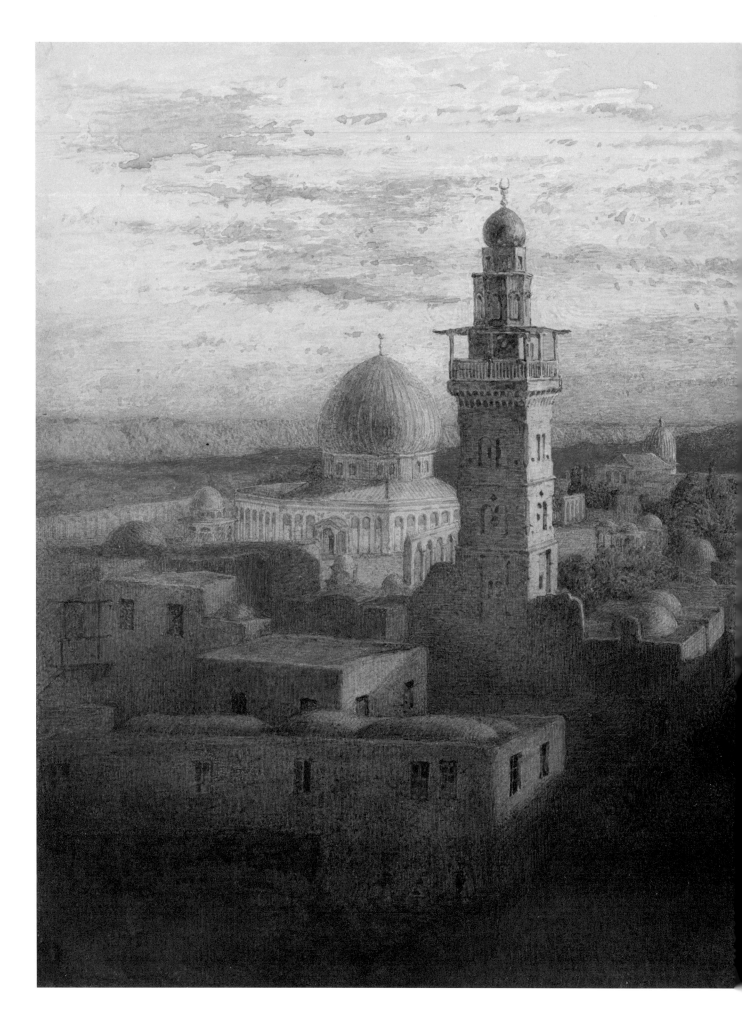

Men and Camels, at a Spring on the Sea Shore at Fortuna, near Mount Carmel, Syria (it is not clear whether the incorrect place name in the title is an error of Dadd's or the catalogue printers). His artist friends were disappointed in its lack of ambition – compared to Dadd's earlier pictures it seemed to Frith to be 'spiritless and poor'.[45]

The evidence is that Dadd's former network of friends was ready to support his recovery. His dedicated early collector, Richard Reeves of Birmingham, acquired both the *Water Carriers* and the St George cartoon. Samuel Carter Hall of the *Art-Union* received a letter from Dadd in August offering to help with the projected sequel to *The Book of British Ballads*.[46] And things were patched up with Phillips, with whom of course Dadd had unfinished business, having not yet it seems handed over any drawings to the financier of their Oriental tour (Phillips reckoned he had laid out around £250 for his companion's expenses).[47] They breakfasted together and Dadd seemed so much better that Phillips started making plans for him again. He would suggest a subject for a picture and, as a lesson in combining a career in art with modesty and good sense, Dadd would be set to read the recently published *Life of David Wilkie* by Alan Cunningham, the biography of the most sensible, sociable and successful British artist of recent times.

Dadd's anxious family had reason to hope for the best, and perhaps it was this very optimism that led Dadd's father finally to ask for a medical opinion late in August. Dr Alexander Sutherland (fig.35, p.70) had inherited the position of Physician to St Luke's Hospital for Lunatics from his father in 1841, ran in addition a thriving private practice and was one of the elite of London's gentlemen psychiatrists. His special research interest was in the urine of the insane. His verdict on Richard (whom it does not seem he was able to examine in person) was characteristically unequivocal: he was dangerous and urgently needed quiet and care – that is, hospitalisation.[48] Perhaps in response to this initiative to have him restrained, Dadd now asked to see his father alone, so that he might at last 'unburthen his mind to him'.[49] He wanted them to travel back together to the family's roots, to the picturesque village of Cobham, midway between Chatham on the Medway and Gravesend on the Thames, an easy steamer trip downriver from London.

They met on Monday 28 August, during an oppressively hot late summer. The plan was for them to stay overnight at Cobham, but there were no rooms at the Ship Inn (where Robert Dadd was still well remembered) and beds had to be arranged in local cottages. Around 8.30 p.m., Richard pressed his tired father to take a walk in Cobham Park, a name now familiar to the many readers of Dickens, for this was where Pickwick had gone to rescue his friend Tupman from the romantic melancholia into which he had fallen. The park belonged to the Earl of Darnley, whose seat, Cobham Hall, where Dadd had gone as a youth to study the picture collection, was of 'the quaint and picturesque architecture of Elizabeth's time'.

> Long vistas of stately oaks and elm trees appeared on every side: large herds
> of deer were cropping the fresh grass; and occasionally a startled hare
> scoured along the ground, with the speed of the shadows thrown by the

Overleaf
32
Water Carriers (*Caravan Halted by the Sea Shore*)
1843
Oil on canvas
90.2 x 151.1
Private collection

light clouds which swept across a sunny landscape like a passing breath of summer. 'If this,' said Mr Pickwick, looking about him; 'if this were the place to which all who are troubled with our friend's complaint came, I fancy their old attachment to this world would very soon return.'[50]

But Dadd's story took a different turn.

> Describing the scene of patricide, he said he was impelled to the act of killing his father ('if he was his father' he said) by a feeling that some such sacrifice was demanded by the gods & spirits above. He said that they were walking side by side in Cobham Park when Richard suddenly sprang upon his father & stabbed him in the left side. When his father fell, Dadd (posing himself with upstretched arm), thus apostrophised the starry bodies 'Go,' said he '& tell the great god Osiris that I have done the deed which is to set him free.'[51]

This was Dadd's version of events, recounted whilst in an uncharacteristically talkative mood more than thirty years later. But he makes the event into an operatic tableau. Surely murders are rarely so elegantly executed. Indeed an earlier 'confession' of Dadd's describes a messier business. According to this account of the killing of Robert Dadd, his son 'inveigled him, by false pretences, into Cobham Park, and slew him with a knife, with which I stabbed him, after having vainly endeavoured to cut his throat.'[52]

After Robert Dadd's body was recovered early the next morning by a butcher from Rochester, there was indeed some initial difficulty in establishing the precise order of events.[53] The body was found at the edge of a deep dell or ravine just off the road, circled by elms; it had apparently been dragged towards the drop but not thrown over. The victim may have been occupied answering a call of nature when he received the first blow – a blow possibly delivered not from a sharp weapon but a fist, as the deceased's head was badly bruised.[54] A razor found under the body had been used to inflict a one-and-a-half-inch gash on the neck – an aborted attempt to cut the throat, not in itself lethal. Death had been caused by a five-inch folding rigger's knife recovered a few yards from the corpse. With this, Richard had stabbed his father in the chest, pressing the blade again into his lung without fully withdrawing it after the first thrust. There must have been a struggle, for Robert's wrists were bruised, but nothing had been heard. Richard may have tidied up the body before leaving; Robert's coat was fully buttoned up but had not been cut by the knife.

There was no uncertainty over the culprit, and the hunt for Richard began. But he had been well prepared for his flight. Having already obtained a passport before meeting his father, he made his way to Rochester, cleaned himself up at an inn and then drove post-chaise to Dover where he arrived at 4.15 on Tuesday morning. Lying well enough to explain his ragged appearance, he hired a boat to Calais where he told port officials he intended to go to Marseille.[55] He would later

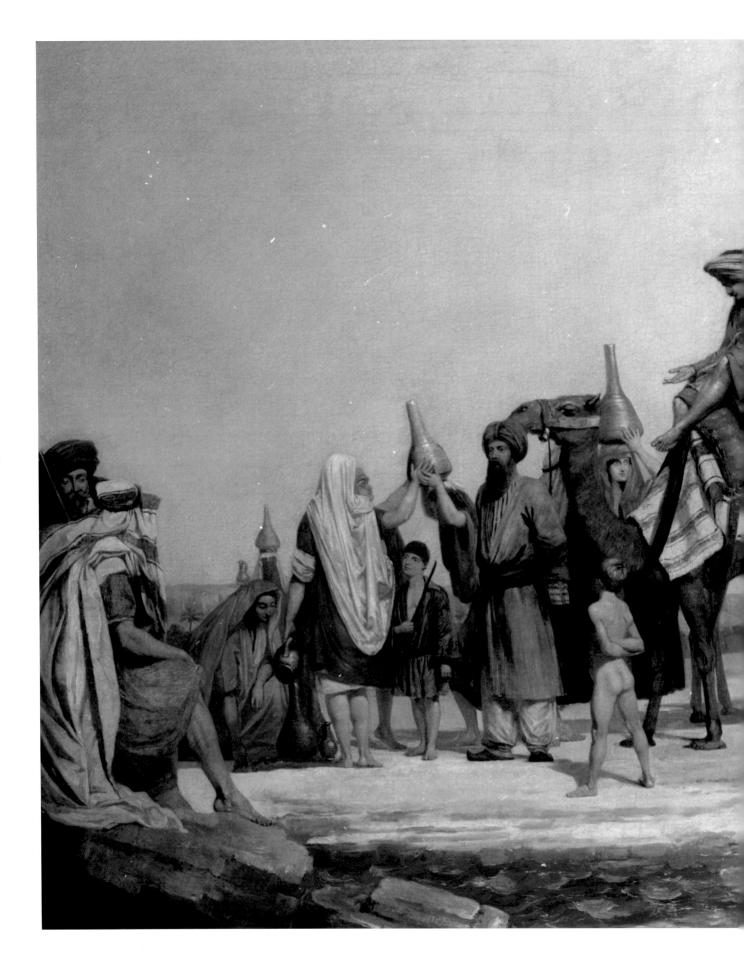

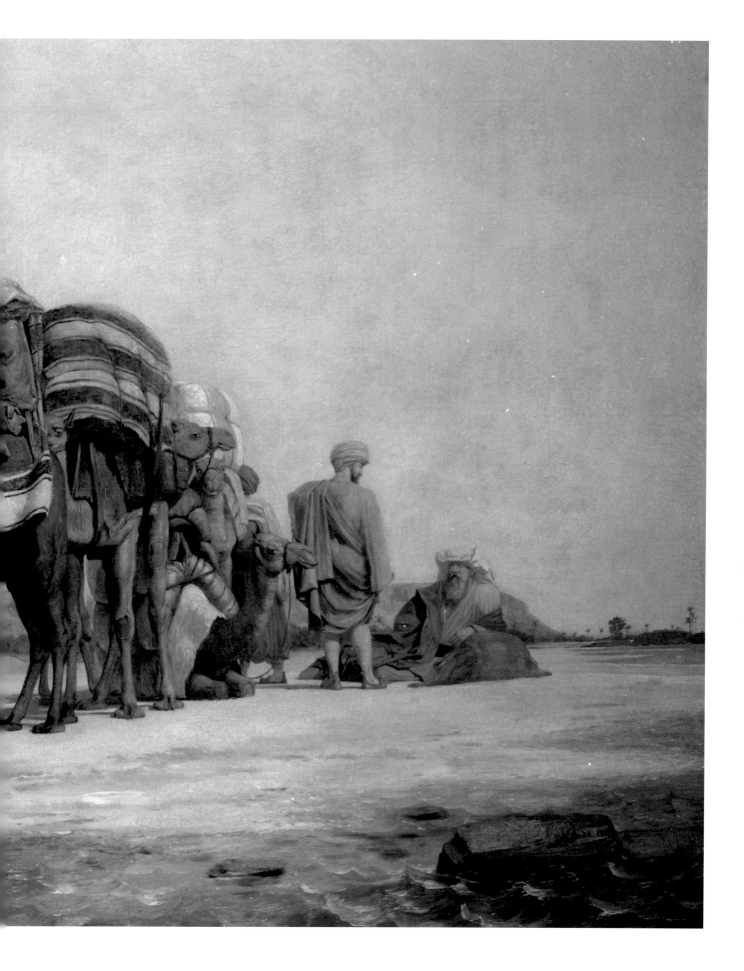

PRESENTED TO THE SUBSCRIBERS

OF

THE KENTISH INDEPENDENT,

SEPTEMBER 9, 1843.

ROBERT DADD.

AGED 57,

From an Original Painting, by his Son.

RICHARD DADD,

AGED 26,

From an Original Painting, by himself.

SCENE OF THE MURDER, COBHAM PARK.

33
Portraits of the Artist and his Father
Engraving from *Kentish Independent*,
9 September 1843
Victoria and Albert
Museum, London

say that he was planning to assassinate the Emperor of Austria, the feeble-minded Ferdinand I.[56] Having changed clothes at Calais, Dadd proceeded to Paris where he took a seat in a coach heading south-east towards Lyon (suggesting he was indeed making for Marseille and not Vienna, with or without some plan of action). But near the Forest of Fontainebleau, Dadd again felt the call, this time believing he would receive a message in the form of the position of the stars in Ursa Major (the familiar Plough): if two particular stars appeared to move closer together, then this was the signal to attack his fellow passenger.[57] The sign was duly observed and Dadd began his assault with (according to the French press) another 'excellent English razor', managing to inflict four serious wounds before being overpowered and arrested. Taken before the justice of the peace at the nearby town of Montereau, Dadd identified himself, explained he had just come from England where he had killed someone, and handed over all his remaining money for the care of his French victim.[58] On the night of Wednesday, 30 August 1843, Richard Dadd was taken into custody.

3 Inside

The psychiatric profession into whose care Dadd fell in 1843 was in the ascendant.
Since the late eighteenth century, the ideal of the asylum as a temporary refuge
from the madding world, managed by enlightened and disinterested physicians,
had grown in appeal until European governments came to see it as their duty
to provide national systems of hospitals for the mentally afflicted (or lunatics as
they continued to be called in Britain). In France, legislation adopted in 1838
not only undertook to build enough asylums in which to treat the nation's mentally
ill, but also entrusted the 'alienists' who ran them, rather than courts of law, to
decide whether ill persons taken into custody should be placed there. Interviewed
about the killing of his father whilst being held at the prison in Montereau,
Dadd explained that he was 'the son and envoy of God, sent to exterminate the
men most possessed with the demon', that in killing Robert Dadd he had done a
good thing by destroying an enemy of God, and that he intended to continue his
campaign.[1] Thus Dadd was quickly judged to be thoroughly disordered in the mind
and duly dispatched to the rapidly expanding asylum at Clermont, some fifty miles
north of Paris.[2]

The physician at Clermont was Eugène-Joseph Woillez, best remembered today
as the inventor of an early version of the iron lung. He was also a serious amateur
antiquarian and must have been intrigued to find an artist in his asylum, where
the great majority of the patients were agricultural labourers.[3] Woillez's diagnosis
was that Dadd was suffering from *monomanie homicide,* the formula invented in 1825
by Étienne-Jean Georget to designate a condition, discernible only to the trained

alienist, which might stand as a legal defence in cases of murder. The very notion of monomania – insanity filtered through an *idée fixe* – was indeed calculated to privilege the testimony of the professional psychiatrist who alone might tease out its thread, and it was a crude tool with which to describe Dadd's new mental world.[4]

In the Clermont casenotes, and in a later book based on his asylum work, Woillez was able to give a more personal account of Dadd's condition.[5] The patient had calmed down quickly, but could not or would not speak French, making it difficult for Woillez to follow his thinking. He was the son, not of the imposter whom he had killed, but of the sun, at which he would stare, *'dans une sorte d'extase'*, almost the whole day without blinking – a habit that however had no effect other than to give a red tint to his vision. Dadd was compelled by an inner voice to put to death all demons, which he identified with the people around him with the exception of Woillez himself whom he saw as Jesus Christ but not on that account as any better than the others. The demons entered his body and he spat them out furiously, identifying them in his spittle. The only treatment offered was the standard course of cold showers, which had no effect.

There was huge interest in Dadd's condition back in Britain, and the press managed to obtain enough details to keep the story alive.[6] For some of his friends, however, the idea of the charming and brilliant young Richard Dadd as a raving lunatic was more than they could face. One wished he had killed himself after the murder, while another – Samuel Hall of the *Art-Union* – wrote of 'the late Richard Dadd' as having morally perished.[7] Many papers explained that he could not survive long because 'his brain is wasting away'. Dadd's siblings were unable to indulge in such convenient rhetoric and had to plan for the future. They arranged for him to have painting materials, but were told by Woillez that he showed no interest in these and that his mind was now 'an utter and irreclaimable blank'. Another press report, however, had it that he was asking after the success of his pictures (*Come Unto These Yellow Sands* and the *Water Carriers* had been sent to the 1983 Liverpool exhibition).[8] Physically healthy as he was, the family would have been happy to see him remain at Clermont in the care of Woillez and away from the potentially lethal machinery of the English legal system (there was no guarantee an English court would not condemn him).[9] But only the previous year the British government had made its first reciprocal extradition treaties with France and the United States, and the Home Office was soon busily arranging Dadd's return to face the charge of murder. To the frustration of the Metropolitan Police, the diplomats were still getting the hang of the new system, and Inspector Charles May, dispatched to retrieve Dadd in July 1844, was kept waiting three weeks in Paris while officials meandered through red tape.[10] By the time the paperwork was finally settled, May had to complete his mission in great speed in order to have Dadd back in Kent in time to appear before the scheduled assizes of the magistrates on 29 July.

Any anxiety on the part of his family and friends that Dadd might be held fully responsible for the death of Robert Dadd was immediately allayed. To all present at the Rochester assizes for his brief pre-trial hearing, Richard appeared completely

mad. His hands secured, he muttered to himself, stared wildly and generally behaved as a lunatic was expected to. The public had a greater opportunity to ogle this spectacle when Dadd appeared a second time a week later for the committal proceedings, and they were not disappointed.

> Nothing could be more changeable than the expression of his fine countenance and his demeanour. At one moment he was laughing with almost childish glee; the next he would appear deeply agitated, drawing his breath with a hissing noise and grinding his teeth; then mild and affected almost to tears, with his head bent nearly to his knees, and afterwards erect, with a fierce bullying aspect and loud voice.[11]

Dadd hectored the courtroom, appearing to comment on the proceedings, but incoherently: 'I tell you I didn't do it – no gammon about it. I shan't do it, I dare say. I tell you I never did it.' But then: 'I used no more violence than was necessary … I only stabbed him once.' Conversing with an imaginary person, he eventually had to be temporarily removed from court.[12]

Any attempt to question the accused seemed pointless, but the magistrates had no trouble making their decision. Since 1840 the law allowed them, as in France, to send a mad prisoner into permanent custody without trial. When requested to take this course by the solicitor representing the Dadd family, the magistrates assured him that this was their intention.[13] This spared Dadd the experience of being tried for his life, but it also spared the system the potential embarrassment of trying him using current legal precedent. Only the year before, following the shooting of Robert Peel's private secretary by a Scottish Chartist, the McNaughton Rules had laid down that insanity might only be accepted as a defence in a criminal trial when the accused was ignorant either of the real nature of their crime or of its illegality. As was to be observed by Victorian legal theorists on many occasions, Dadd could not have appealed to the second clause of this defence as he had clearly planned his getaway from the scene of the murder, expecting to be pursued.[14] But his delusions would probably have qualified him to plead clemency on the basis of being unaware of the true nature of his act. The question was anyway academic, as Dadd was now labelled a 'criminal lunatic' despite not having been found guilty of any crime. Soon after the invention of the category of criminal lunacy in 1800 (to accommodate the case of a brain-damaged former soldier who had taken a shot at King George III), a special institution had been envisaged to keep this novel group of special prisoners, who were directly under the control of the Home Secretary. Since 1816 this had existed as part of Bethlem Hospital in Lambeth (the remains of the hospital have housed the Imperial War Museum since 1936). Dadd was admitted as a patient there on 22 August 1844. The hospital recorded that he was 5ft 8in in height, had light blue eyes, and was wearing a straitjacket.

'Bethlem' was the officially accepted nickname of the Bethlehem Hospital: it was preferable to Bedlam, its unofficial nickname. The hospital has a history as dramatic and pathetic as perhaps any institution surviving in Britain today, a history

alienist, which might stand as a legal defence in cases of murder. The very notion of monomania – insanity filtered through an *idée fixe* – was indeed calculated to privilege the testimony of the professional psychiatrist who alone might tease out its thread, and it was a crude tool with which to describe Dadd's new mental world.[4]

In the Clermont casenotes, and in a later book based on his asylum work, Woillez was able to give a more personal account of Dadd's condition.[5] The patient had calmed down quickly, but could not or would not speak French, making it difficult for Woillez to follow his thinking. He was the son, not of the imposter whom he had killed, but of the sun, at which he would stare, *'dans une sorte d'extase'*, almost the whole day without blinking – a habit that however had no effect other than to give a red tint to his vision. Dadd was compelled by an inner voice to put to death all demons, which he identified with the people around him with the exception of Woillez himself whom he saw as Jesus Christ but not on that account as any better than the others. The demons entered his body and he spat them out furiously, identifying them in his spittle. The only treatment offered was the standard course of cold showers, which had no effect.

There was huge interest in Dadd's condition back in Britain, and the press managed to obtain enough details to keep the story alive.[6] For some of his friends, however, the idea of the charming and brilliant young Richard Dadd as a raving lunatic was more than they could face. One wished he had killed himself after the murder, while another – Samuel Hall of the *Art-Union* – wrote of 'the late Richard Dadd' as having morally perished.[7] Many papers explained that he could not survive long because 'his brain is wasting away'. Dadd's siblings were unable to indulge in such convenient rhetoric and had to plan for the future. They arranged for him to have painting materials, but were told by Woillez that he showed no interest in these and that his mind was now 'an utter and irreclaimable blank'. Another press report, however, had it that he was asking after the success of his pictures (*Come Unto These Yellow Sands* and the *Water Carriers* had been sent to the 1983 Liverpool exhibition).[8] Physically healthy as he was, the family would have been happy to see him remain at Clermont in the care of Woillez and away from the potentially lethal machinery of the English legal system (there was no guarantee an English court would not condemn him).[9] But only the previous year the British government had made its first reciprocal extradition treaties with France and the United States, and the Home Office was soon busily arranging Dadd's return to face the charge of murder. To the frustration of the Metropolitan Police, the diplomats were still getting the hang of the new system, and Inspector Charles May, dispatched to retrieve Dadd in July 1844, was kept waiting three weeks in Paris while officials meandered through red tape.[10] By the time the paperwork was finally settled, May had to complete his mission in great speed in order to have Dadd back in Kent in time to appear before the scheduled assizes of the magistrates on 29 July.

Any anxiety on the part of his family and friends that Dadd might be held fully responsible for the death of Robert Dadd was immediately allayed. To all present at the Rochester assizes for his brief pre-trial hearing, Richard appeared completely

mad. His hands secured, he muttered to himself, stared wildly and generally behaved as a lunatic was expected to. The public had a greater opportunity to ogle this spectacle when Dadd appeared a second time a week later for the committal proceedings, and they were not disappointed.

> Nothing could be more changeable than the expression of his fine countenance and his demeanour. At one moment he was laughing with almost childish glee; the next he would appear deeply agitated, drawing his breath with a hissing noise and grinding his teeth; then mild and affected almost to tears, with his head bent nearly to his knees, and afterwards erect, with a fierce bullying aspect and loud voice.[11]

Dadd hectored the courtroom, appearing to comment on the proceedings, but incoherently: 'I tell you I didn't do it – no gammon about it. I shan't do it, I dare say. I tell you I never did it.' But then: 'I used no more violence than was necessary … I only stabbed him once.' Conversing with an imaginary person, he eventually had to be temporarily removed from court.[12]

Any attempt to question the accused seemed pointless, but the magistrates had no trouble making their decision. Since 1840 the law allowed them, as in France, to send a mad prisoner into permanent custody without trial. When requested to take this course by the solicitor representing the Dadd family, the magistrates assured him that this was their intention.[13] This spared Dadd the experience of being tried for his life, but it also spared the system the potential embarrassment of trying him using current legal precedent. Only the year before, following the shooting of Robert Peel's private secretary by a Scottish Chartist, the McNaughton Rules had laid down that insanity might only be accepted as a defence in a criminal trial when the accused was ignorant either of the real nature of their crime or of its illegality. As was to be observed by Victorian legal theorists on many occasions, Dadd could not have appealed to the second clause of this defence as he had clearly planned his getaway from the scene of the murder, expecting to be pursued.[14] But his delusions would probably have qualified him to plead clemency on the basis of being unaware of the true nature of his act. The question was anyway academic, as Dadd was now labelled a 'criminal lunatic' despite not having been found guilty of any crime. Soon after the invention of the category of criminal lunacy in 1800 (to accommodate the case of a brain-damaged former soldier who had taken a shot at King George III), a special institution had been envisaged to keep this novel group of special prisoners, who were directly under the control of the Home Secretary. Since 1816 this had existed as part of Bethlem Hospital in Lambeth (the remains of the hospital have housed the Imperial War Museum since 1936). Dadd was admitted as a patient there on 22 August 1844. The hospital recorded that he was 5ft 8in in height, had light blue eyes, and was wearing a straitjacket.

'Bethlem' was the officially accepted nickname of the Bethlehem Hospital: it was preferable to Bedlam, its unofficial nickname. The hospital has a history as dramatic and pathetic as perhaps any institution surviving in Britain today, a history

34
After Caius Gabriel
Cibber, *Melancholy
and Raving Madness*,
engraving (1816)
after a drawing by
Thomas Stothard
of the sculptures
erected c.1680 over the
gateposts of Bethlem's
Moorfields building.
Bethlem Royal
Hospital, London

that rarely if ever saw the hospital at the leading edge of developments in caring
for the mentally ill, but which repeatedly placed it and its patients in the middle
of intriguing power struggles between contending lay and professional interests.
Its most loyal historian, Patricia Allderidge, complained that too often legend
and myth defined thinking about Bethlem, but in truth the place's importance
has been in large part played out at those levels.[15] Beginning as the Priory of St
Mary of Bethlehem in the thirteenth century, Bethlem was formally placed under
the control of the City of London by Henry VIII in the 1540s and managed by a
large body of merchant-class governors (who were eventually far more numerous
than the patients). It became a conspicuous City charity, an aspect of the City's
self-image, and thus a part of that self-consciously historical and reform-immune
culture of the Corporation that still bemuses Londoners today.

Bethlem's original location was on the present site of Liverpool Street Station.
After the Great Fire of the 1660s it was rehoused nearby in a new building
designed by the great polymath of the Royal Society, Robert Hooke. With its
epically baroque, even palatial facade facing north on to Moorfields (now Finsbury
Circus), and with Caius Gabriel Cibber's famous pair of statues known as *Raving*
and *Melancholy Madness* writhing over the entrance gateposts (see fig.34), this
Bethlem became one of the great sights of eighteenth-century London and a
favourite topic of reference for writers, not least the hacks of Grub Street just two
blocks to the west.[16] Indeed Bethlem was as much spectacle as asylum, its patients
notoriously entertaining paying visitors (until the 1770s) within a structure that

was itself virtually a stage set – magnificent as an architectural composition but extending only a single row of rooms deep and so shoddily built that by the later eighteenth century it was literally falling apart.[17] There was also something less than met the eye about Bethlem's success rates in curing its patients. These rates looked impressive but they were greatly helped by the conditions the hospital attached to admission, which demanded that patients be not just poor (to qualify for charity in the first place) but strong in body and have a good chance of recovery. This meant that they should have been ill for less than twelve months prior to application, and could expect to be moved on if not recovered after a year at Bethlem (the hospital however opened dedicated 'incurable' wards around 1730).[18]

In 1815 Bethlem moved again, to its Lambeth site, simultaneously going through a very theatrical purge of its management. Since the 1790s the professional doctors treating the mad had been challenged by a lay philanthropic movement led by Quakers demanding the more humane treatment of lunatics. Building on a tradition that reached back to George Fox, their credo, which came to be labelled 'moral therapy', was less forcible restraint and chastisement and more social interaction and useful labour. Their twin models were the Quaker Retreat at York, and a mythologised image of the French alienists Philippe Pinel and his pupil J.-E.-D. Esquirol, who were believed to have cast off the chains of the insane along with the other constraints of the *ancien régime*.

Bethlem was the reformers' great prize, and success came, or appeared to come, after a Parliamentary Committee set up in 1815 to investigate the state

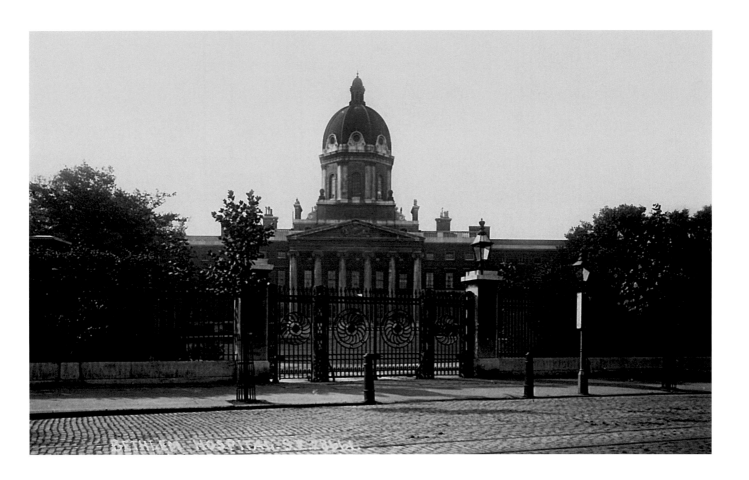

of madhouses inspected Bethlem and made spectacular use of the evidence they found there of apparent neglect and cruelty.[19] The health of the patients was under the daily care of the Apothecary, then John Haslam, who still played his medieval role as functional assistant to the gentleman physician, Thomas Monro. The latter visited the hospital regularly, but did not reside there. He was in any case more interested in watercolour painting than mental illness, and was an early patron of J.M.W. Turner, whose mother was a patient at Bethlem (she died there in 1804). Monro's father and grandfather had both been physicians to Bethlem before him, forming a dynasty representing the fundamental continuity of the establishment. Even after the very public humiliation and retirement of Haslam and Monro in 1815–16, the new Visiting Physician appointed in the latter's place was his son, Edward and, three decades later, in 1844, it was to this latest Monro (fig.35) that patient Richard Dadd was assigned.

Given that, during the early nineteenth century, Bethlem continued to succeed in securing its exemption from successive lunacy legislation (and so from regular government inspection), it remained a key target for reformers. They now turned their attention to the defects of the new Bethlem building at Lambeth, a functional and bleak structure begun in 1812 and opened in 1815 during the climactic year of the Napoleonic Wars and in the middle of the scandal over the reported neglect of the patients. To the Victorians, who came to embrace an ideal of the asylum as an essentially rural retreat, it was 'that dismal, dreary prison in the Lambeth marshes'.[20] A few years before Dadd's arrival, the architect Sydney Smirke had added two new long blocks of wards at the back of the hospital, more

GENERAL PLAN
OF
BETHLEM HOSPITAL.
Shewing the Improvements now in progress.
SIDNEY SMIRKE ARCH.

The black tint indicates the walls of the present buildings
The light tint indicates the walls of the new buildings.

or less doubling its capacity (in 1844–5 Smirke built the dome that is still an architectural landmark of Lambeth today).[21] At a ceremony in 1838 to inaugurate the construction of these unlovely brick extensions (see fig.37), Bethlem's ritual mode was to be seen in full effect. Present along with the President of the governors, Sir Peter Laurie, a conspicuous City figure, was a quite astonishing turnout of the great and the good. Among those conducted to their seats by a beadle were senior politicians including the Home Secretary and the 6th Earl of Shaftesbury (perpetual Chair of all House of Lords committees and father of the great Victorian reformer), the Archbishop of Canterbury and several heavyweight ambassadors.[22] Also invited, representing the cultural sphere, was David Wilkie, that most respectable of painters whose life Thomas Phillips had wanted Dadd to study. Whether or not there was in his invitation any tacit recognition of Wilkie's own battles with a recurring nervous disorder is not clear. But all this gentility clearly signalled Bethlem's acknowledged special character as a hospital catering to needy members of the respectable middling sorts – those too genteel for a large pauper institution, and too poor for private care.[23]

37
Plan of Bethlem
from Peter Laurie,
*A Narrative of the
Proceedings at the laying
of the first stone of the
new buildings at Bethlem
Hospital* (1838) with
Male Criminal Block
outlined
Wellcome Library,
London

38
Plan of the Male
Criminal Block at
Bethlem from *Report
of the Commissioners
Appointed ... to Continue
the Inquiries Concerning
Charities*, 32nd report
(1840)
British Library,
London
1 Connecting passage
from the main hospital
building
2 Gallery with
bedrooms on each side
3 Extension built late
1830s
4 Dining tables
5 Staircase
6 Pump and engine
room
7 Sink and water-closet
9 Keeper's room
10 Large sleeping-
room
11 Ordinary sleeping-
rooms
12 Sleeping-room with
connecting water-closet

The criminal lunatic department at Bethlem comprised two blocks – male and female – behind, and semi-detached from, the main hospital. Originally a stubby cross in plan, the male block was expanded in the 1830s to hold some seventy to eighty patients housed over four floors (see fig.38).[24] These patients lived totally segregated from those in Bethlem proper (indeed technically they were not its patients at all but prisoners of the Home Office), although most of their basic conditions were similar. Their cells or sleeping rooms were the same size as those in the main hospital, that is 9ft 9in by 7ft 11in (3 x 2.4m), and their dedicated exercise yards (or 'airing courts') were, in proportion to their numbers, as spacious as those of the other patients – but also as gloomy, with their 12ft (3.6m) walls and bleak views of nothing but the back of the hospital. The daily regimen was again comparable, with the same regulation flannel suits, early meals and long evenings shut up in their rooms.

The two key differences inside the criminal blocks were that there was much less common space, and that the social mixture was broader. The patients' rooms flanked both sides of poorly lit 'galleries', which doubled as dining spaces (the

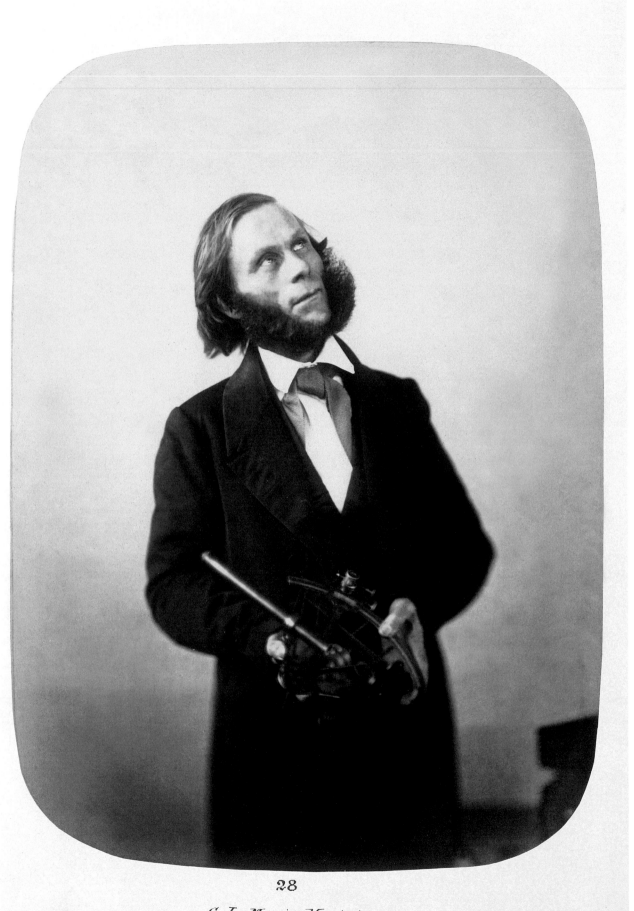

28

G. J. Maria. Homicide.

regular patients had dedicated dining rooms). This shared space was further reduced in some parts of the criminal blocks by screens of inch-thick metal bars that marked out space for each patient immediately in front of his room, thus allowing him to enter only partly into the common area and preventing him coming into physical contact with anyone else.[25] It is not clear how long, if at all, Dadd was placed in one of the wards with these 'cages', which a visitor of the 1850s described as being 'more like those which enclose the fiercer carnivora at the Zoological Gardens than anything we have elsewhere seen employed for the detention of afflicted humanity'.[26]

This same writer on the criminal block objected to the fact that the 'male lunatics are herded together without regard to their previous social or moral condition'. Bethlem may increasingly have targeted the decent patient of modest means, but a criminal lunatic might come from any social class. Among Dadd's companions in the male criminal block were William Frost, a methodist lay preacher who fell into melancholy after being falsely accused of drinking and had murdered his children; Captain Johnston of HMS *Tory* (fig.39) who had fallen out violently with his crew but to all at Bethlem now seemed entirely sane;[27] and even a minor aristocrat, the Hon. William Ross Tuchet, who had shot an assistant at a firing range for no apparent reason. Several such men had friends on the outside convinced they had only suffered from some passing paroxysm.

No such campaigner was more dedicated than John Perceval, son of the Prime Minister assassinated in 1812, who himself had suffered from psychotic episodes and spent time in asylums, but recovered to become the moving force behind the Alleged Lunatics' Friend Society from the mid-1840s.[28] One of the 'alleged lunatics' whose cause Perceval adopted was Arthur Pearce, a wealthy surgeon who had been sent to the criminal block at Bethlem in 1841 following an attack on his wife. Pearce took to writing poetry – versions of Old Testament stories and sentimental sonnets – which Perceval published in 1851. In his preface, Perceval described the horror of a gentle poet confined along with 'maniacs … crawling, jabbering, shouting, or taking their hurried and excited exercise', while Pearce himself lamented that the 'wretched and unlettered' were now 'the society by which I am for the most part surrounded amidst adverse circumstances and bewildering sounds'.[29] Among such 'unlettered' companions was, to take one briefly notorious case, Thomas Wheeler, a seriously ill local young man from Lambeth who had been admitted to Bethlem in 1849 but discharged uncured. Moving back to live with his mother, he had eventually murdered and beheaded her. He joined the criminal lunatics in 1852. Before moving on to describe Dadd's response to this environment, it is high time that we asked: what was the matter with him?

What was wrong with Dadd was that he became murderous. A succinct summary of Dadd's own account of the events of August 1843 was elicited, recorded and edited by the Apothecary of Bethlem from 1845, William Wood:

My religious opinions varied and do vary from the vulgar; I was inclined
to fall in with the views of the ancients, and to regard the substitution
of modern ideas thereon as not for the better. These and the like, coupled
with the idea of a descent from the Egyptian god Osiris, induced me to
put a period to the existence of him whom I had always regarded as a
parent, but whom the secret admonishings I had, counselled me was the
author of the ruin of my race.[30]

Robert Dadd was thus an imposter, for Richard's true father was the Egyptian god
Osiris whom he equated with the sun. Robert was an enemy of the god, potentially
the ruin of Richard's actual divine heritage (or 'race'), a man possessed by an evil
demon or perhaps even the Devil himself. In killing him, Richard was offering a
sacrifice that would set Osiris free. The first modern technical psychiatric label we
might reach for should perhaps be Capgras Syndrome, defined in the 1920s as a
delusion involving doubles, classically a conviction that an imposter had taken the
place of a family member. But Dadd believed that his so-called father must always
have been an imposter, given that Richard's actual 'descent' had been otherwise.

The narrative Dadd wrote for Wood makes it clear that his understanding of his
situation had only become clear to him after his return to London from the tour.
Aware that the opinions he was forming were unacceptable to his friends, Dadd
became suspicious and reclusive. His father, however, persisted in wanting to
help him and eventually consulted a psychiatrist who advised Richard be taken
into care. These efforts on Robert's part must have helped precipitate Richard's
plan to 'put a period to his existence', but Robert was probably also implicated in
the theological explanations Richard developed for the necessity of the killing.
As it happens, we know that immediately prior to his son's return from his tour,
Robert Dadd had been studying the religion of the ancient Egyptians, and in his
freethinking Unitarian way had become one of those intellectuals to be struck by
the continuity between the myths of the Egyptian gods on one hand and the Old
and New Testaments on the other.[31] Osiris, for example, had played a role not so
very different from Christ. A god appearing in the world, he was betrayed (by Seth)
and killed (then cut into pieces), but rose again to become the judge of the souls
of the departed. Perhaps following conversations with his father on such subjects,
Richard seems to have concluded that the wisdom of the ancients – the Egyptians
but also the Greeks and Romans – had been essentially true and, as he later himself
wrote, 'what is true or was true then must be true now in spite of new doctrines
and religious *suum cuique*'.[32] So, the later modifications to these traditions offered
by the likes of Jesus or Muhammad, prophets of 'vulgar' religion, could not offer
any real improvements. Equally, Dadd preferred the classical understanding of
the complex legends of Osiris as opposed to the readings of modern scholarly
Egyptologists. The ancient writers described Osiris as the sun god, rather than the
god of the underworld, and believed there had been a tradition of human sacrifices
to him – notions refuted by the great modern authority John Gardner Wilkinson,
whose works Robert Dadd had been studying.[33]

JUDGMENT

40
Osiris (enthroned on
the right) and other
Ancient Egyptian
gods judging the
dead, from John
Gardner Wilkinson,
*Manners and Customs
of the Ancient Egyptians*,
Second Series (London
1841)
British Library,
London

Richard Dadd's adoption of an ancient religious system and rejection of
conventional modern Christianity may have been eccentric, but was it mad?
Different kinds of sun-worship were not so very rare in Victorian England:
'The sun is God' were words attributed to Turner, not Dadd.[34] The judgement
of John Charles Bucknill, perhaps the most conspicuous voice of the professional
asylum doctors around mid-century, was clear on this question:

> The belief of the unfortunate parricide, Mr Dadd, in Osiris and the
> religion of ancient Egypt, was far more dignified, and scarcely more absurd,
> than the religion of the Mormons, the Lampeter brethren, the followers of
> Johanna Southcott, or Swedenborg. It could not therefore on its own merits
> or demerits be pronounced to be an insane delusion.[35]

But to the religion of Egypt, Dadd also added a more specifically Graeco-Roman
understanding of the working of spirits, or demons. Dadd's Bethlem casenotes
describe his talk at the time of his admission: 'some vague idea ... filled his mind
... that certain spirits have the power of possessing a man's body and compelling
him to adopt a particular course whether he will or no.'[36] Dadd's conception was
of a demon, or genius (to use the Greek and Latin forms respectively), controlling
his actions. He also made reference to the tradition of each person having a pair
of tutelary spirits or demons competing to lead the individual to the good or the
bad, a tradition he in turn connected with the iconography of Osiris using scales to
weigh the good deeds of the soul after death (see fig.40).[37] The Socratic notion of
a demon – comparable to a Christian patron saint – was of a spirit able to intercede
with the gods on behalf of the individual. That Dadd called on the stars to tell
Osiris the good news of Robert Dadd's demise, and that later in France he looked
to the constellations for his instructions, suggests that, at least temporarily, he
identified the stars as intermediaries between himself and Osiris, the sun.[38]

77

Thus Dadd explained the murder. As he had told the magistrates at Rochester: he didn't do it. He was merely 'the cat's paw' in 'an act of volition', which could not be attributed to him although he approved of it.[39] Dadd was disavowing the 'genius' that had been attributed to him as a successful young artist of the imagination, and the complete mental freedom that went with that role, exchanging it for the opposite status of a passive subject. Deliberately, he was returning to a classical account of a modern problem. Within Christian theology there was room only for saints and evil demons, not the range of ethically equivocal spirits of the ancients whose newly demoted habitat gradually evolved in folklore into the fairyland in which Dadd had made his reputation. From the Renaissance and especially during the Enlightenment, the notion of the personalised guiding genius was secularised and collapsed into the person who now became himself (almost never herself) a genius with an inbuilt and ineluctable direct line to the transcendent. Mix this with the massively expanded and more competitive marketplace for culture of the Romantic age, and the popular notion of the Byronic genius, licensed to transgress and liable to crash, comes into focus.[40] In British art history, it was Benjamin Robert Haydon who most eagerly held to this persona, using it to berate those people (and there were many of them) who declined to purchase his massive pictures. There were, however, also those more worldly writers who sought to return 'genius' to its sense of a guiding spirit, such as the historian Thomas Babington Macaulay who suggested Haydon was not a genius, merely a crashing bore, and Charles Lamb, who saw genius as a sort of inverse monomania – a hidden thread of sanity sustained even amid apparent madness, such as those which guided Shakespeare's paths through fantasy, journeys that never ended in confusion.[41]

Dadd expelled his genius, placing it aside from himself but then attributing to it his actions. This process he carried on with some self-consciousness, behaving anti-socially but then immediately apologising. The Bethlem casenotes record that 'For some years after his admission he was considered a violent and dangerous patient, for he would jump up and strike a violent blow without any aggravation, and then beg pardon for the deed'. He would gorge himself until he vomited, but then return to the meal. In France he had tried to cut a man's throat and then offered money for his care. Dadd seemed to be very aware of the distinction between the will he was subject to and the negative impression he – its agent – was making. He never lived, however, to confess any regret for the murder of his father, the act that led to his being classified as mad.

If the legal answer to our question – What was the matter with Richard Dadd? – is that he became murderous, then the medical answer being begged must be that he was schizophrenic. Indeed, Dadd appears to present a textbook checklist of symptoms of that disorder even though, in the 1840s, no such textbook existed. Schizophrenia, as it came to be understood in the twentieth century, might almost have been developed to account for cases such as Dadd's. In fact, it might be argued that something like this happened.

The concept of schizophrenia, established around 1900, was intended to tidy up the messy range of diagnoses developed as asylum medicine had so dramatically expanded during the nineteenth century. Building on categories already used by figures such as the French asylum director Bénédict Morel, the German psychiatrist Emil Kraepelin laid down two fundamental forms of serious long-term mental illness: manic depression, which was cyclical in occurrence and affective (emotional) in nature; and *dementia praecox*, a loss of mental faculties early in life, which was irreversible.[42] The latter term soon swapped its Latin name for the rather romantic-sounding Greek neologism 'schizophrenia' – literally, broken or split mind. The advent soon afterwards of Freudian psychoanalysis confused the diagnostic framework again, and later in the twentieth century the 'anti-psychiatry movement' launched a hugely successful campaign against the biological or neurological understanding of psychosis that underpinned Kraepelin's thinking (a debate we will return to in Chapter Six). In recent years, even after the renewed success of the biological model in the wake of the development of antipsychotic drugs, many psychiatrists have remained convinced that there is no such thing as schizophrenia – that its classic symptoms do not truly define a stable disease entity.[43] Hence the stormy controversies over the tricky business of retrospective diagnosis, that is, the effort to match old case histories to modern medical nomenclature.

Among the core symptoms of schizophrenic illness have been said to be: onset in late youth or early adulthood; disordered and delusional thinking, especially regarding the special status of the patient as a victim of persecution or as of some exalted station; hearing voices and otherwise receiving information from unconventional sources; and a flattening of the emotional life. As critics of the concept of schizophrenia have thoroughly demonstrated, however, longer lists of supposed symptoms have changed drastically over the years, and remain very different today from one medical jurisdiction to another.[44] Whether schizophrenics tend to violence is for example an especially controversial question (in today's world the answer seems to be yes, but only perhaps because of their high rates of alcohol and drug abuse).[45] Defenders of the category have sought to argue that the symptoms have changed over time for good reason, namely that the delusions and other mental aberrations of schizophrenics entwine themselves around reality – they are not random gibberish – and therefore the illness itself evolves with the 'sane' world in which it develops.[46] So schizophrenia, like plenty of other diseases, is always updating itself. Another suggestion, the 'recency hypothesis', is that schizophrenia really is a new illness, possibly with a viral cause, that only came into being during the massive urbanisation of the late eighteenth century.[47] To the lay observer of these debates there can sometimes appear to be a confusion between the supposed novelty of the illness and the novelty of record-keeping. It seems too much of a coincidence that the first apparent cases of schizophrenia are said to date from the period when psychiatric casenotes first become available in any sizable numbers, around 1800.

The history of cyclical manic-depressive illness (or bipolar disorder) has always been closely linked with creative originality. The long lists of famous writers, artists

and composers who have been 'touched with fire', as one survey of the relationship is titled, are familiar.[48] But in the hunt for the first schizophrenics, artists and images have also always held a special place. The most often cited early descriptions in English were made at Bethlem by Haslam, the Apothecary disgraced in 1815. In 1810 Haslam published an entire book, *Illustrations of Madness*, which sought to demonstrate the lunacy of a patient of his, James Tilly Matthews, whose friends were mounting an effective campaign to have him discharged.[49] Haslam felt his clinching argument was Matthews' belief in an Air Loom, an influencing machine hidden in a cellar around the corner from Bethlem's Moorfields site, which used state-of-the-art technology to control the actions of politicians. Haslam had his patient make a drawing of the Loom and, in publishing it, he felt he had finished the argument with a *reductio ad absurdum* (fig.41). In fact he had unwittingly provided posterity with a compelling image of poeticised science, which in 2002 was actually constructed for real by the artist Rod Dickinson in Newcastle.[50] Meanwhile, the best-documented effort to diagnose schizophrenia in an even earlier period centred on the seventeenth-century Austrian painter Johann Christoph Haitzmann.[51] There has seemed, then, for the more imaginative medical historians of recent times, a crucial if ill-defined link between schizophrenia and art – to be sure, a link that a sceptic would put down to the simple fact of the much greater survival rate of art compared with less permanent records of behavioural abnormalities. The phenomenon of a capacity for image-making being liberated by madness, which first attracted broad attention in the early twentieth century, described art *according to* schizophrenia. But the reverse process was also in action, and schizophrenia's founding case studies in turn depended upon the image. Hence, I suggest, the reason Dadd can appear, rightly or wrongly, such a 'classic' case.

Returning again to Dadd's illness: what understanding of this was available to his contemporaries? The basic theory of asylum medicine of the 1840s was, on the face of things, stuck in a kind of therapeutic stalemate. That mental illness was ultimately biological, organic and caused by damage to something in the brain was more or less universally accepted; any other conclusion would risk undermining the physicians' custodianship of the asylum. For example, one leading authority, Forbes Winslow (fig.35), suggested that 'demonomania' was caused by congestion of dark blood in the vessels of the brain.[52] But the only treatments available were tranquillising therapies, useful labour and kindness.[53] The brain was to blame but could not be fixed directly, leaving only the possibility of 'holistic' interventions (to use another anachronism). This is not so far from the position of psychiatrists today. The assumed somatic basis of madness led the early psychiatrists to pay close attention to hereditary symptoms, and to think in terms of an inherited liability to madness that might manifest itself as illness in certain circumstances. There seemed to them to be links between madness and genius, understood as exceptional creativity.[54] (Again, modern neuroscience agrees.)[55] Common sense thus seemed to suggest that Dadd's profession and apparently almost excessive imaginative leaps would easily provide the trigger. But was the genetic gun loaded? Soon after the murder of Robert Dadd, the evidence began to mount, in tragic ways, that this was the case.

41
Engraving after J.T.
Matthews, *Air Loom*,
in John Haslam,
Illustrations of Madness
(1810)
Wellcome Library,
London

Richard's youngest full brother (by Robert's first wife), George, had apparently long shown some extreme behavioural problems. Described even by a family friend as 'a sad reprobate', George seems to have caused such trouble that, on the death in 1876 of Robert Dadd Jr, Richard's eldest brother, one of their half-brothers (by Robert Sr's second wife) recalled how, when they were all young men, Robert had 'stood up as the champion to protect the rights of others from the selfish desires of a weak and erring brother'.[56] George, who had worked as a carpenter, had apparently become obviously mentally ill from the spring of 1843 (exactly when Richard's symptoms first showed themselves) and he eventually returned to the family home on the day after the discovery of Robert Dadd's body, destitute and delusional. George was admitted to Bethlem aged twenty on 13 September, one week before Richard arrived at Clermont. Following hospital policy, after a year he was transferred to the incurable wards and died there in 1868. It is likely that the staff at least attempted to reintroduce the brothers to one another, although there is no evidence of this.[57]

Meanwhile there seemed to be happier news from other family members. Robert Jr married in August 1843 – just a fortnight before the murder – and followed his father's first profession of chemist in London. Maria Dadd (fig.2) married a family friend, the painter John Phillip, a member of Richard's Clique. But it was apparently in the year of her wedding, 1844, that she suffered a first attack of the insanity that became fixed about 1853. From at least 1859 she was cared for privately in London before eventually being sent as a well-funded private patient to the main asylum in Phillip's native Aberdeen in 1863. Maria had become violent towards her husband and believed herself persecuted by religious figures (she 'was much punished by Jesuits and by the clergy of Kensington') on the instructions of the Prince Consort. Later, her casenotes say, 'She weaves anything she reads into a delusion especially if it be anything connected with royalty'.[58]

In his application to have Maria admitted in 1863, John Phillip could confidently state that the cause of her illness was 'hereditary tendency'. By that time the Dadds had also lost Stephen, the second son, who had taken over the family gilding business, moving it to Soho, before switching to a career as an ale and pork pie merchant in Manchester around 1850. He died aged only thirty-eight in 1854, it was said from a carbuncle.[59] But George's Bethlem casenotes of 1853, recording the family's hereditary tendency, state in this context not only that Richard was in the criminal department of the same hospital, but also that 'another brother has a private attendant'.[60] If this was not a confused reference to Maria (i.e. 'brother' may have been a slip for 'sibling'), which seems possible, then the other brother can only have been Stephen; if so, he cannot have been ill for long. None of this of course proves a *hereditary* genetic cause of these siblings' illnesses or liability to illness, however much it may be suggested. Other environmental factors may have been to blame, such as the early death of their mother – a recognised factor in the incidence of schizophrenia – or even, conceivably, poisoning from the mercury used in the water-gilding process that took place daily at Suffolk Street.[61] In fact, the immediate cause most often cited by Richard Dadd's contemporaries for the onset of his illness was the most mundane of all: sunstroke suffered in the East.[62]

After his admission to Bethlem in 1844, Dadd's condition went under the no-nonsense label of 'insane'.[63] In their survey of asylums of that year, the Metropolitan Commissioners in Lunacy used a five-part taxonomy of insanity, reflecting the practices of the institutions they visited. The established categories of Mania, Dementia (the decay of mental faculties) and Melancholia were followed by the new-fangled partial insanities: Monomania (regarding the real existence of which the commissioners however expressed scepticism) and Moral Insanity (coined by the Quaker ethnologist and physician James Cowles Prichard in 1835). Aside from mental illness proper, the commissioners added the further categories of Congenital Idiocy and Imbecility (when the faculties never developed), General Paralysis of the Insane (generally recognised from the early twentieth century as a symptom of syphilis) and Epilepsy. Mania meant thoroughly disordered thought, bad enough to prevent sustained lucid conversation on any topic – seen as a feature of Dadd's condition. Unfortunately, Dadd's doctor, E.T. Monro, had inherited from

his ancestors not only his position at Bethlem but also their belief that little could be known of madness and little done for lunatics beyond the respite offered by an asylum. During the eight years in which he was nominally in charge of Dadd, Monro never bothered to record any casenotes for him. It is not then claiming much to say that the other senior managers of Bethlem took more interest in Dadd than did his physician.

Until the 1850s, Bethlem had no single overall director. There were the governors, chaired by the President, and two Visiting Physicians – Monro and, from 1835, Alexander Morison, one or other of whom was supposed to make the rounds of the wards every day (Monro and Morison maintained their headquarters in, respectively, Harley Street and Cavendish Square, at the epicentre of elite private medicine).[64] In charge of the daily dispensing of medicine was the Apothecary, and in charge of just about everything else was the Steward. Wood, the Apothecary, obtained from Dadd the account of his thinking from which we have quoted, while Nathaniel Nicholls, the Steward since shortly after Bethlem's move to Lambeth, also apparently followed Dadd's progress carefully. Dadd had started to draw again soon after his arrival at Bethlem, and Nicholls and Morison were among the first people in a position to acquire his new work.

By May 1845, the *Art-Union* was able to report to its readers on the revival of Dadd's art:

> He is in good health, and we have lately seen some drawings recently executed by him which exhibit all the power, fancy, and judgment for which his works were eminent previous to his insanity. They are absolutely wonderful in delicate finish. They consist principally of landscapes – memories of Eastern scenes, or wrought from a small sketch book in his possession. One is, however, of an avenue of close box-trees, terminated by the tall gate of a mansion. It is a marvellous production – such as scarcely any of our living painters could surpass. This drawing was, we believe, produced within the last few weeks. Two or three of his productions indicate the state of his mind. One describes a castle, shattered by lightning: underneath is written 'The Wrath of God'. Others contain brief written descriptions (on the backs) in oddly mingled French and English.[65]

Neither the avenue of box-trees nor the shattered castle have been traced, but a magnificent watercolour clearly connected to this report turned up on the BBC television programme *Antiques Roadshow* in 1986. *Halt in the Desert* c.1845 (fig.42, pp.84–5) records the evening Dadd and Phillips spent on the shore of the Dead Sea in November 1842. On the back of the drawing, Dadd described its origins in the Franglais noted by the *Art-Union* writer:

> Ici on voit clair de lune, peignè des recollections qui existent dans la tete du peinteur, et des certains marques et lines dans la livre petit que je crois de n'avoir pas ète dans le possession du Sir Thos Phillips.

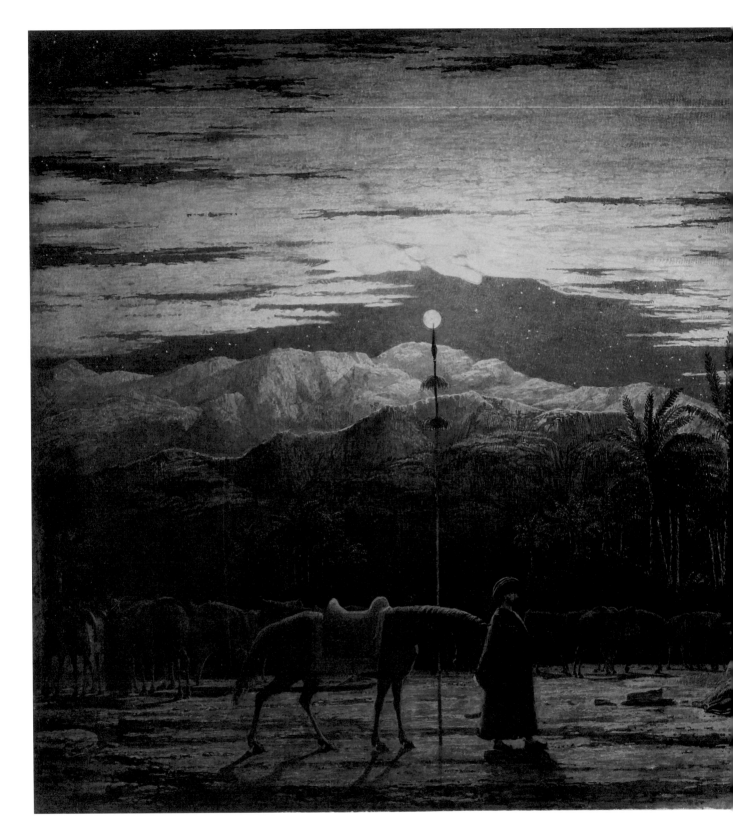

42
Halt in the Desert c.1845
Watercolour on paper
36.8 x 70.7
British Museum,
London

The 'little book' from which Dadd filled out his recollections is the sketchbook mentioned by the *Art-Union*, a still unlocated book similar to the one now in the V&A, which Phillips had retained.

Dadd's Bethlem works, or at least many of them, soon left his possession; some left the hospital and entered the art market. By 1857, the Preston lawyer and collector Thomas Birchall was able to lend to the vast Manchester Art Treasures Exhibition not only *Halt in the Desert* but also two other watercolours, now untraced but probably made around the same time: a *Dead Camel* being protected from vultures by its owner 'with a cave of carved monsters of hideous forms framing the vista', and the *Vale of Rocks*, 'a lofty precipice of rocky scenery'.[66] Oriental landscapes were clearly central to Dadd's iconography during the early Bethlem years – outlines from his sketchbook mixed with memories and with a certain cruel biblical flavour that his 1845 visitor felt 'indicate[d] the state of his mind'. Among the drawings that Nicholls acquired from Dadd were rocky landscapes, a *Portrait of a Divine* ('in pen with a border formed of the text of the Psalms of David in Hebrew') and, unpredictably, two studies of fisherwomen from Newhaven outside Edinburgh.[67] The famously picturesque fishwives of Newhaven, with their standard attributes of wicker baskets and striped dresses with vast pockets at the front, were a common emblem of Scotland in the days before the cult of the Highlands had become entirely dominant. Dadd, who as we have seen had a penchant for sturdy women, developed a curious fascination for them, and the cue for this was most likely his relationship with Alexander Morison, who had been born at Newhaven in 1779.[68]

Morison was for decades a prominent figure in British psychiatry, but one whose fundamental commitment to the discretion of the private physician meant that his standing within the newly public profession of asylum medicine was ultimately undermined. He trained and first practised, early in the century, in Edinburgh where he later pioneered public lecturing on mental diseases.[69] Morison developed a reputation as a confidential fixer for well-to-do families needing help in arranging care for mentally ill relatives. His status as a gentleman physician with pronounced conservative and religious principles meant he was seen as a safe name to nominate as the medical overseer of several new asylums, especially from the 1830s when, now into his fifties, Morison also looked the part of the patrician alienist. He was knighted in 1838, but his problems also began about the same time, as a new breed of younger asylum doctors led by John Conolly eschewed professional privacy and bowled over the public, the press and the lunacy reformers with their declaration that asylums, even the new large county pauper establishments, should and could be run entirely without physical coercion or restraint by straitjackets, chains and the like. This was more than the old moral therapy – it was a bold appeal on the part of the emerging psychiatric profession to be admitted to full responsibility and respectability within Britain's unfolding panoply of public institutions, with their administrative cycles of report-writing, legislation and inspection.

Suspicious of large public asylums per se and regarding the non-restraint mantra as a slogan, Morison was soon on the defensive, excluded in 1840 from the huge Middlesex County Asylum at Hanwell in London's distant western suburbs, to which he had been visiting physician but where Conolly raised the non-restraint standard on becoming Superintendent in 1839. At Bethlem, another of Morison's several visiting physicianships, Laurie, the President of the Governors, was soon pressing non-restraint upon him, and it seems he alienated the resident staff, Wood the Apothecary informing him that he was considered too 'sensitive'. This was evidently patched up, as Morison later records lending Wood books by the great Esquirol, the legendary French compounder of psychiatric statistics and authority on the planning of asylums. He was one of the few doctors whose authority all in the British profession could agree upon.[70]

When Morison first met Esquirol in Paris in 1818 he particularly noted the Frenchman's collection of hundreds of plaster casts of the faces of the insane, a physiognomic archive that impressed him deeply. Esquirol's first major book, a version of his university thesis, had been published in 1805 as *The passions considered as causes, symptoms and means of cure in cases of insanity*. His subsequent thinking about madness evolved the traditional theories of the passions into the notion of *manie partielle*, of which monomania was one form, and Prichard's 'moral insanity' (where the moral compass decays without delusional deterioration of the intellect) another. In France, Dadd's diagnosis came under the heading of a *manie partielle*. Physiognomy – the study of facial expression and character – became a fellow-traveller in this evolution, for it had always been associated with the analysis of the passions and now seemed able to make a contribution to the analysis of mental alienation.[71] Thanks to his positions at several large British asylums, Morison was able to follow Esquirol in creating a pictorial survey of the appearance of patients afflicted with a wide range of conditions. In the 1830s he hired two young Scottish artists, Charles Gow and Alexander Johnston, to make drawings for him at Bethlem and other hospitals, many of which were reproduced in Morison's *Physiognomy of Mental Diseases* in 1840 (see fig.43, overleaf).

It appears that it was Gow who first made Morison aware of Dadd as an artist (he continued to work for Morison into the 1840s). In his diary for 21 November 1844, Morison notes that Gow 'says Dadd is an extraordinary artist'.[72] Morison was wealthy enough to be in the habit of collecting art and now began acquiring Dadd's watercolours. Although frustratingly little can be said of precisely what he owned, by the 1850s the dining room of Morison's house in Scotland was 'hung around' with Dadd's watercolours 'as close as they will go'.[73] A group of seven watercolours, presumably first owned by Morison, appeared in the 1878 auction of the collection of his son-in-law, Barron Grahame of Morphie. They included *Dymphna Martyr* 1851 (fig.52, p.102) and *Aesculapius Discovered by Shepherds* 1851 (fig.50, p.100), both images that relate the myths of medicine to Christian iconography (see Chapter Four).[74] As for what Dadd generally received in return for such works, in 1850 Morison noted in his diary that he had sent money to an attendant 'to buy apples for Dadd'.[75]

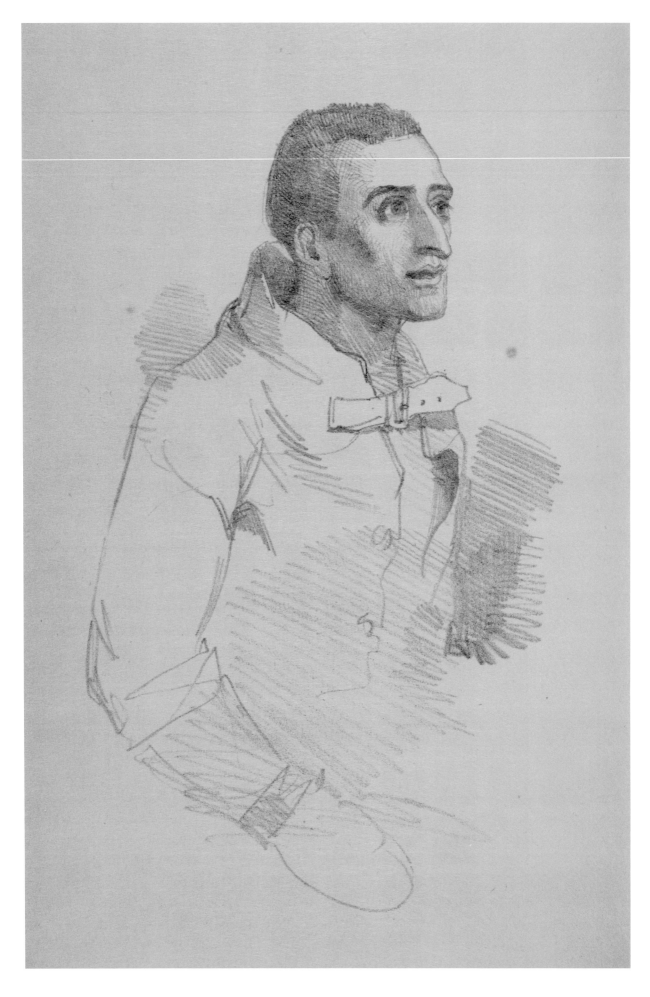

The relationship of artist and patron was not recorded in any formal medical way. It was strictly a private affair between the two men, and as such ran harshly against the grain of the new culture of lunacy administration of the 1840s, the rhetoric of which turned on the transparency of a fully accountable public sphere. In 1842 Morison had launched his counter-offensive to that new culture, the Society for Improving the Conditions of the Insane, an association of mad-doctors (to use the term that was still standard) who refused to sign up to the non-restraint bandwagon and who stressed instead the importance of raising the standards of medical training for psychiatrists and of the humane conduct of asylum attendants.[76] Morison's attitude towards Dadd formed part of his larger philosophy of mental medicine, which was dominated by principles of privacy and discretion, and a strong sense of the physician's role as an independent gentleman best placed to assess the full picture of patient, illness and institution. Soon this would prove an untenable position within the newly reformed system of public asylumdom. But before concluding the story of Morison's relationship with Bethlem we need to examine Dadd's attitude towards his new patrons.

Dadd's highly successful early career had been based on projecting to the public, via exhibitions, a personality of uniquely imaginative insight. After 1843 he had entirely to revise this way of seeing both his public and his own creative gifts. His former audience were being told in the *Art-Union* that he had in effect died, and when friends came to see him soon after his arrival at Bethlem he apparently merely shrugged his shoulders, turned away and exclaimed 'Friends!'[77] Dadd's new understanding of the world offered some consolation for these losses. With his newly acquired antique perspective on history, he saw that, as cultures rose and fell over the centuries, civilisation never gained purchase over the great majority of mankind, who always 'relapse to the savage state'.[78] As Dadd concluded in some notes written in the 1850s: 'pictures are like monks, secluded from and very little noticed by the world, so that after all what matters about its quality except to the few, the initiated? The great masses if they do notice will still wonder "What is the good of such things?"'[79] So to believe in some role for art in society was a delusion, felt Dadd, as was also the myth of the entirely independent artist bringing forth expressions of his genius. For as all people were influenced by spirits (or demons or devils) that contended for the control of their actions, how absurd such an expressionist view of art must become:

> Perhaps the artist is himself the greatest victim of delusion – self-delusion. Pleasing oneself is like trying to be satisfied with a gross mistake. If you try to please a devil, a more implacable customer you cannot meet. And as he is more subtle than most artists – and all men or women have the devil in them – how can they please themselves except by fallacies? And what lies, what fallacies pictures are – in the grand style of art especially.[80]

Dadd thus renounced total creative freedom: this was abolished along with everything else that depended on the notion of a perfectly free and autonomous human being. Another of the casualties of this process had to be the artistic

naturalism that underwrote modern theories of landscape painting. If spirits influenced the making of art, then the naturalist's rhetoric of 'I saw this' was no longer credible. So, instead of compositions that would make sense to a popular audience as records of complex visual impressions, Dadd produced at Bethlem landscape images which, while combining material from his sketchbook with his memories, disavowed his own vision's transparency through a curious way of pattern-making within the picture.

The *Art-Union* reported in 1848, as if it were news, that Dadd had taken to using oil paints and canvas as well as watercolour, but in fact a picture in oil survives dated from as early as 1845, *Caravanserai at Mylasa* (fig.44). Painted on panel, this memory of his Turkish travels somehow found its way into the impressive art collection of Thomas Turton, the intellectual Bishop of Ely, by the early 1860s.[81] The *Art-Union* piece describes Dadd's early Bethlem oils as being 'in parts eminently beautiful, but other parts, in madness, without method. How singular these outpourings of disease and mind will be to future collectors.'[82] The *Caravanserai* picture shows, rather like the *Water Carriers* of 1843 (fig.32, pp.62–3), an Oriental scene with nothing much happening and little either in the sense of character or even local colour. The only action appears in the disconcerting flurry of birds above the roof of the khan. The pattern-making referred to above can be seen in the heads of two camels on the right, one exactly superimposed upon the other in a way that playfully offers a two-dimensional contrast with the perspectival depth of the picture's space. Similar deconstructions of naturalism can be seen in the *Halt in the Desert*, where the perfectly vertical tufted lance on the left has pierced, and even seems to support, the moon; and the undated *View in the Island of Rhodes* (fig.45), in which the fabulously elegant and intricate details are set against a marine horizon positioned at an unlikely height (in fact at two slightly different heights), and terminated by a little standing figure at the point where it meets the landscape. This tendency seems of a part with the self-consciousness with which, as we have noted, Dadd often presented his insanity. In his landscapes there is a fundamental tension between the artist's vision and his certainty that an individual's perceptions cannot be enough to make sense of the world. Patterns and meanings existed that could not be accommodated to the gaze of the artist, trained to believe that his or her eyes alone could capture the truth. Isolated at Bethlem, with nothing to look at now but brick walls, Dadd almost appears to mock the authority of vision.

An extreme example of this method is represented by Dadd's most ambitious surviving oil painting from the early Bethlem years, the so-called *Flight Out of Egypt*, dated 1849–50 (fig.46, overleaf). It seems to aspire to be a resumé of Dadd's Oriental tour, with figures representing many of the places he had visited and sights he had witnessed, crammed together like refugees in the valley of a dried-up river now reduced to a tiny stream at which the figures in the foreground collect water. The rocky landscape resembles that of Ein Gedi in Palestine through which he had travelled during his excursion to the Dead Sea in November 1842 – a place that had seemed to him 'like the end of the world'.[83] The effect is biblical, hence the

44
Caravanserai at Mylasa
1845
Oil on panel 21.3 x 30.5
Yale Center for British Art, Paul Mellon Collection

45
View in the Island of Rhodes c.1845
Watercolour on paper 24.5 x 37.2
Victoria and Albert Museum, London

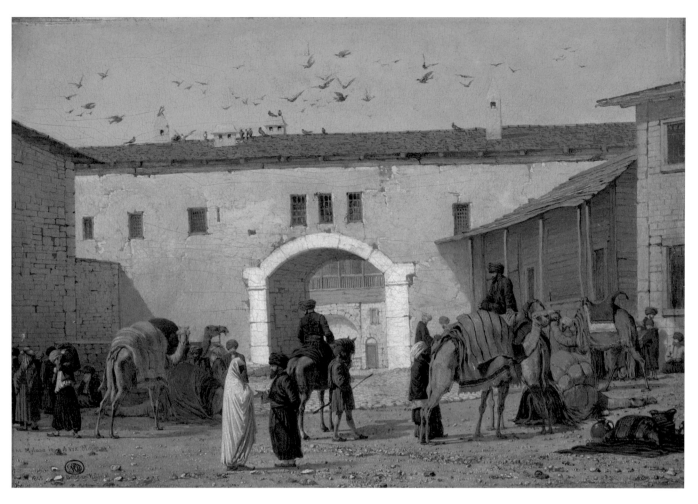

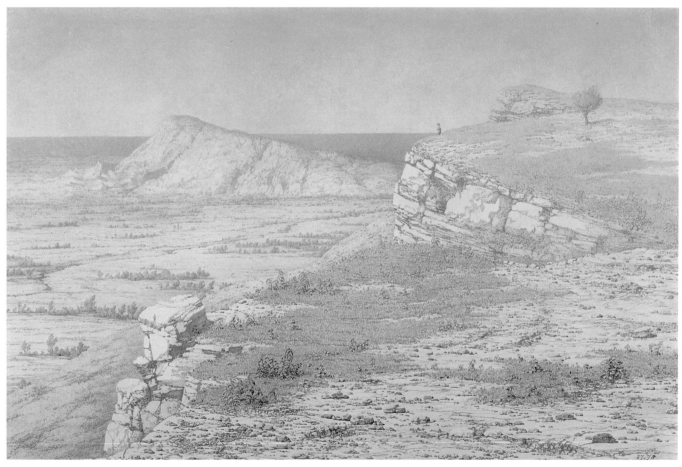

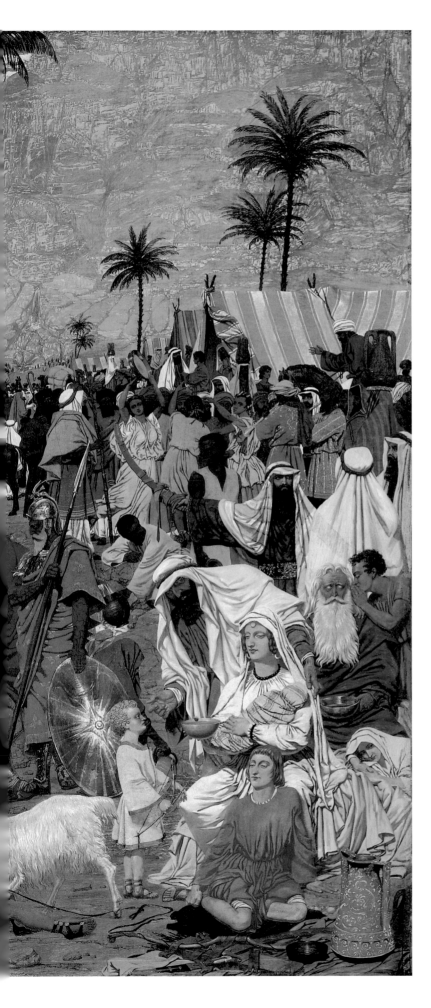

46
Flight Out of Egypt
1849–50
Oil on canvas
101 x 126.4
Tate

title that later became attached to the painting, referring to the Israelites' escape from bondage in Egypt and their wanderings in the wilderness before arriving in the Promised Land. But mixed into the crowd are various classical figures such as the dancing girl with a tambourine on the right, who has been borrowed from a Pompeian wall-painting of a maenad, and the men in the centre raising their arms in salute who resemble the Roman brothers from Jacques-Louis David's great *Oath of the Horatii* 1784, in the Louvre (Dadd would have seen these sources in Naples and Paris respectively during the spring of 1843). Throughout, Dadd has invented his own decorations on objects and clothing that defy any attempt to be specific about the historical identity of the figures. The chaos of the whole scene is brutally challenged by the central palm tree that almost appears to be holding up the sky and which terminates below in the circle – at the exact centre of the picture – formed by the base of a large drinking vessel that the leader of the soldiers holds to his face, tidily eliminating the identity of the person who is ostensibly the overseer of the situation.

By the time Dadd completed the *Flight Out of Egypt*, Bethlem was in trouble again. The Lunacy Bills of 1845 had required all counties in England and Wales to construct asylums for their mentally ill poor, and established a permanent national Commission of Inspectors to oversee the standards of all asylums. Bethlem's governors had again insisted on its exemption, but the hospital's medieval independence was no longer sustainable. Various scandals, among them the massive embezzlement of funds by the hospital's treasurer and accountant in the 1830s, encouraged campaigners such as Thomas Wakley of the *Lancet* along with many politicians to believe the hospital could not be trusted to regulate itself.[84] The cases of two female patients said to have been cruelly treated were the occasion for the commissioners finally to lay precedent aside and insist on entering Bethlem in June 1851. Their subsequent report repeated all too many of the complaints of the 1815 investigation.[85] The physicians were too distant from the patients; they made cursory rounds without really getting to grips with their individual needs, leaving such work to the Apothecary and Matron as if they were running a household not a large modern hospital. Again, as in 1815, the physicians' efforts to defend themselves supplied their critics with their best lines. If any patients had been battered, concluded Monro in his defence, then that was terrible; but such a question was as distinct from his own proper concerns as visiting physician as were the duties 'of the architect or cook'.[86] The time had come for Bethlem to fall in line with the new asylum system and this meant the appointment of a resident physician-superintendent: someone with whom the buck would stop.

Following the publication of the 1852 report, the entire senior management of Bethlem were let go – the Apothecary, the Steward and both visiting physicians.[87] Monro, supposedly Dadd's doctor, lived only a few more years, ending his life as a patient in his family's own private asylum.[88] Morison retired to Scotland, taking with him a valedictory portrait by Dadd (fig.47). Looking rather like an undertaker, Morison stands before a view of his house at Anchorfield outside Newhaven, with the Firth of Forth beyond.[89] The landscape was based, so an inscription explains, on a drawing sent to Dadd by Morison's daughter Ann.[90] The Newhaven photographs by David Octavius Hill and Robert Adamson of the 1840s, with which the Edinburgh pioneers of the new art celebrated their picturesque neighbours, seem to have been the source for the fishwives who have sportingly turned out to welcome the old man home.

4 Contradiction

When the hero of the non-restraint movement, John Conolly, retired from the Middlesex County Asylum at Hanwell in 1852, his colleagues presented him with an elaborate silver centrepiece, a kind of domestic sculpture nominally for the dining table (fig.49, overleaf).[1] At the top of the structure is Aesculapius, the god or genius of healing, flanked by figures personifying Mercy and Science. Below are figures derived from Gabriel Cibber's famous pair of sculptures for Bethlem of *Raving* and *Melancholy Madness* (fig.34, p.69), a female patient convalescing, and finally a male patient being restored to his tearful family, gratefully pointing up to the agents of his recovery. At the base are plaques presenting summary pictures of life in the asylum 'before and after' non-restraint. Before, the patients are locked in a dungeon, their heads shaved for bleeding; after, they make themselves useful in a fruitful garden, grasping the hand of their physician. The Conolly testimonial speaks powerfully of the great confidence of asylum medicine at mid-century, and of its appropriation of the emotive bonds of the family circle. The mad-doctor, especially the asylum superintendent, was now to be imagined almost as the family patriarch, as the autocratic but benevolent head of the extended clan of his patient body. This was the role taken up by William Charles Hood (fig.48) when he arrived at Bethlem as its first resident Physician-Superintendent in November 1852, and this chapter is about Dadd's life and art under this new regime. It is here that we need to confront the fundamental insight of Michel Foucault into the history of the asylum. While much of the detail of his account has had to be rejected, Foucault's argument that the kindness and 'humanity' of the non-restraint ethos were also means by which the asylum physician was able to extend his authority

within medicine and over the ever-expanding community of the 'insane' remains persuasive, and certainly needs to be taken seriously in the case of Dadd.[2]

At the same time that the Conolly testimonial was being created, Dadd made his own image of Aesculapius (fig.50, p.100), illustrating the legend that the founder of medicine had been abandoned as a baby and raised by a goat and a dog until discovered by shepherds attracted by a strange glowing light around the child. The watercolour is dated Christmas 1851 and was apparently first owned by Alexander Morison. In giving the infant Aesculapius a halo, Dadd was clearly deliberately providing his own original alternative to the conventional Nativity scene with its adoring shepherds. The identification of the physician with Christ had already been made by Dadd in France, when he perceived Dr Woillez as Jesus, but now Dadd seems to be eliding the birth-legends of medicine and Christianity. As we saw in the last chapter, Dadd's interpretation of history turned on the idea that nothing really new had happened since classical times and that later religious and cultural forms were merely variations on those original themes. This helps us interpret the Aesculapius drawing. It implies the origins of Christian legend in ancient myth, but was there also in it some ironic reference to the arrogance of medicine, perhaps to the saintly rhetoric of the modern asylum doctor? As we will see, something of this kind must be present in Dadd's large series of watercolours illustrating the *Passions,* begun in 1853. Another watercolour dating from 1851, *Dymphna Martyr* (fig.52, p.102), explicitly repeats the theme of the overlap of Christian tradition and modern medicine. Dymphna was an early medieval Irish

98

49
*Silver Testimonial
presented to Dr John
Conolly* 1852
94 x 58 x 47
Auckland Art Gallery
Toi o Tāmaki

or British Christian princess who fled to Belgium to escape her father (who was either enraged at her conversion or else had conceived an incestuous passion for her). He caught and beheaded her at Geel, where eventually her relics were seen to cure lunatics, whose patron saint she duly became. A tradition of domestic therapy – housing patients among local families – was maintained at Geel into Dadd's time, and it became a place of pilgrimage for modern psychiatrists (among them Alexander Morison who owned the drawing). Dadd's interest again appears to be in the curious antiquity of the rhetoric of modern medicine.[3]

Before describing Hood's arrival and the changes he effected at Bethlem, and evaluating the impact of these on Dadd, we need to pause to take a brief overview of the style and subject matter of Dadd's art during his years at Bethlem. The Aesculapius drawing is composed with a very clear, firm and flat outline, almost like a design for a decoration. This is a style very different to the watercolour miniature method used by Dadd on other occasions during his Bethlem years, for example in the landscape of Rhodes (fig.45, p.91), where the artist has used the miniaturist's dotting or stippling technique to evoke a poetic ambiguity of spatial depth. The flatter, more linear style was most probably influenced by prints – engravings on copper or wood – which were available at Bethlem both in books and as singly framed works donated by Graves & Co., the leading print publishers of Pall Mall.[4] While not wanting to risk making Dadd's working methods sound tidier than they were, perhaps we can suggest that, among his watercolours, the delicate stippling technique was more often used for images that are at least nominally representations of things Dadd had himself observed, especially remembered landscapes; while the more linear, print-like watercolour manner was used for invented imaginative figure subjects.

Dadd did not make art explicitly about his illness or even about his asylum home. This should not really surprise us, as Dadd did not consider himself to be ill, and in any case we know that Dadd believed picture-making, like all human activity, to be at least partially directed by spirits, and that he held the notion of an audience more or less in contempt (which was of course convenient as Dadd no longer had access to an audience of any size). He did not see himself as expressing his inner truth as part of some socially relevant project. But, on the other hand, neither does Dadd's asylum art fit the model of the obsessive pattern- or model-making of so-called Outsider (untutored) art. Searching for any measurable madness in Dadd's art seems unlikely to take us far, and indeed when, in the 1990s, two psychiatrists conducted a thorough stylistic analysis of Dadd's asylum work, they felt able to conclude only that 'It is necessary to drop stereotypes about "the mentally ill artist"'.[5] As objects, certainly, his works are not strange. They are expertly executed, carefully signed and of modest dimensions.

If we persist in wanting to connect the work to the life, it seems to me there are two basic ways in which this might responsibly be done. First, through iconography. As we have already seen, we can observe Dadd deliberately making connections between different bodies of legend – the ancient, the Christian and the medical.

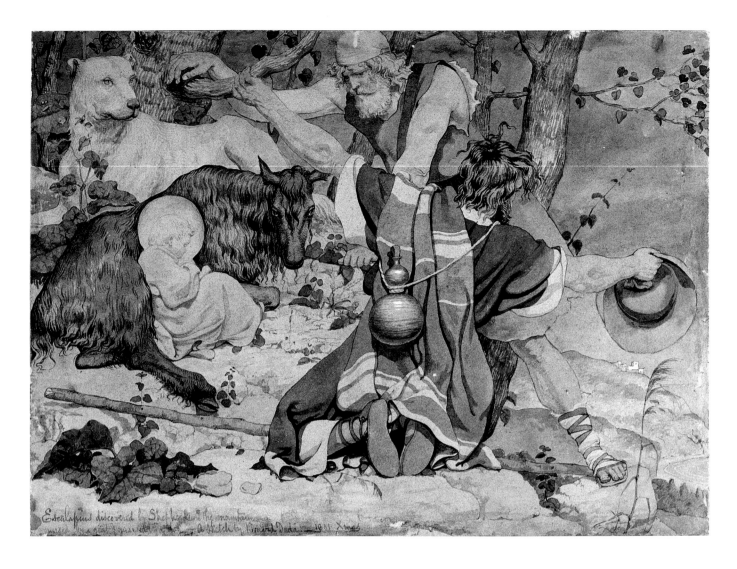

In working in this way Dadd seems to be using iconography to explore his own conception of myth and history. Some of Dadd's most important oil paintings of the Bethlem years are examples of this. In *Mercy* 1854 (fig.51), Dadd retells the Old Testament story of David's relationship with King Saul. David had soothed Saul's melancholia with his songs but the old man still turned against the younger and pursued him into the wilderness of Ein Gedi (the setting of Dadd's *Halt in the Desert*, fig.42, pp.84–5). But, coming across Saul sleeping in his camp, David commands his general Abishai to spare his persecutor's life.[6] The obvious echoes of New Testament forgiveness are matched with ancient Egyptian references, implying once more Dadd's theme of the fundamental continuity of culture. In Dadd's *Mother and Child* of 1860 (fig.53, overleaf), again a Christian icon is given twists of chronological ambiguity by the juxtaposition of ancient architecture with strikingly modern clothes.[7]

Dadd evidently prided himself on the insight he had gained into history, which was, in effect, that there was no history to speak of, only the repetition of civilisation's founding truths or legends. He told Dr Wood, the Bethlem Apothecary, that 'My religious opinions varied and do vary from the vulgar', and when proper casenotes were eventually written to describe Dadd's condition in 1854 it was noted that 'He is very eccentric and glories that he is not

50
Aesculapius Discovered by Shepherds on a Mountain
1851
Watercolour on paper
25.9 x 35.8
Wellcome Library, London

Opposite
51
Mercy: David Spareth Saul's Life 1854
Oil on canvas 68.6 x 55.9
The J. Paul Getty Museum, Los Angeles

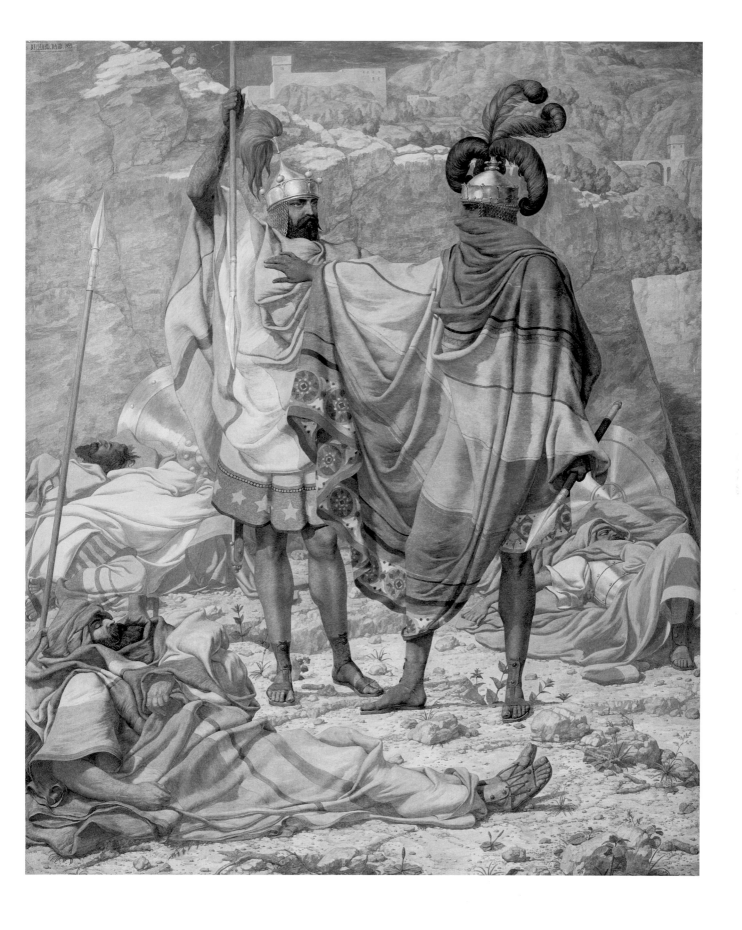

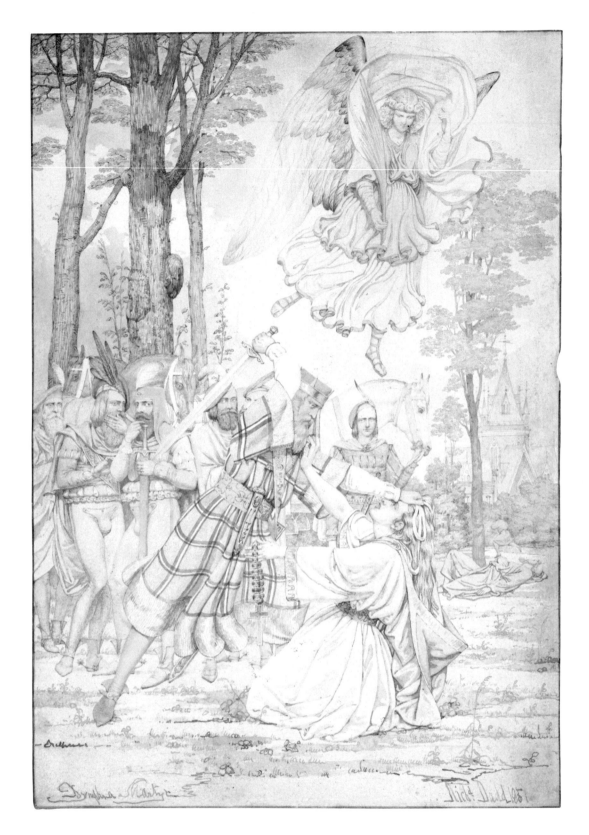

52
Dymphna Martyr 1851
Pen and watercolour on
paper 36.2 x 26
The Huntington
Library, Art Collections,
and Botanical Gardens.
Gilbert Davis Collection

53
Mother and Child 1860
Oil on canvas
48.3 x 30.5
Private collection

influenced by motives that other men pride themselves in possessing'.[8] Dadd seems
to have had little capacity for taking an interest in the people around him, unable
as they were to see the world as he saw it. Here is the second possible way into the
problem of relating Dadd's imagery to his inner life – through his loss of a shared
human scale. In his *Madness and Modernism*, Louis Sass suggested that the art of
people with schizophrenic-type symptoms is often characterised by the loss of the
conventionalised, but apparently naturally human, 'middle distance' of everyday

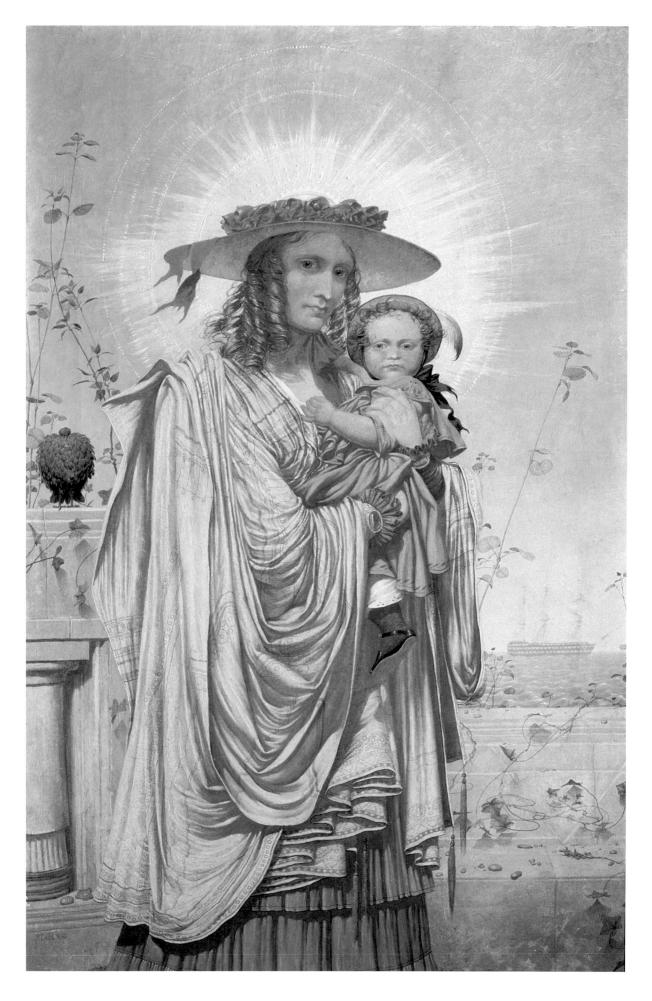

life.[9] It appears to attend to miniature and epic qualities more comfortably than to a recognisable human scale. In Chapter Three, it was suggested that Dadd's abandonment of naturalistic landscape conventions had to do with his belief in the role of spirits in picture-making. His lack of a public audience whose conventions of scale he had to respect was another factor in eliminating such traditions. So without necessarily accepting this tendency as being a general feature of 'the art of the insane', we can nevertheless often apply it to Dadd's art.

In several of those landscape watercolours in which the artist's own memories are evoked (sometimes with the help of the little sketchbook he retained from the 1842–3 tour), Dadd uses the most minute touches and finishing while simultaneously managing to evoke great expanses of space. *Reminiscence of Mountain Scenery in Caria* 1857 (Yale Center for British Art) is a good example, as are the *Reminiscence of Venice* 1858 (fig.54) and *A Dream of Fancy* 1859 (private collection). Above all, in his depiction of the sea, Dadd manages to suggest something both delicate and vast, as in the Venice scene and *The Pilot Boat* 1858–9 (Tate). The most powerful of all Dadd's landscapes in this epic-miniature mode, however, has to be *Port Stragglin* 1861 (fig.55), an invented landscape 'not sketched from Nature' in which 'The Rock and Castle of Seclusion' tower impossibly over a port harbouring magnificent, microscopic sailing ships. These images appear to exclude the human dimension – literally, in that people form no

54
Reminiscence of Venice
1858
Watercolour on paper
20.1 x 28.3
Laing Art Gallery,
Newcastle

55
Port Stragglin 1861
Watercolour, pen
and ink and wash on
paper 19.2 x 14.3
British Museum,
London

important part of their compositions, but also in terms of their scales of reference, which work, as it were symmetrically, on either side of the human scale.[10]

When Dadd does represent figure subjects unrelated to the drawings he still had with him in his sketchbook, he more often adopts a style like that seen in the Aesculapius watercolour that I have compared to prints, with their clear lines and flat spaces, and the sense of emotional distance that a printed (that is, multiplied or manufactured) image implies. Normally we would reach for the term 'genre' to describe such images of ostensibly human interest but, leaving aside the *Passions* series, Dadd's human stories seem especially opaque. Genre scenes typically require substantial audience participation for their interpretation – they need to be actively read – and without an audience the meanings of images such as *Juvenile Members of the Yacht Club* 1853 (fig.57) or *A Curiosity Shop* 1854 (fig.56) refuse to take shape. There was no one to query why figures in these pictures should wear, respectively, a ruff collar or spurs. Once Hood arrived, however, the question arises: did *he* constitute an audience, and if so did this allow new, more objective meanings to establish themselves in Dadd's work?

Hood was still in his twenties when appointed resident Physician-Superintendent of Britain's most famous lunatic asylum. He was too young to have established

a reputation as an academic writer on insanity, but had proved his complete
commitment to the non-restraint ethos as head of the public asylum at Colney
Hatch in North London, opened in 1851 as the Second Middlesex County Asylum.
Conolly's Hanwell, the original Middlesex asylum, was Hood's model. In his brief
time at Colney Hatch, Hood placed himself firmly in Conolly's slipstream, and
furthermore aligned himself with the Lunacy Commissioners in expressing doubt
regarding the existence of monomania (see Chapter Three).[11] Once appointed

to Bethlem, his mission was clear: to bring that ancient institution unequivocally into line with accepted best practice in the public asylum system. This he set about vigorously, making many material and conspicuous changes to the appearance and regime of the hospital, including the completion of the abolition of restraint, allowing more light into the building, instituting trips out to places such as Kew Gardens and the National Gallery for the most trustworthy patients, and lecturing to medical students (although this last initiative did not survive long). Living at the hospital himself and ceaselessly busy about its daily life, Hood soon appeared the living embodiment of the utopian asylum director envisaged by the Scottish alienist W.A.F. Browne in his book *What Asylums Were, Are, and Ought to Be* (1837). Later a pioneer of the promotion of painting among his patients, Browne's imagined asylums of the future were described by a reviewer of his book as being happily autonomous 'miniature worlds'.[12]

Browne and other writers on the reformed asylum spoke of the superintendent as a feudal lord overseeing the welfare of his subjects, attending to 'the most minute working of the great moral machine' of their hospital.[13] Wary of the ambivalent implications of this rhetoric, modern historians of the Victorian asylum have shown how some of the initiatives of figures such as Hood were undeniably 'humane' but at the same time also intent on securing the asylum doctor's further control over the patient. A good example, in the case of Bethlem, was the recording of casenotes, a job badly neglected in the past. Hood now made sure all patients had their conditions and symptoms described, one result of which, as Akihito Suzuki has argued, was that the hospital effectively took greater control of the patients' histories and henceforth placed less emphasis on information received from the sufferer's family and friends, who were thereby politely relegated to the position they occupy in the Conolly testimonial centrepiece – bystanders awaiting the benevolence of the physicians.[14] Hood lost no time in using his newly improved record-keeping as part of his campaign to promote his reforms. In the hospital's Annual Report for 1853, he printed an example of his own case histories of that year alongside a grisly report from 1808 detailing the cruel treatment of an earlier patient at the hands of, it seemed, almost everyone around her.[15] This dramatic comparison was in turn picked up by the writers, both journalists and specialists, for whom Hood was an excellent story.[16] In Dickens's periodical *Household Words*, Hood's little kingdom was written up in unashamedly emotional terms, the author describing the complete absorption of the lives of the Superintendent and his patients into one another, to the extent that the physician's little children were to be seen playing happily in the hospital's well-tended gardens with some of the lunatics.[17] As it became more closely knit, the Bethlem family thus also became more publicly visible than ever before.

But what was really going on behind the new improved facade of Bethlem? Most of the wards were now lighter and better furnished (see fig.58), but a careful look at patient numbers reveals that the statistical background to Hood's tenure was the hospital's shift of emphasis to a long-stay institution. Hood prided himself on the rate of recovery among the 'curables' (who after twelve months were still either

108

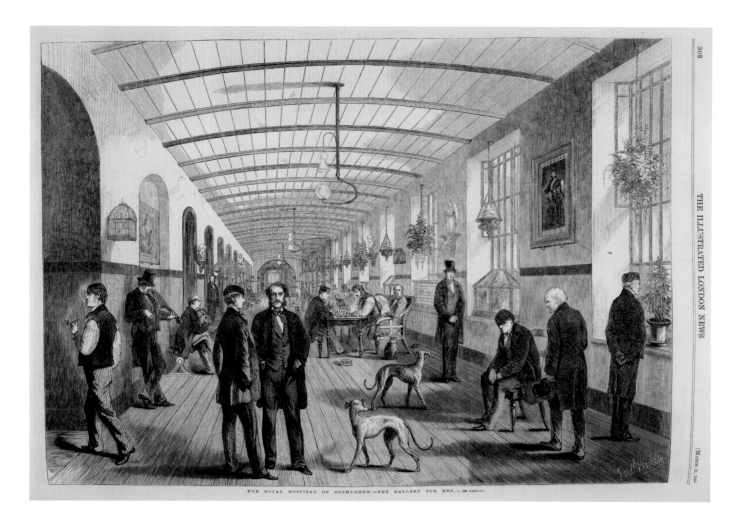

THE ROYAL HOSPITAL OF BETHLEHEM.—THE GALLERY FOR MEN.—(SEE PAGE 311.)

58
Male Ward at Bethlem,
Wood engraving in
Illustrated London News,
1860
British Library,
London

discharged or moved to the wards for 'incurables'). But in 1852, for the first time, the curables formed a minority within the average number of patients resident in the hospital at any one time. From this point on, they were outnumbered by the combined numbers of incurables and the criminal lunatics, Dadd of course still featuring among the latter, whose dedicated wards remained unreached by Hood's reforms for several years.

This was the context for Hood's most ambitious initiative of the 1850s: his explicit policy of making Bethlem more bourgeois. The overall population of the hospital was in decline at this period on account of the new county asylums, such as Colney Hatch, taking in many of the paupers who would otherwise have come to Bethlem. So Hood envisaged an asylum of modest scale offering respite to the mentally afflicted of the self-made classes, the highly skilled artisans and the poorly remunerated professionals, who were unsuited for the pauper houses but could not afford private care.[18] Hood became highly conscious of the social, educational and professional backgrounds of his patients, carefully tabulating this data among his many other statistics, and lunatics of gentle origin featured strongly in the imagery of his reformed hospital. Andrew Wynter, editor of the *British Medical Journal*, described musical parties and suchlike, at which 'Clergymen, barristers, governesses, literary men, artists, and military and naval officers make up the staple of the assembly'.[19] But, while there were indeed very many governesses among

the Bethlem patients, the hospital records do not bear out the suggestion of the place being overrun with artists, and in fact Dadd remained the only artist of any reputation to reside there in this period. (Although by the early 1860s there was a patient in the criminal department named John Thompson, a former factory hand, who 'employs the greater part of the day in drawing rude figures of which he is very proud, and styles himself the Artist of Bethlem', which was rather presumptuous given Dadd's presence there at the time.)[20] Nevertheless, the *idea* of Bethlem housing clergymen and artists was rhetorically important to Hood's image. In 1852, immediately prior to Hood's arrival at Bethlem, the hospital found itself charged with the care of the great Gothic Revival architect A.W.N. Pugin, driven to illness by his work on the new Houses of Parliament. There was a public outcry that such a man should be thrown upon charity in these circumstances, and he was soon removed to private care.[21] This spectacle of Bethlem being denounced as shameful to the reputation of a major artist must have encouraged Hood in his decision formally to reshape Bethlem's social make-up.

What then of Dadd's place in this new scheme of things? Even Hood's most vocal champions regretted that the criminal blocks remained as dismal as ever, and that Dadd was still 'obliged to weave his fine fancies on the canvas amidst the most revolting conversation and the most brutal behaviour'.[22] Hood got around to writing up his impressions of perhaps his most notorious patient on 21 March 1854.[23] He noted Dadd's delusions regarding spirits, his incoherence when talking of them or of the cause of the death of his father, and that 'he pays no sort of attention to decency in his acts or words, if he feels the least inclination to be otherwise; he is a perfectly sensual being, a thorough animal'. Nevertheless, concluded the Superintendent:

> With all these disgusting points in his conduct he can be a very sensible and agreeable companion, and shew in conversation, a mind once well educated and thoroughly informed in all the particulars of his profession in which he still shines and would it is thought have pre-eminently excelled had circumstances not opposed.[24]

Hood seems eager to present himself as so sympathetic a physician that he could see the best even in a patient showing such challenging behaviour as Dadd. He almost appears to be describing a monomania in his account of Dadd's conversation losing its plot specifically when touching on spirits, but we have seen that Hood preferred not to use that category. Hood's interpretation of madness emphasised its moral basis to a greater degree even than was standard in the 1850s. For him, insanity was a perversion of the whole personality, not only a physical illness or a derangement turning on an *idée fixe* (although madness might be precipitated by a specific event or anxiety.)[25] He saw conversing with the patient as a fundamental aspect of treatment, not with a view to teasing out lurking delusions, and certainly not in order to contradict these should they appear, but rather to help lead the patient's mind gradually back towards healthful thoughts and to concerns beyond their own situation.[26]

Given his position as the youthful patriarch of Bethlem, it was predictable that Hood should soon become resentful of the only part of the hospital that was not his to control – the criminal blocks, which remained under the direct management of the Home Office. Hood was determined that his new, respectable writ should extend even there. The criminal lunatics at Bethlem comprised not only patients such as Dadd, whose crimes were accepted to have been the result of illness, but also convicts who had become mentally ill whilst serving time in regular prisons. Hood was convinced that most of this latter class were faking in order to escape the hard work of a prison regime for the much gentler life at Bethlem, which, so he claimed, they referred to as 'the Golden Bank'.[27] Taking advantage of the great reputation he had acquired for his humane work at Bethlem, in 1857 Hood was allowed to split up the two groups. The convict malingerers (as Hood saw them) remained in the bleak criminal block, but those who had been respectable until struck with insanity were moved to a larger, brighter – but still fully secure – ward in the main hospital. As Hood himself described it, this ward was well furnished and equipped with its own collection of books 'and various other means of amusement … It is moreover light, airy, and cheerful; its walls are decorated with prints and flowers, and its galleries are enlivened by the song of many birds'.[28] Therefore, from 1857 until Dadd's departure from Bethlem seven years later, his immediate environment was enormously improved. At some point during this period he made the touchingly sensitive portrait of the attendant in charge of his new ward,

60
The Child's Problem 1857
Watercolour and
pencil on paper
17.1 x 25.4
Tate

61
Dadd's *Good Samaritan*
in situ at Bethlem
Hospital (late
nineteenth or early
twentieth century
lantern slide)
Bethlem Royal
Hospital, London

John McDonald (fig.59), in which the miniaturist's stippling he normally used for remembered landscapes was for once deployed in a naturalistic portrait.

Notwithstanding the empathy apparent in this image, it seems Dadd's mental isolation was not breached. In the only other descriptive casenote added to the notes he had entered in 1854, Hood wrote in 1860 that 'He associates very little with other patients but is generally civil and well-behaved to them. His mind is full of delusions'.[29] This makes Dadd sound rather worse than he had been in 1854 when his delusions were described as showing themselves only in the context of talking about the work of spirits. There is in fact other evidence that Hood did not believe Dadd's condition had improved during his superintendency, even perhaps that Hood had in some way become wary of his agreeable companion. Four times a year Hood was required to make summary reports to the Home Office regarding the criminal lunatics in his care. In these lists, from 1856 and for the remainder of his time at Bethlem, Dadd was listed as being 'Dangerous', one of only two or three so described in any one report.[30] All the criminal lunatics were of course supposed to be dangerous, hence their being put permanently away, and so to single out Dadd in this way may seem hard to explain. By this time, 1856–7, Hood had become something of a collector of Dadd's art. Either through commission or gift, Hood came to own at least thirty-three of his works.[31] The contradiction within this extraordinary relationship was that Dadd became labelled with this new, compromising designation by the doctor who, on the face of things, was the greatest champion of his art.

Around the time that Dadd was transferred to the new, more comfortable ward, Hood joined in the vogue among his colleagues for photographing his patients. Henry Hering, the fashionable Regent Street portraitist, was invited to Bethlem and patients of all kinds sat to him.[32] Occasionally the patients are shown with some attribute indicating their former professions. Captain Johnston, for example, is holding a sextant (fig.39, p.74), and Dadd (fig.1, frontispiece) is shown at work on the picture he painted for Hood, *Contradiction: Oberon and Titania* (fig.68. pp.124–5). The photograph seems emblematic of this particular doctor-patient relationship. Dadd is shown entirely isolated except for the creative outlet provided by Hood; the doctor allows him still to be an artist, and makes available to him the best accommodation any humanitarian could desire for a criminal lunatic. But we know that, to leave no room for doubt that this clever, sensitive man must remain isolated, the doctor has insisted that he be designated as 'Dangerous'. Dadd's skills as a painter are celebrated in Hering's portrait, but he was a painter now without a formal audience. Hood indeed shrank Dadd's remaining audience yet further by

restricting the movement of his works. In 1856, Alexander Morison, by now in retirement but still actively interested in Dadd, was told that no more of Dadd's pictures would be allowed to leave the hospital.[33] And yet, although the display of patients' art was common enough in asylums – at Colney Hatch for example – neither does it seem that Dadd's work was displayed publicly within Bethlem itself.[34] The only exception to this was the large painting of *The Good Samaritan* (see fig.61, p.113) that Dadd painted for the main staircase of the hospital, an image of course celebrating the magnanimity of the caring professions. One key reason, then, why so many of Dadd's works ended up in Hood's 'collection' was that there were now few other places for them to go.

To judge from Dadd's surviving oeuvre, his work was given a significant boost by Hood's arrival at Bethlem. The artist began to produce far more figurative watercolours of modern British life than previously, with a great range of themes far beyond the memories recorded in his Middle Eastern sketchbook. In addition to the *Juvenile Members of the Yacht Club* (fig.57) and *A Curiosity Shop* (fig.56) already mentioned, there were images as apparently conventional as *The Ballad Monger* 1853 (British Museum) and as original and difficult to interpret as *The Child's Problem* 1857 (fig.60, p.112). Several of these works include children or youths, shown halfway between naughtiness and malevolence, possibly indicating something of Dadd's sense of how he was perceived by Hood. More clearly connected to the two men's relationship was the long series Dadd made of *Sketches to Illustrate the Passions*. There were thirty-two of these watercolours, begun in 1853 and completed in 1857, and Hood owned precisely half of them.[35] The *Passions* (as we can call them for short) purport to give examples of harmful emotions, characteristics and experiences, for example *Jealousy* 1853 (Yale Center for British Art), *Melancholy* 1854 (private collection) and *Treachery* 1853 (fig.62). Some borrow existing stories, from Shakespeare for instance, while others are entirely Dadd's inventions. Their range of subjects, and the way they mimic a sort of treatise on the pathology of the emotions, must surely reflect the efforts that had been made for decades by asylum doctors to categorise insanity and its causes.

One way of conceiving the whole moral therapy approach was as a means of bypassing the confused intellect of the patient and working instead on his or her emotions or motivating passions. The passions had classically played the role of the conduit between the soul and the body. Within nineteenth-century asylum medicine, the passions took on an urgent new role as the potential bridge between the split aspects of a patient who had become alienated from him- or herself. As Gauchet and Swain put it, for Pinel and Esquirol, 'Passions are the central truth of a two-faced being'.[36] In France, the monomanias were evolved from the classical repertoire of the passions, and it was assumed that, if the passions could lead to insanity, then they might also be the route out of it.[37] Hence the interest that attached to cataloguing the passions involved in precipitating madness, an aspect of asylum statistics pioneered by Esquirol, whose 1835 table of causes of insanity includes *onanisme* (masturbation), *passion de jeu* (addictive gambling) and even *lecture de romans* (reading novels).[38]

62
Sketch to Illustrate the Passions: Treachery
1853
Watercolour, bodycolour and pencil on paper 36.5 x 25.7
Yale Center for British Art, Paul Mellon Collection

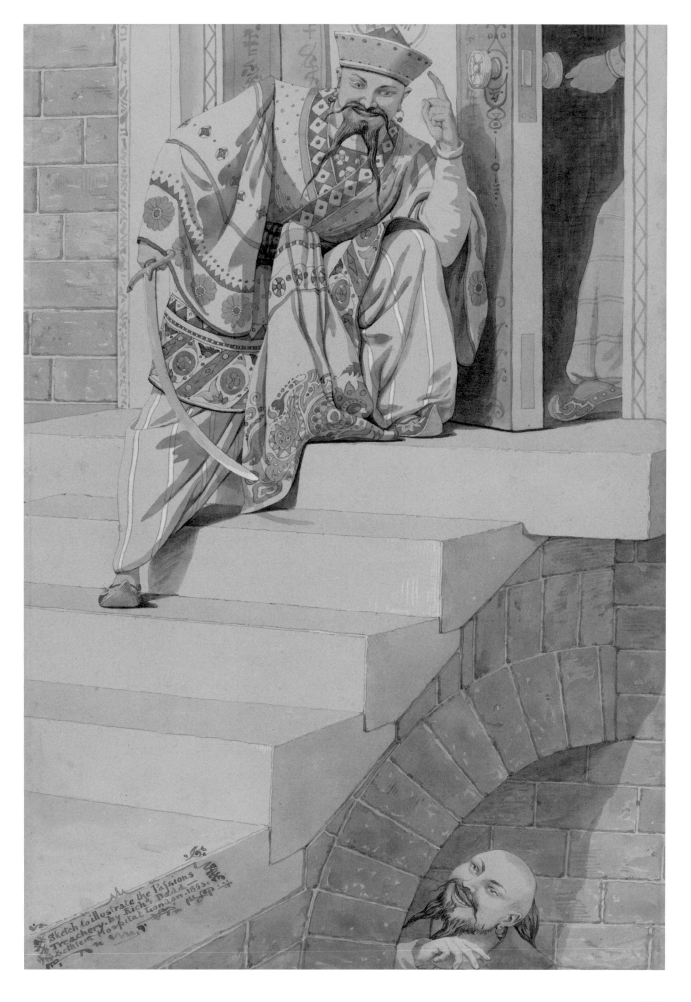

Sketch to illustrate the Passions
Treachery. by Rich.d Dadd.
Bethlem Hospital London 1853.

When Broadmoor Criminal Lunatic Asylum opened in the 1860s, among the causes given in patients' casenotes were Intemperance, Vice, Poverty, Religious Excitement and Exposure to Hot Climates.[39] As for Hood himself, his 1862 table of the causes of insanity includes Fright, Jealousy, Sudden Prosperity, Coup de Soleil and Onanism.[40] There is something inherently amusing about these lists – their effort to compress complex reality is absurd – and certainly several of Dadd's *Passions* are

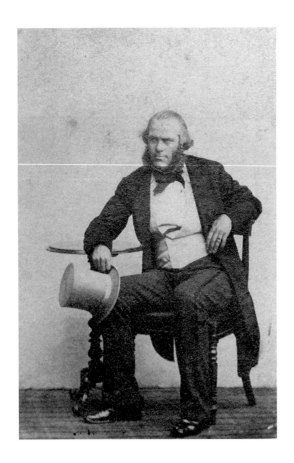

comic. *Love*, for example, is a take on the balcony scene in *Romeo and Juliet*, in which, until the composition is carefully read, the distraught Nurse appears to be sitting on Romeo's face (1853; Yale Center for British Art), or *Treachery*, which features pantomime Oriental figures. Other of the *Passions*, however, seem more sincerely contemplative, such as *Deceit or Duplicity* 1854 (Bethlem Royal Hospital, London) and *Grief or Sorrow* 1854 (fig.63, previous page).

The *Passions* are executed in the print-like character of the Aesculapius drawing, explicitly composed with solid lines and an uncomplicated use of colour. Many of the *Passions* specifically seem to emulate aquatints, a tonal method of etching once common in book plates, and this quality further implies their role as pseudo-scientific illustrations. It also perhaps better qualified them as decorations in the Superintendent's house at Bethlem, for there it seems Hood hung only prints (other than the pictures by Dadd he came to own), and very conventional ones at that – portraits of the great and the good, and historical and genre scenes after popular artists such as Wilkie, Millais and Edwin Landseer.[41] So what was the most likely origin of the *Passions*? Is it feasible to imagine Hood as in some sense their patron? As we have noted, Hood's understanding of madness was essentially moral and affective. Committed absolutely to moral therapy, he believed in the talking cure and in patients doing useful work to help bring their attention more firmly back to the world about them. He saw it as counterproductive simply to contradict patients' delusional beliefs and thereby terminate any conversation. But on the other hand he attached no special significance to the content of delusions. The age of belief in the spontaneous eruption of suppressed autobiography lay in the psychoanalytic future, and so therefore also did the age of art therapy, which was developed only in the 1940s in the wake of the success of Surrealism in yoking art with analysis.[42] There is no explicit evidence of Hood commissioning works by Dadd. The Superintendent has long been identified as the sitter in the 1853 *Portrait of a Young Man* (fig.64, previous page) with its imagined garden setting, fez and monster sunflower. But the fact that the portrait did not appear in the sale of Hood's modest art collection must cast doubt on this.[43] Hood must have at least sanctioned, if not commissioned, Dadd's *Good Samaritan*, which, in its role as Bethlem's public artwork, was in effect a replacement for Cibber's statues, which were sent off to the South Kensington Museum (the V&A) in 1858, having come to be seen as anachronistic and even frightening.[44] What we know for certain of Hood's involvement with Dadd's art is that the hugely ambitious painting

Contradiction (to which we will turn shortly) was painted for him. Otherwise this patient seems to have been caught in a classic asylum 'double bind': yes, Dadd should paint, because he was a painter; but no, his pictures should not be shown, sold or discussed. In other words, Hood liked the idea of a painter-patient, but was at a loss as to how to control his art.

To help us make further progress with this question of Dadd's interaction with the new regime at Bethlem, it will help to look at the artist's relationship with the man appointed Bethlem's Steward in 1853, George Henry Haydon (fig.65). Critics of the changes instituted at Bethlem from 1852 complained that anyone expected to live permanently at the hospital and take on its entire management would have to be 'some modern Goliath'.[45] And this is indeed what Bethlem got in Haydon, a large and powerful man who in his teens and early twenties had spent five years in Australia, turning his hand to all sorts of jobs including teaching drawing in Melbourne.[46] After returning to his native Devon in 1845, Haydon had become Steward to the County Asylum at Exminster where the Superintendent was John Charles Bucknill, one of the leaders of the emerging British psychiatric profession. Together they set up the first citizens' volunteer rifle corps, an initiative characteristic of Haydon's physical vigour and tireless clubbability. After his move to London, he was to become a prominent freemason, a barrister (purely through social connections at the Inns of Court) and a close friend of several of the leading comic graphic artists of the day including John Leech and Charles Keene. Haydon himself contributed drawings to *Punch*.[47] He may have introduced Dadd to the wonderfully original cartoons in that magazine, for sometimes Dadd's watercolours have something of their flavour.

Hood and Haydon formed a perfect professional double-act. If Hood was the patriarch, benevolent but controlling and statistically minded, then Haydon was the indulgent uncle, the larger-than-life figure always to be found at the centre of any jollification, and apparently interested first and only in people. In the humorous illustrated manuscripts that Haydon was fond of making, he was even ready to poke fun at the epic red tape and form-filling generated by the modern asylum system. This is his transcription of Circular no.2186541, supposedly received from the Lunacy Commission in 1858:

> Wanted – by return of post. An immediate return of all other returns, specifying all those not returned, and those not likely to be returned and the dates when ordered. State also who was who, what what, and which which, & why this was and when; also if either was which and which was who and whether they were the others or somebody else was nobody, how long everybody else has been insane, who discharges the remainder, with other like or dissimilar particulars. Specify particularly their present state of mind and your own condition.[48]

The joke about 'your own condition' turned out to be rather closer to home than Haydon could have realised at the time. In 1866 his sister was admitted to Bethlem

and remained there until her death.[49] Haydon himself filled the post of Steward until 1889, dying two years later.

Haydon's family added a further circle of artistic acquaintance to the Steward's house at Bethlem. His brother Samuel was a sculptor and later a print dealer and friend of Dante Gabriel Rossetti.[50] The Pre-Raphaelite recluse apparently enjoyed talking over art-historical stories with him. The Haydon brothers'

father had evidently shared these interests, and in the 1840s had corresponded with the history painter Benjamin Robert Haydon regarding possible shared ancestry (no close relationship was established although both families were Devonian). B.R. Haydon's family competed in tragedy with the Dadds. The artist himself, having spent a furiously frustrated life failing to interest the aristocracy in his epic canvases, committed suicide in 1846. One of his sons, his biographer, was admitted to Bethlem in 1884 and died there in 1886; the other took his own life the following year. Perhaps it was the coincidence of family name that prompted George Henry Haydon to obtain for Dadd a copy of B.R. Haydon's pompous *Lectures on Painting and Design* of 1844. Dadd made many pencil annotations in the book, which G.H. Haydon subsequently considered interesting enough to reinforce in pen.[51] The staccato little texts delight in sparring with the opinionated Haydon, and occasionally digress to offer some intriguing insights into Dadd's thinking on art.

I have already quoted from the Haydon annotations in Chapter Three, where we saw that Dadd sympathised with the ancient popular belief that every person's actions were fought over by a pair of competing spirits or genii, and that Dadd's understanding of the role of these agents in influencing human behaviour made nonsense of the romantic or expressionist notion of the independent artist with his uniquely sensitive personality. 'The double nature of human beings,' wrote Dadd, 'was known to the Ancient Greeks among whom the Genius was as familiar as Christ with us. The two natures were supposed to be always contending for mastery.'[52] And, objecting to Haydon's claim that painting should be considered a science, not a mystery in which to be initiated: 'I am of opinion that there is a great deal of secret in the matter and that it is explained by one's own second self which is perhaps as obstinate and vicious a devil as we could desire to oppose.'[53] Reminded of this perspective, on turning back to Dadd's figurative watercolours of the 1850s, we start to see doubles everywhere. In *Robin Hood* of 1852 (fig.66), we find two Robins. There are twins in *Treachery* and the *Juvenile Members of the Yacht Club* and also in *Patriotism* (V&A), the last of the *Passions*, a satire on the naval manoeuvres familiar to Dadd from his childhood in Chatham. Do these doubles relate to the split personality generated by the contending spirits? Is Dadd once again finding a parallel between an ancient myth and a modern medical paradigm – the 'central truth of a two-faced being'? Certainly, when they appear in the *Passions*, the doubles seem to add to the apparent satire on psychiatric explanations of madness. Which of the characters is conceiving the passion? Which is the person being classified? The rather blank, static or caricatured expressions on the faces of the figures in the *Passions* press this point yet further.[54] Esquirol and Morison had believed in using physiognomy and facial expression to help categorise madness, just as of course these had long been used to define the passions for artists. Anecdotes were told in the 1840s of Dadd teasing the artist Charles Gow when he visited Bethlem to sketch the heads of patients to illustrate Morison's research.[55] In the 1850s Conolly and the other leaders of the non-restraint movement embraced photography as an improved means of carrying on this work, and Hood's commissioning of Hering was above all another aspect of his urge to

122

survey and classify. But the people in Dadd's *Passions* resist any such physiognomic analysis, while in an undated sheet bearing G.H. Haydon's initials (fig.67, overleaf), Dadd squeezes a couple of dozen heads into a single space as if defying the viewer to separate them tidily.

Hood had remarked in Dadd's casenotes that the patient became incoherent when talking of spirits, and in his notes to Haydon's *Lectures*, Dadd does indeed seem to exasperate himself when thinking through the question of the influence of spirits on art. Here he is wondering how spirits, attached in some way to the subject matter of a picture, might interact with the artist's genii:

> In reflecting on this the argument becomes so complicated and difficult that only superhuman characters could speak with precision. The genius producing might be the victim of his work and the principles represented – supposing the principles to have any effect at all – as to say that in representing Alfred we have all the Saxon angels of his time and of his kidney at work upon our spirits and angels like – and to what end? – we may ask – and ask in vain for who will give his knowledge and experience for nothing and if you get it at that price might it not change to a serpent.[56]

Sometimes he appears defeated by the powerless situation he finds himself in: 'What is there more thankless, more hopelessly stupid, more desperately wicked than a parcel of slaves, and what more slavish than painting, what more hopeless?'[57] Painting may have felt to Dadd like the experience of playing chess with oneself, as represented in *The Child's Problem* (fig.60, p.112). In the background of that picture is the emblem of the Anti-Slavery Society with its motto, 'Am I not a Man and a Brother?' If there seems to be an ironic element to much of Dadd's work of the 1850s, this was perhaps born as much from his own sense of art's slavery as from any confident 'answering back' to the discourses of asylum medicine.

If I have been sounding sceptical about the claims of Dr Hood to be considered Dadd's patron in any comfortably magnanimous way, then *Contradiction: Oberon and Titania* (fig.68, overleaf), painted between 1854 and 1858 'for W.C. Hood, Esq.re MD. &c.', takes some explaining. It was by a long margin Dadd's most ambitious painting since the early 1840s, and its only rival, *The Fairy Feller's Master-Stroke* (fig.74), was painted for Haydon after he had admired *Contradiction*. The subject, from *A Midsummer Night's Dream*, returns to the artist's glory days, but in its complexity, detail and invention, leaves even Dadd's early fairy masterpieces standing.

The contradiction of the title is the battle of wills being fought between the King and Queen of the fairies, Oberon and Titania, over the prize of the Indian boy whom Titania has adopted but whom Oberon desires as his 'henchman' (see Chapter One). Titania takes centre stage, her boy bringing up her skirts, with Oberon on the left apparently being restrained by an elfish servant (if this is Puck then Dadd has given a very different characterisation to that of his

68
Contradiction: Oberon and Titania 1854–8
Oil on canvas
61 x 75.5
Private collection

painting of 1841, fig.13, p.28). On the right stand one of the pairs of lovers whose confusions twine through the play: Helena leans upon the shoulder of Demetrius, whom she is pursuing, despite her love for him being unrequited. They seem to be awaiting their cue to enter, which follows upon Titania's storming off and Oberon's instructions to Puck to obtain for him the flower whose juice 'Will make or man or woman madly dote/ Upon the next live creature that it sees'. The King intends to use this to punish his Queen, but also to force Demetrius to return Helena's love. This flower able to produce erotic delusions was 'love-in-idleness' – Heartsease or the purple wild pansy. But in the centre of his picture Dadd has painted his old favourite, a kind of convolvulus, here it seems a Morning Glory.

Throughout the image, especially around the periphery of the oval canvas, a saga of minute micro-narratives is being enacted, as lesser beings – fairy-sized warriors, centaurs and bacchanalians – play out their little dramas in contrast to the tense stand-off among the lead players. The impression is of a series of plunging registers of scale, each appearing extraordinarily delicate until yet another new layer of miniaturised life is discovered beneath it. Offering some sense of overall structure is the sequence of plinths or platforms in the centre-middle ground, echoes perhaps of the displays at the Great Exhibition of 1851, which was universally covered in the illustrated press. Dadd appears from time to time to have let off a little of the steam that must have built up while working on the picture by writing graffiti-like comments on the back of the painting, most now sadly almost entirely illegible.[58] He seems to have been playing with language rather than trying to explain anything, as in the Latin inscription on *Bacchanalian Scene* 1862 (fig.69).[59]

By the mid-1850s fairy painting was a well-established genre in academic art and, as Allderidge suggested, Dadd may well have known (through engravings), and even wanted to compete with, recent illustrations of the *Dream* by Robert Huskisson and Joseph Noel Paton (see fig.71, pp.130–1).[60] But Dadd's picture, as a composition, has decidedly left academic, public painting behind. Dadd had no public beyond Hood, Haydon and perhaps a few others, and so had no need to obey the basic rules of composition, which required the knitting together of a convincing three-dimensional space with a surface pattern of balanced weights of light and shade. *Contradiction* abandons that tradition, relating instead to an invented world without stable proportion. It resembles the view – or rather a series of views – through a microscope, but at the same time it feels like something vast, perhaps a Baroque ceiling painting of apparently infinite depth in which some tremendous but mysterious central scene morphs around the edges into a busy flurry of centrifugal activity.[61] Dadd has also left behind the kind of unified setting required by an audience. The clothing is vaguely classical, as befits the Athenian locale of the play, but it resembles designs for theatrical costumes free of the constraint of ever having to be made. As for the characterisation of the principals, the hook-nosed Oberon might have come over from *Flight Out of Egypt* (fig.46, p.93), while Titania is evidently a deliberate alternative to the nubile living sculpture that conventionally stood for the female form. Her more-than-matronly figure is made the point of one of the picture's micro-jokes, as dainty fairies flee

69
Bacchanalian Scene
1862
Oil on wood 35.6 x 24.1
Private collection,
on loan to Tate

her mighty footfall. The strong facial features that Dadd has given this Titania bear some resemblance to those of his male personification of *Agony – Raving Madness* 1854 (fig.70), one of the *Passions* and clearly a deliberate reprise of the iconography of one of Cibber's twin sculptures (fig.34, p.69). Both faces may have been based on a Bethlem patient or officer.

When travelling with Thomas Phillips, Dadd had admired the physically stronger, active women he had seen; 'feminine beauty' he attributed instead to the young men of the Eastern Mediterranean.[62] There are no reliable stories of any romantic attachments to girls at home before his illness. Once at Bethlem, Dadd's contact with women would have ceased entirely. Even those rare occasions when the sexes might meet, such as at chapel or the odd entertainment, would have been either repugnant or off limits to Dadd. In *The Music Lesson or the Governess* 1855 (Yale Center for British Art), however, Dadd seems to refer to the category of professional women notoriously well represented as patients at Bethlem.[63] So with no women to draw or paint from, did he simply perhaps lose track of their anatomy, rather as his drawing of animals becomes distant from the real originals?[64] In Dadd's version of the archetypal modern madwoman, *Crazy Jane* 1855 (fig.72, p.134), a decent ordinary girl driven to distraction after being abandoned by her lover, he appears to have used – as perhaps for Titania in *Contradiction* – a male model.[65] In other watercolours of the 1850s where women are the central characters, they tend much more to the powerful heroine mould than to the pretty young girl.[66] The great exception is *Columbine* 1854 (fig.73, p.135), Dadd's version of the great literary icon of female madness, Ophelia.[67] Her head entwined with convolvulus, and a lead line (used by sailors to measure sea depth) trailing over her shoulder, this figure might be a posthumous version of the sickly looking *Young Lady Holding a Rose* that Dadd had painted in 1841 (fig.8, p.18), glassy-eyed after her resurrection from a watery grave.

To return to Titania in *Contradiction*, she has been made the central motif of the painting, for the fate of the fairy world, so insists Oberon, depends on her response to his demand. Since the royal couple's falling out over custody of the adopted child, all of Nature has gone awry. Titania describes how spring showers have become downpours flooding the landscape, causing crops to rot and animals to starve, while humans feel they are enduring a deadened landscape with none of the compensating pleasures of Yuletide. Nevertheless spring shows itself alongside this artificial winter, the seasons grotesquely simultaneous:

> And through this distemperature we see
> The seasons alter: hoary-headed frosts
> Fall in the fresh lap of the crimson rose;
> And on old Hiems' [winter's] thin and icy crown,
> An odorous chaplet [wreath] of sweet summer buds
> Is, as in mockery, set; the spring, the summer,
> The chiding autumn, angry winter, change
> Their wonted liveries; and the mazed world,

70
Sketch to Illustrate the Passions: Agony – Raving Madness 1854
Watercolour on paper
35.5 x 25.3
Bethlem Royal
Hospital, London

71
Joseph Noel Paton
The Quarrel of Oberon and Titania 1849
Oil on canvas 99 x 152
National Gallery of Scotland, Edinburgh

By their increase, now knows not which is which.
And this same progeny of evils comes
From our debate, from our dissension;
We are their parents and original.[68]

Dadd seems to conjure up this surreal situation, setting his scene in the context of a wonderfully elaborate *nature morte*, a still-life that might have been kept in a box for a year before being painted. The only lively looking things, other than the human and fairy beings, are the butterfly, the wilting Morning Glory and the green egg at the top of the picture – emblems of the brevity and cyclical patterns of life (in popular myth the butterfly lives for just a day, like the flowers of the Morning Glory). But over the whole of the composition are drops of moisture – the dewdrops that Titania's fairies were charged to distribute – which cling to, but are unable to refresh or impregnate the natural world. The cycle of life is suspended (the egg is literally suspended) whilst Titania insists on keeping her changeling boy as if he were a son.

Contradiction and Dadd's painting *The Fairy Feller's Master-Stroke* (fig.74, p.137) have more in common than has been generally recognised. An inscription on the back of the *Fairy Feller* – 'quasi 1855–64' – suggests it took Dadd almost a decade to paint, and it was apparently still unfinished when he was transferred to Broadmoor in 1864. A broad strip of ochre priming can be seen near the bottom of the canvas (although the artist may have liked the impression this gave of a sort of stable foreground for the feller to stand upon). The Hering photograph of Dadd at work on, or rather posing beside, *Contradiction*, was probably taken in 1857 (see fig.1, frontispiece). The picture is shown only about one quarter completed, but we can see that Dadd had drawn out the entire composition by this time. If he really did begin work on that picture in 1854, then it seems the drawing or planning took much longer than the actual execution of the painting. Assuming the same method was applied to the *Fairy Feller*, then the 'quasi' ('sort of') in the inscription probably suggests that his first thoughts for the work dated to 1855 but that it was in fact painted later, perhaps only after *Contradiction* was completed.

Strangely absent from existing accounts of the *Fairy Feller* is the observation that its starting point is again Shakespeare. Here is the speech in *Romeo and Juliet* in which Mercutio imagines a fairy fantasy with which to half entertain, half bully his friend Romeo:

> MERCUTIO O, then I see Queen Mab hath been with you.
> She is the fairies' midwife, and she comes
> In shape no bigger than an agate stone
> On the forefinger of an alderman,
> Drawn with a team of little atomies
> Over men's noses as they lie asleep.
> Her chariot is an empty hazelnut,
> Made by the joiner squirrel or old grub,

Overleaf
72
Crazy Jane 1855
Watercolour on paper
35.5 x 25.4
Bethlem Royal
Hospital, London

73
Columbine 1854
Watercolour on paper
36.2 x 25.1
Private collection

Time out o'mind the fairies' coachmakers.
Her wagon spokes made of long spinners' legs;
The cover, of the wings of grasshoppers;
The traces, of the smallest spider's web;
Her collars, of the moonshine's watery beams;
Her whip, of cricket's bone; the lash, of film;
Her wagoner, a small grey-coated gnat,
Not half so big as a round little worm
Pricked from the lazy finger of a maid.
And in this state she gallops night by night
Through lovers' brains, and then they dream of love;
O'er courtiers' knees, that dream on courtsies straight;
O'er lawyers' fingers, who straight dream on fees;
O'er ladies' lips, who straight on kisses dream,
Which oft the angry Mab with blisters plagues,
Because their breaths with sweetmeats tainted are.
Sometime she gallops o'er a courtier's nose,
And then dreams he of smelling out a suit.
And sometime comes she with a tithe-pig's tail
Tickling a parson's nose as 'a lies asleep;
Then he dreams of another benefice.
Sometime she driveth o'er a soldier's neck;
And then dreams he of cutting foreign throats,
Of breaches, ambuscados, Spanish blades,
Of healths [toasts] five fathom deep; and then anon
Drums in his ear, at which he starts and wakes,
And being thus frighted, swears a prayer or two
And sleeps again. This is that very Mab
That plaits the manes of horses in the night
And bakes the elf-locks [tangled hair] in foul sluttish hairs,
Which once untangled much misfortune bodes.
This is the hag, when maids lie on their backs,
That presses them and learns them first to bear,
Making them women of good carriage.
This is she –

ROMEO Peace, peace, Mercutio, peace!
 Thou talkest of nothing.

MERCUTIO True. I talk of dreams;
 Which are the children of an idle brain,
 Begot of nothing but vain fantasy.[69]

Thus Shakespeare invents Mab (or adapts her from folklore) as the Elizabethan unconscious, compelling shameful desire to show itself through dreams. She is an alternative Queen of the Fairies, slighter and less regal than Titania, and with more

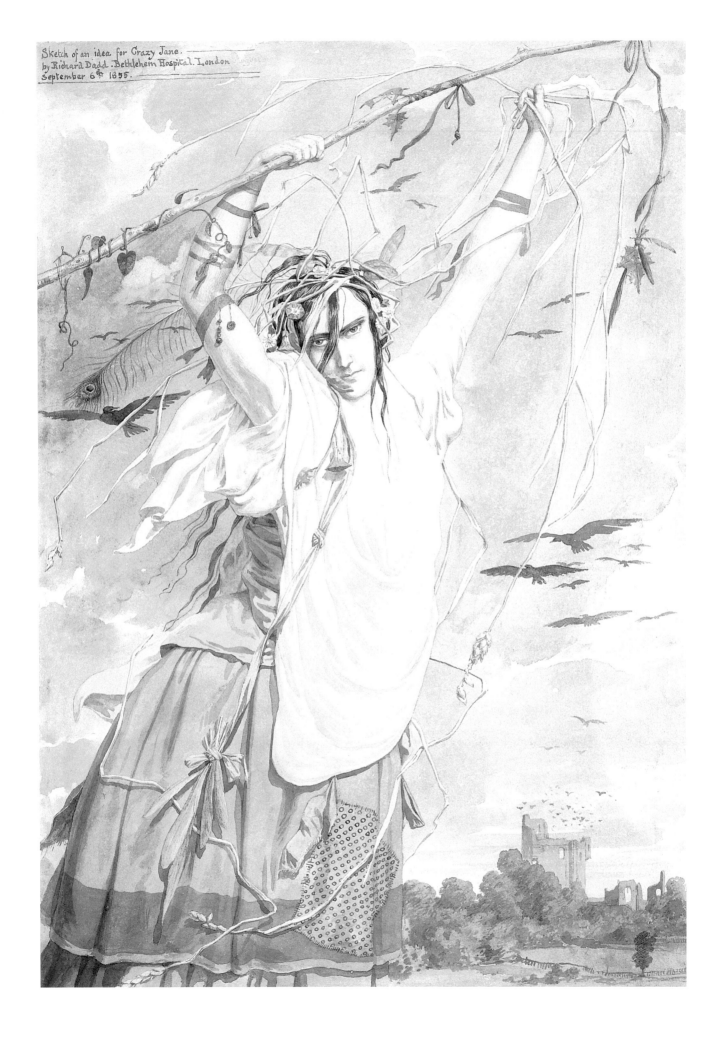

Sketch of an idea for Crazy Jane.
by Richard Dadd. Bethlehem Hospital. London
September 6th 1855.

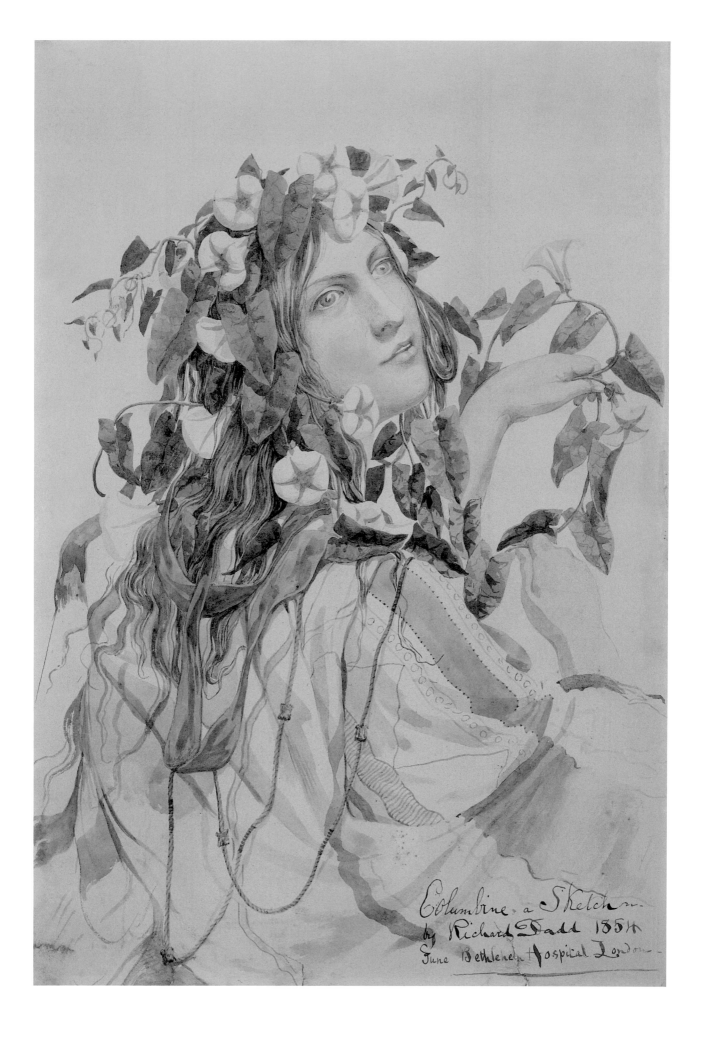

Columbine — a Sketch —
by Richard Dadd 1854
June Bethlehem Hospital London —

than a touch of Puck in her mischievous ways. Bucknill, who had been Haydon's colleague at the Devon asylum and who had written about Dadd's case (see Chapter Three), published a book in 1859 on *The Psychology of Shakespeare* in which he praised the Bard's extraordinary insights into mental pathology. Conolly, too, wrote a book on Hamlet in which the prince was demonstrated to have been tending to lunacy from the opening of the play (so much for wariness of retrospective diagnosis).[70] As we have seen, Dadd uses cases of disturbed minds from Shakespeare to help illustrate the *Passions. Jealousy* 1853 (Yale Center for British Art) is represented by Othello, and *Hatred* 1853 (fig.76, p.147) by Richard III – looking very much like Dadd himself – as the murderer of Henry VI. Shakespeare thus provided a common language of sorts for Dadd and the doctors.

The *Fairy Feller* is not indeed an illustration to Mercutio's famous speech, although this might be said to provide its setting in a miniaturised world in which the mismatching of scale entails, in Susan Stewart's phrase, 'a delirium of description', as each item has to be calibrated anew against its now comically estranged environment.[71] The picture's space is much flatter than that of *Contradiction*, its various incidents spread out across the surface as if for sorting. The sense the painting gives of being a kind of compendium or list, taking its structure from Mercutio's exhausting speech, is emphasised by the long description Dadd wrote of it soon after its completion in a poem – or rather rhymed catalogue – which he titled *Elimination of a Picture & its subject – called The Feller's Master Stroke*.[72] Behind a delicate screen of Timothy-grass, what looks like a miniaturised and flattened mountainside is studded with daisies and plane-tree fruit (according to Charlotte Gere, one tenet of botanic folklore was that 'a decoction of daisy roots could produce diminutive stature').[73] Towards the upper-left of the picture, some kind of magnetic force or inverted gravity pulls the plane fruits into suspension and untangles the grass stalks into straight lines (thus perhaps boding 'much misfortune'). The bottom of the composition is littered with hazelnuts, one of which the fairy feller is about to chop in half to make a new carriage for Mab. The feller (that is, a hewer or a chap) looks rather like another self-portrait, but other than being very small it is not clear in what sense he is a fairy. In fact there are few if any fairies of the conventional types in the picture, despite Dadd speaking in *Elimination* of its being set in a sort of fairyland. As in *Contradiction*, there is an unnatural confusion of time as well as of measure: it is night-time (the dark grey background in the top left suggests a night sky) and yet the daisies are open not closed: 'Night's moon time haply extra bright/ By fairie power made all so light' (*Elimination*).

The various characters have gathered here 'To fix some dubious point' known only to 'fairies … or to the lonely thoughtful man recluse'. Officiating at this experiment or trial is the Patriarch, the 'arch magician' in the centre of the picture whose left hand stretches to rest on a 'large little club'. He has appropriately epic facial hair (reminding us of the splendid beards that both Hood and Haydon wore by the 1860s) and a three-tiered crown, probably

74
The Fairy Feller's Master-Stroke c.1855–64
Oil on canvas 54 x 39.4
Tate

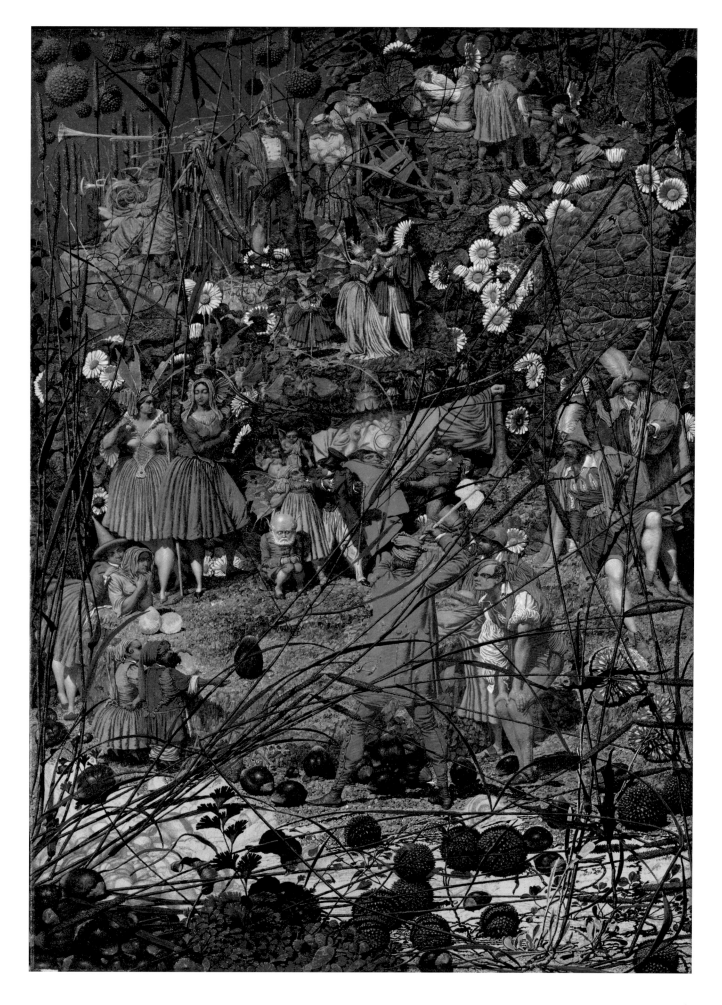

137

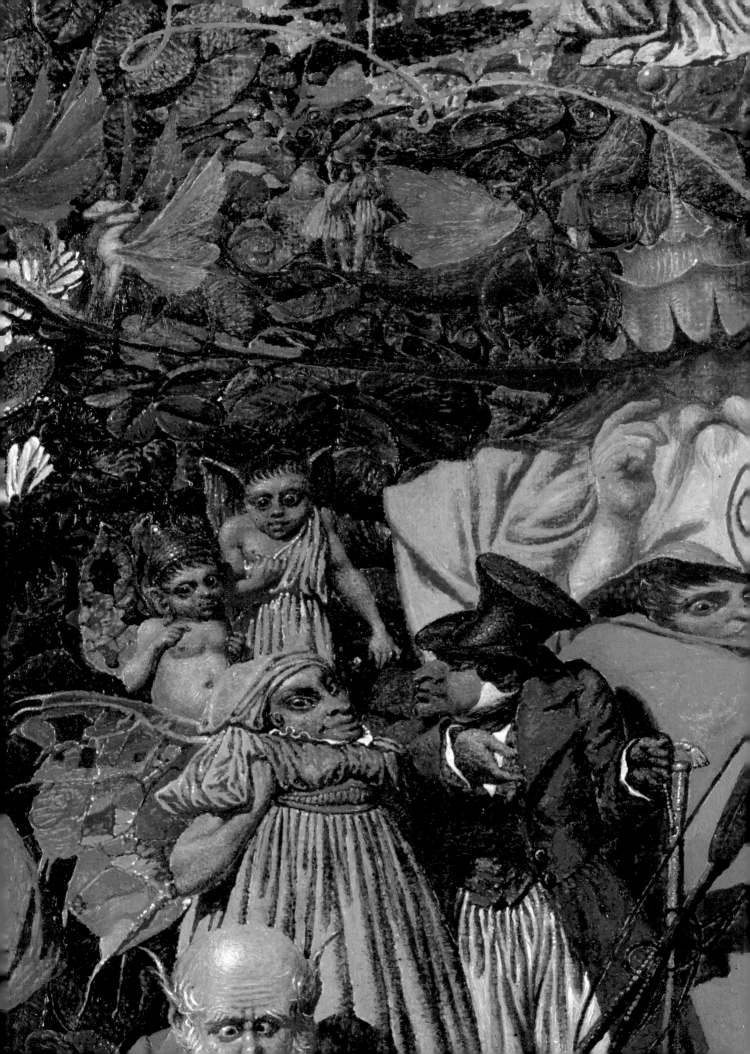

75
Pauline Duvernay in Costume for the Cachucha 1840s. Lithograph by R.J. Lane after A.E. Chalon Victoria and Albert Museum, London

referencing the Papal Tiara. Sprouting from either side of this are stalks of some apparently organic kind that reach out horizontally before twisting into spirals:

> They represent vagary wild
> And mental aberration styled.
> Now unto nature clinging close
> Now wildly out away they toss,
> Like a cyclone uncontroll'd
> Sweeping around with chance-born fold

Unto the picture brings grace
Which else was wanting to its face.

Along this 'brim', to the left, proceeds Mab's chariot driven by its gnat coachman and drawn by a team of 'tiny female centaurs' (Dadd's interpretation of Shakespeare's 'atomies', which he considers 'a dubious theme'). Dadd also gives a classical guise to the two pages standing next to the coachman: 'Cupid and Psyche they enact.' Following the carriage, on the right-hand side of the Patriarch's crown, are singing and dancing figures in Spanish costume, one of them based, says Dadd, on Pauline Duvernay, the French ballerina who had become famous with her dance La Cachucha, performed in London in 1836 (fig.75). Mab herself is evidently queen only of her own register, for the real King and Queen of all fairyland, Oberon and Titania (now reconciled), are present directly above the Patriarch. Graciously they 'approve the sport' taking place, and are attended by a 'harridan' in a red cape and pointy hat.

The less grand characters are identified largely by profession, as in Mercutio's sequence of dreamers. Closely observing the feller are an ostler, monk, ploughman and waggoner; and ranged in front of the Patriarch, from right to left, are: a 'modern fay' in the form of a stylish satyr nonchalantly admiring his shoes; a politician with pipe and pink cape; and a green-coated dandy trying to charm a winged but neckless lady nymph. (The heads of all four of these figures appear to have been anamorphically twisted out of perspective as if by their proximity to the force field of the Patriarch.) Behind the nymph are a couple of naughty infant elves and below, at her feet, a squatting, squinting 'pedagogue'.

The two large women on the left of the picture are elegant ladies' maids, one holding a mirror, the other a broom and a pet moth. Dadd has exaggerated the swell of their breasts and calves ('They've got good legs and feet so small'), and tells us – although we can hardly see him – that a satyr is looking up their skirts from a declivity behind the teacher. Dadd clearly sympathised with this Peeping Tom, writing in *Elimination* of those who find themselves 'shut out from nature's game … because some angel in the strife had got the worser fate', and who therefore have to 'close their eyes, that gate by which reminders enter, and in a paradise of fools contented live'. At the bottom left of the picture are a couple of dwarves (the male one is 'a fairy conjuror … who knows a trick or two at cards') and a spider. The latter is a key image in Mercutio's speech, but the couple of rustic lovers between the dwarves and the maids seem to return us to Dadd's own story. In *Elimination* he names the young man in the pointed hat as Lubin, surely referring to John Clare's poem 'The Village Minstrel' (1821), in which the protagonist of that name features as the poet's alter ego and as an inveterate fairy fancier:

> And tales of fairy-land he lov'd to hear,
> Those mites of human forms, like skimming bees,
> That fly and flirt about but every-where;
> The mystic tribes of night's unnerving breeze.

145

After a brief period of celebrity as a nature poet in the 1820s, Clare succumbed to mental illness in the 1830s and died at the Northamptonshire county asylum in the year that Dadd completed the *Fairy Feller*.

Balancing the maids on the right of the picture are two dashing gallants, edging their way down the rockface with comparably shapely legs – specimens of 'Your fairy man upon the town'. Then, moving to the uppermost tier of figures, at the top left of the picture are three trumpeters summoning others to the event, two human in form, the other an insect, its proboscis developed into a musical instrument (a version of a visual joke Dadd had used years before in his *Titania Sleeping*, fig.10, p.22). Dadd calls the boy trumpeters a 'tatterdemalion' (raggamuffin) and a 'junketer' (holiday-maker), while the insect, which is evidently a mosquito, he calls a dragonfly. Underneath the insect's abdomen is an isolated head wearing a conical red hat. By this point in the *Elimination* manuscript, Dadd is affecting to have run out of explanations for the presence of his characters:

> You from his cap with me perchance agree
> Of the Chinese Small Foot Societee,
> He's a small member.
> But if Confucius sent him
> Now I can't remember.

Finally, across the top of the picture, seven male figures illustrate the traditional children's counting-game list of possible future professions: soldier, sailor, tinker (grinding knives), tailor, ploughboy, apothecary (with pestle and mortar and appropriately resembling the artist's father), thief.

It seems more straightforward to connect the *Fairy Feller* with Haydon than *Contradiction* with Hood. The Bethlem Steward's love of clubbish or institutional humour is reflected in Dadd's punning throughout the *Elimination* account of the painting, which may have been written for him.[74] There is also the association of the *Fairy Feller* with Haydon's interest in natural history, one of his many hobbies. By an intriguing coincidence we know that Haydon was briefly in touch with Charles Darwin in 1881, when the owner of the *Fairy Feller* sent the great man some specimens of North American mosquitoes, writing in a covering note, 'Let the minuteness of my offering plead for me in taking up a minute of your valuable time'.[75] These gifts had been recently acquired for Haydon by his son Walton, working in Canada, but perhaps the insect in Dadd's painting had been modelled on other mosquitoes in Haydon's collection. In one of the few serious attempts to offer an interpretive reading of the *Fairy Feller*, Nicola Bown has however seen in the picture a supernatural alternative to the 'tangled bank' described by Darwin in the famous last lines of *On the Origin of Species* (1859), in which endless biological diversity obeys certain general rules of generation and competition.[76] In Dadd's world, the moment of sex, the splitting of the seed, is endlessly deferred. Indeed it can never be achieved because the axe raised by the feller remains unpainted: its blade is one of the parts of the picture Dadd

76
Sketch of the Passions:
Hatred 1853
Watercolour on paper
31.1 x 25.7
Bethlem Royal
Hospital, London

never completed.[77] As in *Contradiction*, then, in which a king and queen place Nature in gridlock while they argue over possession of a child that belongs 'naturally' to neither, in the *Fairy Feller* generation is stalled. Dadd, who had disowned his own parent, evokes the asylum's supersession of the family, that process which is suggested by the testimonial centrepiece presented to John Conolly with which we began this chapter. The asylum generates and controls its patients, treating its neutered charges as dependants, now affectionately,

77
Reverse of *The Fairy
Feller's Master-Stroke*
showing Dadd's
inscription on the back
of the canvas

now sternly. Its long-term population, at least, are 'shut out from nature's game' and forced to be contented to live in 'a paradise of fools'.

In the *Fairy Feller*, mental creativity is trapped as much as biological generation, for without her new chariot, Mab will presumably no longer be able to gallop about seeding dreams in human brains. The first part of *Elimination* is given over to an account of the origins of the *Fairy Feller*. Haydon had seen *Contradiction* and wished 'To have the like'. He had a friend 'who wrote in verse about the fairies', which

suggested a starting-point for Dadd (there is no other evidence as to who this might have been and possibly the reference is a comic one to Shakespeare). But there inspiration dried up. Dadd waited for 'That flight of fancy wild' by which 'Artists are oft compelled to draw', but 'Fancy was not to be evoked from her etherial realms'. Only by allowing the random patterns discernible on the unpainted canvas (or in its priming layer of paint) to suggest forms did Dadd make progress in the 'Design and composition'.[78] The creation of the *Fairy Feller* was thus effected 'Without intent', which is no more nor less, as we have seen, than might be said of any of Dadd's works through which spirits of different kinds were always working. Hood and Haydon may have prompted the beginning of these two extraordinary paintings, but they were only two among many other influences. This is why it seems to me unlikely Dadd was addressing Haydon in these closing lines of *Elimination*, which echo Mercutio's confession that his account of Mab is merely a dream, 'Begot of nothing but vain fantasy':

> Your notions may be more endured
> But whether it be or be not so
> You can afford to let this go
> For nought as nothing it explains
> And nothing from nothing nothing gains.[79]

More likely, I suggest, he was writing to himself. What more slavish than painting? What more hopeless?

5 Pleasure Men: Dadd at Broadmoor

Bethlem Hospital, in its bogeyman guise of Bedlam, had been the phantom against which Augustan rationality had defined itself for generations, until the reforms of the 1850s finally brought the ancient institution under full government surveillance. Properly regulated and inspected, Bethlem became and has ever since remained another hardworking hospital within the state system.[1] The national imagination now needed a new symbolic focus for its fears of madness and cruelty, and this was to be the role played by Broadmoor, which opened as the first purpose-built State Criminal Lunatic Asylum in 1863.[2]

Following the invention of the new category of 'criminal lunatic' in 1800, those deemed both insanely irresponsible and too dangerous for liberty had been gathered in separate wards at Bethlem's Lambeth site. As their numbers grew, and as Charles Hood, the reforming Superintendent of the 1850s, determined to make Bethlem more respectable, a consensus formed that something had to be done with them.[3] As we saw in Chapter Four, Hood was convinced that patients such as Dadd, whose violence had been consequent upon an illness, had to be separated from 'convict lunatics' transferred to asylums from prisons, often, so he believed, having hoodwinked the authorities to perceive their malingering as madness. Hood followed the logic of moral therapy, which emphasised classification of patients according to their behaviour, and indeed in 1857 had been allowed to separate the two classes of criminal lunatics at Bethlem. But at the same time, the government was preparing a national solution to the question, which was to involve all criminal lunatics being housed together in a new hospital out of London, Broadmoor.

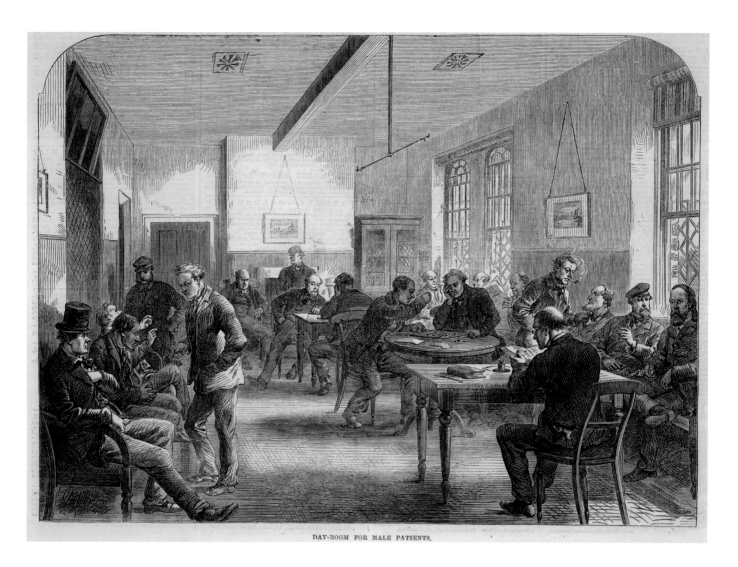

DAY-ROOM FOR MALE PATIENTS.

Hood had already argued against this, stressing the benefits to milder criminal lunatics of interaction with ordinary patients, denying the supposed advantages of a secluded rural setting for asylums, and above all warning that a building in which were concentrated the country's violently insane could only become the focus of public fear and scorn – 'a bastile' of lunacy.[4] He was eventually to be proved right. In the later twentieth century, Broadmoor indeed succeeded Bedlam as the focus of modern Britain's dark imaginings. Its mythic madmen were now conceived, not through the imagery of Hogarth or Shakespeare, but through the lens of gangster and horror films.[5]

Hood's advice having been ignored, the Criminal Lunatics Asylum Act was passed in 1860, and just three years later Broadmoor Hospital was open for business in the Berkshire countryside not far from Reading.[6] On 23 July 1864, Dadd left Bethlem for the first time in twenty years. The London and South Western Railway carried him, his fellow patients and their attendants on the Reading–Reigate line to the station at the village of Crowthorne near Wokingham. To some of the patients, this brief exposure to the sights, sounds and smells of all they were now denied must have been agonising, and Bethlem's report on the transfer recorded that 'several of them were most violent and dangerous to themselves and others. In three cases it was absolutely necessary to use handcuffs'.[7]

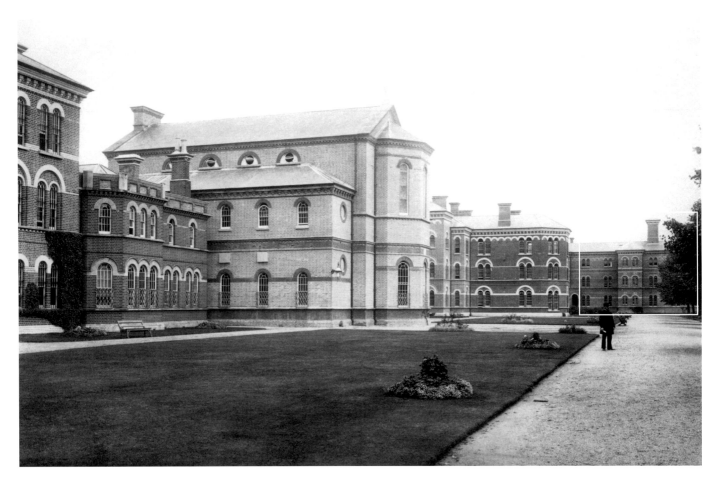

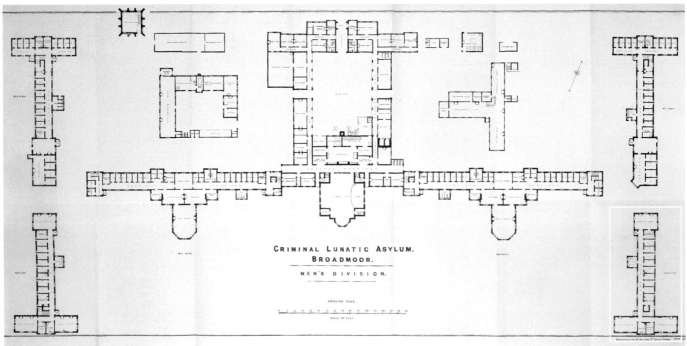

Dadd would have entered his new home by cart along the avenue to the north of the asylum, which led, through the massive neo-Romanesque gateway, into a courtyard formed by blocks of administrative offices and storerooms. On formal admission, Dadd was entered as patient no.130, and still retained the label of 'dangerous to others' assigned to him by Hood at Bethlem.[8] He would then have

had the first chance to see the glory of Broadmoor – the magnificent view from the long southern front of the main building (see fig.79). The ground fell steeply away down a sequence of stepped terraces to reveal a twenty-mile vista of lush summer landscape. The cheaply constructed buildings themselves were scarcely finished, and much of the accommodation intended eventually to house patients was still occupied by local prison convicts brought in to prepare the asylum estate.[9] But the sheer sense of light and space was a liberation of sorts for those transferred from Lambeth. As the Lunacy Commissioners recorded after their first tour of inspection later in the year, 'Some former inmates of Bethlem took occasion to speak of the change to their present abode as an improvement in their condition for which they were grateful'.[10]

There were, however, other changes of the kind Hood had warned against. At Bethlem Dadd had been separated from the convict lunatics and placed in a more genteel ward, but now at Broadmoor he found himself again amongst a hospital population that was overwhelmingly working class: labourers and the illiterate predominated.[11] But the asylum doctors' perennial instinct to classify their patients was soon in operation again. As Broadmoor's population expanded swiftly during its first years, towards its capacity of roughly 400 men and 100 women, a clear physical division of patients was effected. The main, male buildings of the asylum comprised (at least from the end of the 1860s) six three-storied blocks of wards, each with its own character. In the back blocks, One and Six, were the hard cases, the consistently aggressive men – and this generally meant the convicts.[12] Blocks Three and Four flanked the Chapel in the main building and housed patients of various intermediary levels of difficulty, as well as those new arrivals awaiting classification. The two blocks to the sides of the main building, Two and Five, were for the best-behaved patients, with Two housing those who were thoroughly trusted to require the minimum of supervision. In this block the old class-divisions were deliberately fostered, with some of the convict prisoners serving fixed sentences – known as Time Men – employed as assistant attendants upon those (such as Dadd) indefinitely awaiting Her Majesty's Pleasure and known, with a touch of that black humour not unknown in the profession of psychiatric nursing, as Pleasure Men.[13]

Block Two had only single bedrooms (no dormitories), its own dedicated reading room, and was home to most of the older and better-educated patients. Although the patient records do not tend explicitly to identify the wards in which patients were housed, various pieces of evidence make it clear that Block Two is where Dadd spent most of the last two decades of his life, evidently having demonstrated the falsity of his 'dangerous' appellation to the attendants and doctors.[14] He remained, however, resistant to the place's atmosphere of aspiring clubbability, an atmosphere later (not entirely convincingly) compared to the Athenaeum, the elite London club for the intellectual professions.[15] A fundamental problem with the Broadmoor scheme of patient classification turned out to be that the convicts' behaviour seemed to deteriorate when they were placed together. As inveterate criminals, they were perceived to have a natural tendency to combine in plots, whilst the peacefully deluded appeared to live largely in psychological isolation. An engraving

published in an 1867 *Illustrated London News* feature on Broadmoor shows a day room, probably in Block Two (asylums naturally tended to conduct journalists towards their gentlest patients), with a man looking very much like Dadd on the far right (fig.78, p.151). The man next to him is chatting away, but Dadd – if it is indeed him – stares into space, preoccupied by his own thoughts.

Among Dadd's neighbours in Block Two was the American surgeon William Minor (fig.81), a killer suffering agonising delusions but also a masterly etymologist. Having turned one of his two rooms into a library, Minor spent his Broadmoor years combing through rare old books for significant historical usages of particular words, and forwarding the information he thus meticulously compiled to the editors of the first Oxford English Dictionary.[16] He was in effect one of its authors. Minor's luxuries extended well beyond his books. Among the many items he was allowed to purchase through the asylum staff were, in 1876, 'two champagne glasses'.[17] How comforting it would be to imagine he and Dadd toasting one another with these as they vied to suggest the most likely Greek or Latin root of an archaic English noun. But Dadd's casenotes tell a sadly different story. In 1865 it was recorded that he 'associates with some of the most weak-minded of his fellow patients', perhaps those least likely to contradict the 'fanciful ideas connected with spiritual agency' that the Broadmoor casenotes describe as still dominating his conversation.[18] That Dadd and Minor related in some way is however hinted at by the survival of a watercolour by Dadd dated 1873, the year following Minor's admission (fig.82, overleaf). Now belonging to Yale University, Minor's Alma Mater, the sheet was for many years owned by the Minor family and thus, we assume, originally by Minor himself.[19] It appears to show the landscape around Broadmoor, complete with agricultural business going on. It is one of those English watercolour landscapes that delights in the simple verdant ordinariness of the countryside, and perhaps pleasure in this was all that Minor and Dadd, each locked in their separate delusional states, were able to agree upon.

As for fellow artists, if Dadd had been willing to seek them out, he could have found one or two around the asylum. Thomas Holmes and Phillip Dawe were both described as artists on their admission forms, but they came without established reputations. More interesting perhaps to Dadd, and certainly to us, were those patients whose interest in art evolved among the delusions that accompanied their illnesses. The admission notes of patient John Hughes record as symptoms of his insanity that he expressed an extreme misogyny and was

'iconoclastic'.[20] Hughes himself readily confessed to having 'destroyed an accurst mad king's accurst picture', that is, a portrait of George III. It was Hughes who, apparently enraged by a prayer for Queen Victoria, nearly succeeded in murdering John Meyer, Broadmoor's first Superintendent, in the chapel in 1866. More creative was Richard Wheeler, who had been an architectural sculptor before his admission in 1875.[21] At Broadmoor he turned to painting and, after a vision of Christ, to religious themes on a large scale. When seeking to sell his pictures to London dealers for spectacular amounts, he carefully signed his (unforwarded) letters from 'A Saint, Artist and Sculptor, Block 4, Broadmoor Asylum'.

Exasperatingly, there is often more in the Broadmoor archives on such communicative, outgoing figures as Wheeler than on the self-contained Dadd. Among 'the treacherous and explosive compounds of badness and madness' that Broadmoor was designed to contain, Dadd was simply not a managerial priority.[22] Although he never wavered from his own original account of the murder of his father as commanded by Osiris, or from his own very personal demonological cosmology, he had clearly quietened down dramatically since the 1840s, partly no doubt because of the premature ageing that institutional life induced and from which Dadd evidently suffered. Eventually, at the time of his death, his condition was described as 'melancholia, with delusions', a distinctly different label to that given him by Hood at Bethlem.[23] But the stability of Dadd's condition was now further reason not to bother to record his progress in any detail. William Orange, the Deputy Superintendent who succeeded as Superintendent in 1870, records in Dadd's casenotes merely some examples of his talk, which 'will go on from one idea to another in an insane and incoherent manner'.[24] Orange particularly notes those conversations where Dadd's understanding of the influence of spirits extends to such mundane topics as chess ('the power some people have of playing chess without the board was probably due to their having a familiar spirit and that towards some people the chess pieces were evidently unfriendly and that this unfriendliness might be due to the antiquity of the game') or the weather ('he says he thinks that mad people suffer more from the sun than others because they have no spirit to intercede for them, and shelter them from the sun's rays').[25] It is a shame not to be able to do more than merely recycle these picturesque quotes, and say more about how the authorities at Broadmoor regarded Dadd's art. Dadd has long been supposed to have painted a portrait of Orange (fig.83, overleaf), but the 'portrait in oils of one of the officers of the asylum', as it was described by a visiting journalist in 1875, looks nothing like the Superintendent, and its sitter has yet to be identified with certainty.[26]

Orange was brutally assaulted in 1882 by a clergyman patient, the Revd Henry Dodwell, desperate to have his day in court, and retired early in 1886, to be replaced by David Nicolson who had arrived as his deputy in 1876.[27] Nicolson seems to have been more drawn to speculative thinking about his charges than Orange, who was regularly in the unenviable position of being asked by the courts to give his decisive opinion regarding a condemned person's sanity – to judge whether or not they were fit for the gallows. Nicolson contributed several thoughtful pieces to the

Journal of Mental Science, and it was he who on Richard Wheeler's death in 1887 made a point of keeping some of his pictures 'for the asylum'.

Dadd clearly made a deliberate effort to maintain at Broadmoor some continuity with his work at Bethlem. When he was taken from Bethlem, the *Fairy Feller's Master-Stroke* (fig.74, p.137) remained behind, unfinished. To make good this interruption, once settled at Broadmoor Dadd resumed, or possibly began, a watercolour version of the painting, which differs astonishingly little from the picture itself and to which he gave the title *Songe de la Fantasie* (fig.85, overleaf), the title adapting Mercutio's confession that his Queen Mab speech was merely a dream bred of idle fantasy. This is the only picture or drawing of Dadd's to be specifically mentioned in his Broadmoor notes. Orange noted on 7 November 1864 – apparently without much interest – that Dadd 'Employs himself generally in painting and is at present engaged on a water colour fairy scene which he is executing with great care'. That first winter at Broadmoor, Dadd also wrote out in a small notebook his *Elimination* of the *Fairy Feller*, his meandering but enlightening catalogue of the picture's content. In the autumn of 1865 Dadd was back with his Middle Eastern material, no doubt continuing his practice of recycling drawings from the precious sketchbook that must still have been with him. His pair of watercolours, *Fantasie Egyptienne* (fig.86, p.160) and *Fantasie de l'Hareme Egyptienne* (fig.87, p.161), are signed 'par Mons.ʳ Rᵈ. Dadd', as if he were adopting the persona of a French academic Orientalist painter, although

the idea of painting a pair of separately gendered Oriental scenes in this fashion
was popular on both sides of the Channel. These drawings have the classic quality
of Dadd's later work, in that a first impression of daintiness gives way on close
inspection to the awareness of an astounding display of minute technical discipline.

There was some continuity for Dadd, too, in terms of the professionals interested
in his case: he was not suddenly entirely overseen by strangers. Charles Neville,
who had been the attendant in charge of the criminal lunatics at Bethlem, joined
Broadmoor on its opening as its first Chief Attendant.[28] Hood, meanwhile, who
was key in bringing Neville from Bethlem to Broadmoor, himself joined the latter's
Council of Supervision (despite, or perhaps because of, his misgivings about the
whole idea of isolating criminal lunatics) and regularly attended its meetings in

London and at the asylum throughout the 1860s. Most steadfast of all, however, proved old Alexander Morison, now in his eighties and living in retirement in Scotland, in a house decorated with the Dadd drawings that he had managed to obtain since first encountering the artist at Bethlem in 1844. Morison died in 1866, leaving bequests to the Royal College of Physicians of Edinburgh, but shortly before this it seems he somehow managed to convince the Broadmoor authorities to allow Dadd to create one last work for him. This was to be a pair of designs for certificates to be given to recipients of the Morison Prize, an award made by the Edinburgh College to asylum attendants who had distinguished themselves through humane attention to their patients (figs.88 and 89, p.163).[29] Dadd's designs – one male and one female, just as in his pair of Orientalist watercolours of the same year – each show twin 'before and after' images. First, a lonely raving lunatic of almost medieval conception, and then a fully socialised patient, a patient indeed so thoroughly socialised that they are indistinguishable from their accompanying attendant.[30] We seem to be back with the doppelgangers and the fascination with 'the double nature of human beings' that characterise many of Dadd's watercolours of the 1850s. It is as if Dadd has identified a form of split personality as the resolution, not the cause, of madness.

84
Photograph of the
senior Broadmoor
male staff (Nicolson
and Orange seated 4th
and 5th from left in
front row), 1885
Berkshire Record
Office, Reading.
Broadmoor Archive

85
Songe de la fantasie 1864
Watercolour and ink
on card 38.3 x 31.4
Fitzwilliam Museum,
Cambridge

The patients at Broadmoor, as at any other large asylum, were strongly
encouraged to work as part of their treatment. The State Criminal Lunatic Asylum
possessed its own cattle and a kitchen garden covering twelve acres. In 1865 alone
this produced a little short of 16,000 pounds of rhubarb, which as a mild laxative
was one of the few treatments uncontroversially, and therefore enthusiastically,
traditionally prescribed for lunatics who were considered to tend to constipation.[31]
Broadmoor was also well equipped with workshops of all kinds, and so was able
to provide for itself the food, clothing and other basics of everyday life. The
ideal was self-sufficiency. A journalist visiting in the 1870s wrote: 'It is a strange
microcosm, this isolated community, including within itself an *epitome mundi*, as
it were, with its galleries [the long corridors forming the spines of the blocks],

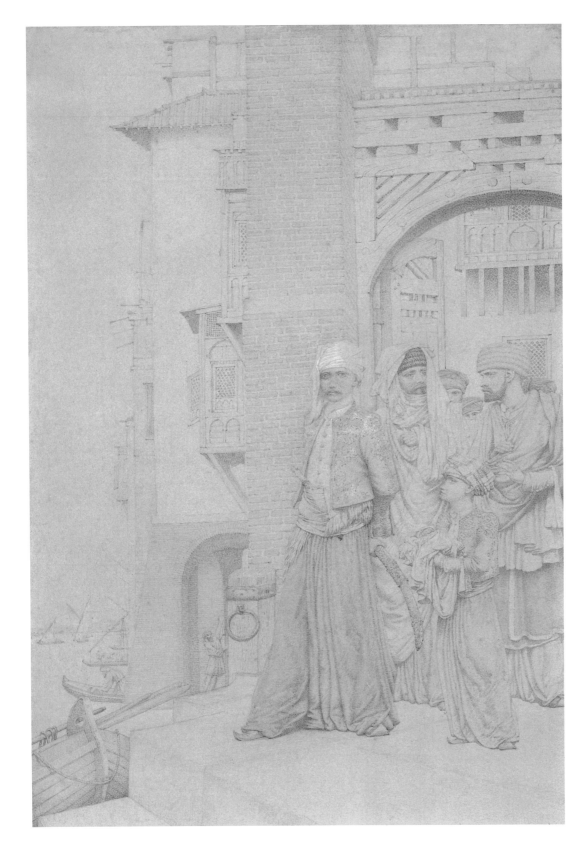

86
Fantasie Egyptienne
1865
Watercolour on paper
25.5 x 17.8
Bethlem Royal
Hospital, London

cottages, fruit and kitchen gardens, reservoirs, rivulet … and even, to complete the comparison, a cemetery.'[32] But as the chaplain (whose chapel was poorly attended) was fond of observing, there were too few meaningful incentives to good behaviour at Broadmoor. No one was going to get early release for planting carrots and singing hymns. Hence the introduction in 1874 of payment for labour within the asylum. Dadd does not seem to have needed such encouragement,

87
Fantasie de l'Hareme Egyptienne 1865
Watercolour on paper
25.5 x 17.8
Ashmolean Museum,
Oxford

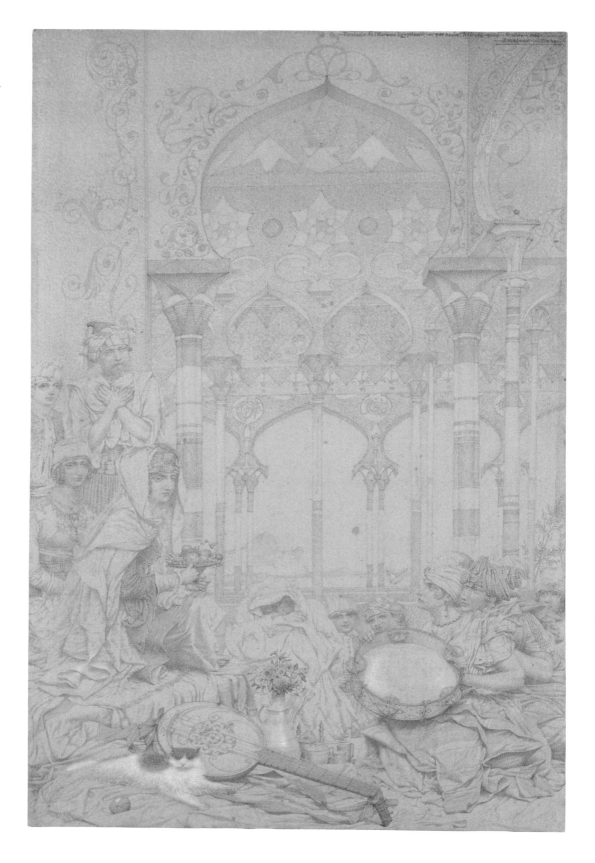

being very happy to apply his skills to useful tasks around the asylum, although the only organised activity beyond his own former professional competence in which he is recorded as having shown an interest was the cricket matches. In February 1868 Dadd's casenotes record that he is 'now painting the royal arms on some fire buckets', and around the beginning of 1872 he began a much larger project, the decoration of the stage of the central hall, the large

room on the ground floor beneath the chapel that was used periodically for entertainments. An entry in the casenotes for June of that year reads: 'Has been going on very well. For some months past has been employed painting scenery for the stage in the central hall and is allowed a good deal of liberty when so occupied; steady supervision considered unnecessary. At this work he has taken considerable interest. Has the use of his own room in Block 3.'[33] The room in Block Three – the block nearest the hall's stage – was presumably made available to Dadd as a makeshift studio for the year or two during which he worked on this project, to which he commuted from his home in Block Two.

Whether Dadd strictly painted 'scenery' for the stage, as in sets, is unclear, but we know he did design and paint a drop-curtain, as well as decorative paintings for the front of the low stage itself, and other mural decorations described as made up of 'quaint arabesques, and lines painted in a medley of vivid colours'.[34] The pictures for the front of the stage are thoroughly classical in conception, featuring playful putti in togas (fig.91, overleaf). The composition painted on the drop-curtain was carefully described by a visiting journalist in 1877:

> It represents the temple of Fame; an elegant Greek edifice standing on a single peak, which soars high into the clouds of a wild and stormy sky. Crowds press onwards and upwards by a series of winding stairs and platforms, but upon the crag-summit there is foothold for but one at a time; and he who outstrips his fellows at first and wins the ascent is in danger of being overtaken, displaced, and hurled down the sheer straight precipice into the angry waves of a tumultuous sea. In the foreground is a wide terrace, paved with marble – it might be the Piazzetta of Venice – which is the starting-point for all who climb. It is crowded with figures – some eager, some apathetic, some pointing with feelings of envy or contempt to those who are already on the rise.[35]

What is clearly a preparatory sketch for this huge work survives in the V&A (fig.90, overleaf) with the soaring peak represented as a kind of helter-skelter ziggurat, but without any elements of the great human tragicomedy of the competition for fame that was the subject of the curtain itself.

The same journalist who reported on the theatre curtain – writing for the *World* – also described how Dadd would turn his hand to all kinds of lesser graphic tasks at Broadmoor, such as designing Christmas decorations or illustrations for lectures and entertainments. Around the turn of the twentieth century, some of these were still on display in the hall, and even today a handful of watercolours of London male types, such as a sailor and a coachman, are owned by Broadmoor.[36] Dadd also developed an interest in woodwork, decorating chairs for neighbouring Wellington College, the boys' private school, and in 1872 was recorded as being 'able to amuse himself painting, carving wood & in reading'.[37] That Dadd was by now being allowed to entertain himself with a knife – an object that would have sparked drastic alarm if spotted in the hands of a patient in another block

88
Morison Prize Certificate for Male Attendant 1865
Engraving after design by Dadd
Royal College of Physicians of Edinburgh

89
Morison Prize Certificate for Female Attendant 1865
Engraving after design by Dadd
Royal College of Physicians of Edinburgh

RICHARD DADD. 1865. BROADMOOR.

Eng.ᵈ by Banks & Cᵒ Edin.ʳ

RICHARD DADD. 1865. BROADMOOR.

Eng.ᵈ by Banks & Cᵒ Edin.ʳ

– speaks volumes about his placidity and perceived trustworthiness. Quite what he was carving, other than furniture, we are not told, but the chunky frame around his 1871 watercolour of *A Wayside Inn* (fig.92, overleaf) must be another of his experiments in carpentry.[38] Seen together as they were evidently intended to be, the picture and its homely frame have a decidedly rustic feel, inspired by Broadmoor's rural surroundings, and might have come from a European artists' colony. The

90
Design for the Broadmoor Stage Drop-Curtain 1873
Watercolour on paper
30.5 x 42.5
Victoria and Albert Museum, London

91
Panel from the Broadmoor Stage: Folly 1874
Oil on hessian
35.6 x 92.1
Bethlem Royal Hospital, London

same aesthetic is at work in Dadd's *Still-Life Study* 1874 (fig.93, overleaf), which combines fruits of the forest with some of the produce of the Broadmoor gardens.

Dadd's two last major oil paintings to survive, *Atalanta's Race* 1875 (fig.95, p.169) and *The Wandering Musicians* c.1878 (fig.96, p.170), share this rustic ethos, now developed within more ambitiously classical, Arcadian structures. One of the resources of memory to which Dadd often turned during his asylum years was naturally his childhood and his time at grammar school, where Greek and Latin would have been at the centre of the curriculum. He remained a lifelong reader of classical literature, although one with an idiosyncratic interpretation of it, founded on the belief that the wisdom of the ancient Egyptians and Greeks had been so influential because it was true, and that, if true once, it remained true now. In his mind, the rich heritage of the classical world lived and breathed a full existence, one far removed from the scholastic discipline in which the respectable classes were conventionally educated, where the art and literature of antiquity were hallowed in isolation from the broader cultures in which they had evolved.

At Broadmoor, Dadd, as a trusted patient, was allowed to send out of the asylum for books and, although he never competed with his neighbour Minor in terms of library-building, the records of his purchases preserved in the archives make clear the continued dynamism of his intellectual life. Among other items, Dadd was supplied with modern poetry (Byron, Henry Wadsworth Longfellow), with religious texts (the Apocrypha, the Qur'an, the Talmud) and above all with classical literature (Homer, the military histories of Caesar and Josephus). The lists of his purchases also include artists' materials, photographs (unidentified but perhaps topographical), reference books including travel guides, and serious quantities of treats for a sweet tooth (acid drops, treacle, biscuits, sweetmeats, gingerbread, marmalade, barley sugars, peppermints).[39] With a bag of acid drops on one side of his desk, a copy of one of his classical texts on the other, and by now making use of a magnifying glass, Dadd worked on at Broadmoor, creating in the late 1870s his last two masterpieces.

The story of Atalanta was that of a warrior maid tamed by love. The daughter of the Arcadian King Iasus, Atalanta was raised in the wild as a huntress, and was so averse to marriage that she required any suitor to beat her in a running race. (Her appeal to Dadd recalls his attraction to the Amazonian women of Anatolia.) Every race ended in her victory and the admirer's execution until Melanion, pitied by Aphrodite, was supplied by the goddess of love with some of the golden apples kept by the Hesperides. Artfully placed in Atalanta's path, she could not resist stopping to pick up the apples, allowing Melanion to race ahead first to the finish and to win his bride. In Dadd's picture he is shown approaching the group of figures in the background on the left, alongside the telescopic castle. On the right, lurking in the undergrowth, a tortoise and hare amplify the theme of cunning versus agility. This must rank as Dadd's most beautiful asylum painting. The coagulated complexity of the two great Bethlem oils (*Contradiction*, fig.68, pp.124–5; *Fairy Feller*, fig.74, p.137) is here replaced by a composition of apparent

166

naivety where a familiar story is recounted as straightforwardly as possible, with the focus on the fatal moment when Atalanta succumbs to the will of the gods and is distracted from the race. All the kaleidoscopic detail of *Contradiction* and the *Fairy Feller* is in fact still present, but now managed into flowing patterns of foliage that energise the whole picture surface, as Dadd finally achieves in oil paint an equivalent to his masterly watercolour stipple effect.

The theme follows that of the Temple of Fame that Dadd had painted for the Broadmoor stage a couple of years previously – the compulsive human participation in the race of life and the inevitable casualties derailed during its course. While this is a universal story, we should not underestimate the extent to which Dadd felt it immediately applicable to his own life. There are hints of regret in the 1870s, a suggestion that he realised what he had missed. This comes across most strongly in 'Her Majesty's Pleasure: The Parricide's Story', the anonymously written feature article on Dadd that appeared in the obscure periodical the *World* at Christmas 1877. It formed part of the flurry of journalistic interest in Broadmoor prompted by the appointment of a parliamentary committee to look into the hospital's costs in 1876 (its report was debated the following year).[40] Various politicians had grown restless – or sought public favour by affecting anxiety – over the asylum's diversion of large sums towards the welfare of deranged killers. There were, as there always have been since, those who argued that society and the patients themselves would be better off if the hangman and not the psychiatrists were allowed to deal with the problems of criminal lunacy. The Press were sceptical of the parliamentary report's rosy picture of Broadmoor, 'which it represents, in effect, as a credit to the civilisation of the age'.[41] Here, then, was a medical story for the non-specialist reader, one in which Dadd might have a role. So when the journalist from the *World* was allowed into Broadmoor, he tracked down the artist and succeeded in drawing him out regarding his life and work as never before.

The visitor was struck by the coincidence of Dadd having taken the subject of Atalanta at exactly the same time as it had been used by one of the great classical academic painters of the day, Edward Poynter. Poynter painted his picture for the Earl of Wharncliffe's billiard room, hence its architectural proportions: it was fourteen feet across, while Dadd's canvas is only a couple of feet tall.[42] It earned him full membership of the Royal Academy, of which he was eventually to become President in addition to his role as Director of the National Gallery. Poynter had been inspired to take up the subject of Atalanta by William Morris, in whose *Earthly Paradise* of the late 1860s the story had been retold, and just possibly Dadd also followed the same lead. But there are few other points of overlap, and Dadd himself was keen to talk of the contrast, which he was able to do having studied the engraving of Poynter's picture in the *Academy Notes* published annually by the critic Henry Blackburn (fig.94, overleaf). Poynter had adopted an imperial architectural setting, whereas Dadd felt he had been truer to the prehistoric Arcadian ancestry of the legend which, characteristically, he wanted to see as relevant to all ages, not just to the Homeric epoch. There were still places in the world, he thought, where such ways of choosing husbands existed. More keenly, Dadd felt the difference between

Lecture Room. 61

Two small contributions by F. LEIGHTON, R.A., "Teresina" (926), and "Paolo" (970), the latter of which we have roughly indicated at the end of this chapter, enrich this room.

No. 943. 14 ft. 6 × 4 ft. 10.

No. 943. "Atalanta's Race." E. J. POYNTER, A.

This picture—second only in size, and perhaps equal in artistic importance, to Mr. Leighton's "Daphnephoria"—will be welcomed by all students of art, especially those with whom the decorative mission of painting is held to be predominant. The classic story of 'Atalanta's Race'—how the fair athlete was overtaken in her course by the temptation of the three golden apples, and how she stooped to be conquered—is made the vehicle for a painting of great interest and instruction. In this, as in Mr. Leighton's, we leave critics to discuss certain technical points which will be questioned. Mr. Poynter's picture is especially welcome to us for its scholarly grace and refined scheme of colour.

No. 952. 48 × 39.

No. 952. "The Musician." C. E. PERUGINI.

Seated at a piano, in old-fashioned dress brocaded with flowers.

the professional careers of Poynter and himself. He also had aspired to be Richard Dadd, RA, 'But that is past … some painters – the few, perhaps – achieve renown and substantial rewards; others lag behind'. Dadd points out to the man from the *World* the Roman poet Juvenal's account of patrons' feasts, at which society's winners humiliate their clients by serving them foul dinners. Of course, it was evident to Dadd that Juvenal's satire was as relevant as ever in the nineteenth century.

At Bethlem, Dadd's work had seemed to cope with his enforced celibacy by translating sex into a series of Shakespearean jokes: genders are disguised or borrowed, their images exaggerated into grotesque parodies. That hospital, like the great majority of larger asylums, had been tidily divided into roughly equal male and female portions (although men formed the great majority of the criminal lunatics). The great Victorian county asylums were indeed generally split down the middle, architecturally, into male and female halves, while the mythologies that surrounded them were perhaps also equally balanced in gender terms. But Broadmoor was overwhelmingly male, with only around 20% of women patients in the nineteenth century, and these housed in blocks entirely separate from the principal structures of the asylum. The criminal lunatic was statistically male, and popularly imagined as such too. Love-stricken young Ophelias may have been imagined to haunt the wards of Bethlem, but at Broadmoor the typical woman patient was a sufferer from severe post-natal depression who had harmed or killed her baby, and few sentimental poets saw any mileage in that subject. The sexes could occasionally see one another in Broadmoor's chapel or hall, but otherwise led strictly segregated existences.[43] One patient there, George Houlton (like Minor a former surgeon) 'imagines he can be male or female at will',[44] but for most other male patients resignation to a life without women was the only option. In his painting of Atalanta, in which Melanion scampers away from the heroine as if from the scene of his crime, a deception intended to bring her under control, Dadd perhaps reflects this struggle.

In *The Wandering Musicians* of about 1878 (fig.96), however, the male and female characters have been comfortably reunited, perhaps even accompanied by their child. Whereas *Atalanta's Race* was all movement, this painting is entirely static.

94
After E.J. Poynter,
Atalanta's Race
Wood engraving in
Henry Blackburn,
Academy Notes 1876
Victoria and Albert
Museum, London

95
Atalanta's Race 1875
Oil on canvas
59.7 x 49.5
Private collection

The subject is in the tradition of one of the most popular of nineteenth-century picturesque painters' motifs, the *pifferari*, rustic Italian musicians playing at roadside shrines as they make their way to a Church festival. Dadd's shepherd – who has the air of a rejuvenated self-portrait – carries a pipe as well as his crook, while his companion in her very English bonnet strums a decorative guitar that must have been borrowed from one of Broadmoor's more musical patients. (Dadd himself played the fiddle, and the 1877 *World* feature on him noted that 'he will play by the hour, as a relaxation, weird music – strange variations of old melodies and other pieces learnt in his youth.') The group have paused, it seems to have their photograph taken, before the fragments of a Corinthian temple – perhaps the ruins of the Temple of Fame? To the right an exquisite river landscape, borrowed from the backgrounds of *quattrocento* Italian painting, snakes into the distance. The Italianate setting is contradicted, or perhaps given wider roots, by the names of the great Greek poets of bucolic innocence carved into the remains of the entablature in the bottom right: Theocritus, Bion, Moschus and Tyrtaeus. The painting seems to speak of a kind of benevolent emptiness, of an everyday rustic world that has always been there and always will be, in which a content couple pause briefly to be remembered before passing on.

In Dadd's imaginative world it is not really accurate to talk of the persistence of a classical tradition, one handed down the generations by consent of the cultured few. For him, the truths of the ancients retained their paramount authority simply because they could never truly be superseded. His bucolic couple in *The Wandering Musicians* are temporarily static before that authority; they have no particular story, none at least different to those we already know. After more than three decades in the asylum system, Dadd equally found himself, as it were, back where he started. No one had understood him when he had been compelled to kill his father, and no one listened with much sympathy now. He had spent almost all his adult life at Bethlem and then Broadmoor, complex institutions evolved through endlessly intricate legal debate, itself framed by voluminous intellectual enquiry and controversy. But what, finally, had these places done to him? So far as we know, the sum total of treatments given Dadd by any psychiatrist (other than, presumably, occasional sedatives) was a course of iced water baths administered at Clermont soon after his admission there in September 1843. Thereafter, Dadd became a victim, or beneficiary, depending on how one sees it, of the therapeutic vacuum and consequent general pessimism that increasingly took hold of the British asylum system. As that system silted up with ever more supposedly incurable cases, as the mentally unstable of Victorian Britain were warehoused in epic numbers in vast edifices, at its centre was an ever more painfully obvious void. Dadd was left alone.

The 'Age of Conolly', the period of leaping hope in the ability of the asylum to heal and even eradicate lunacy, was pronounced to be over during the 1860s. The most able alienists were now voting with their feet and leaving the deadening monotony of asylum superintendency to work in private consultancy. Even Hood was one of these, leaving Bethlem in 1862 to become one of the Lord Chancellor's Visitors in Lunacy, advising on the estates of wealthy individuals struck down by mental

illill.[45] To some extent Broadmoor avoided the worst of this downswing of the great manic-depressive cycle of Victorian psychiatry, for it was at the centre of the profession's newly enhanced interest in criminality and, of all asylums, had least reason to reproach itself if its rate of release was low: the patients at Broadmoor were by and large not expected to leave. Orange and Nicolson busied themselves with the statistics of criminal lunacy, and with campaigning beyond the profession from their particular field of expertise. They wanted earlier action to prevent mentally ill people having the crises that ended with their becoming criminals, and above all they wanted the courts to recognise that madness came in degrees; that, contrary to the letter of the law, a person might well be both mad and yet also aware the act they were planning was illegal. Take, they would say, the case of their patient Richard Dadd, once a famous artist who, it would be remembered, a long time ago shocked the country by calculatingly destroying his own father and then efficiently fleeing to France. Yet who would deny he was mad?[46]

The gloomy genius of late Victorian psychiatry, as he has memorably been labelled, was John Conolly's son-in-law Henry Maudsley, late in life the founder of the London hospital that bears his name and which now forms part of the same NHS Trust as the Bethlem Royal Hospital.[47] Goaded by the spectacle of the failed asylum dream, Maudsley's thinking managed to appear both misanthropic and progressive. Like many a campaigner for psychiatric reform today, whose patience with the story-telling of psychoanalysis is exhausted, Maudsley insisted on the physical, neurological basis of insanity, and ruthlessly focused his attention on the illness itself and its aetiology (causation).[48] He concluded that the symptoms of madness – so often garish, tragic or picturesque in the recounting – were distractions from the real quarry, which lay hidden within the secret structures of the brain and which was, in the last analysis, fundamentally congenital.[49] Lunacy was a form of degeneration and the 'cure' could only be to prevent further transmission of the defects. Historians have marvelled at Maudsley's harrowingly fatalistic, Old Testament language, and it can still shock today to read that his suggested remedy for masturbation was an early death.[50] Only once we understand this new temper in Victorian psychiatry can we make sense of Dadd's relationship with the outside world in the last years of his life.

As a classic problem case in the laws of criminal lunacy, Dadd's story remained in the public eye, the more so in the later 1870s when the press followed Parliament in taking a keen interest in the running of Broadmoor. The artist himself appears to have responded positively to this interest, talking at length to the *World* reporter of his disappointed professional hopes and, in the same year, not coincidentally, the newly talkative patient finally confessed to Dr Orange the whole story of the murder of his father. In the same decade, Dadd's work became more publicly visible than ever before. The popular Orientalist painter Frederick Goodall recalled a meeting of an artists' club, probably in the 1870s, to which someone brought along

a remarkable collection of drawings. I was told whose they were; they showed that the poor fellow had retained some part of his artistic knowledge, but mixed up with curious freaks of fancy. One of these drawings, I remember, he had called 'The Difficult Path.' The scene was a rugged mountain-side; a zigzag path was cut in the rock, and a knight in full armour was trying to find his way.[51]

This must have been *The Crooked Path* (fig.97, previous page), the fabulous drawing of 1866 now in the British Museum, inscribed with the mock-pretentious instruction in Italian 'luce al sinistro – quasi', indicating that, when hung on a wall, the light source should be to its left – 'sort of'.[52]

Frustratingly, it is not possible to say who was able to show Goodall a 'collection of drawings' by Dadd (perhaps George Henry Haydon). Probably his works left Broadmoor more easily than they had Bethlem where, at least in theory, Hood had prevented their export after 1856. Hood's own important collection of Dadd's work was released on to the market in 1870 after his death, when *Contradiction* was acquired by the spectacularly wealthy collector Alfred Morrison: in 1879 the *Magazine of Art* described it hanging in his Carlton House Terrace mansion.[53] By this time, Dadd's works had entered the major national art collections for the first time. *Recklessness* (fig.99, p.181), one of Hood's *Passions*, was acquired by the British Museum in 1876. Almost simultaneously, the V&A (or South Kensington Museum as it still was) bought a couple of minor Egyptian drawings from the 1842–3 tour, which were added to in 1878 by a batch of several more important watercolours. Meanwhile *Patriotism* and *Leonidas and the Woodcutters* (painted at Broadmoor as recently as 1873) were bequeathed to the V&A by John Forster, the biographer of Dickens and for long connected professionally to the Lunacy Commission, a position that would have given him unusual access to Dadd even at Broadmoor.

We can thus perhaps talk without too much exaggeration of a modest 'Dadd revival' in the 1870s, one coinciding, on the face of things paradoxically, with the rise of the pessimistic, degenerationist theory of madness, with its obsession with disease and coldly fatalistic attitude towards the individual patient. But there was in fact no paradox. If Maudsley insisted on the physician reasserting his competence in lunacy on the basis of hard science, regarding moral management and holistic therapeutics as lay amateurism, then what did this mean for the status of a mad artist? It meant that the poetic symptoms of Dadd's condition – his pictures and drawings – could cease to be regarded as of any potential psychiatric significance. Something in Dadd's brain had malfunctioned, and hopefully science would one day understand exactly what went wrong in such cases. As it happened, while mad, Dadd made beautiful artworks. As these were of no use to the neuroanatomist then the museum curator, after all, was the proper professional to interpret them. As was discussed in Chapter Four, at Bethlem Hood had seemed in a quandary as to what to do with Dadd's works. He neither allowed them out of the hospital nor displayed them there. Caught in the contradiction of that particular doctor-

patient relationship, the pictures were, so to speak, parked. But now a newly stark division between aetiology and symptom divided also the madman from his art, allowing the latter to enter society while the former remained at Broadmoor until his death in January 1886.

The narrative of Dadd's health in his later years is as banal as most aspects of asylum biography. The lack of exercise or stimulation aged him, so that visitors in the 1870s perceived him as an ancient with flowing white beard, although by 1877 he had only turned sixty. Broadmoor suffered from a water supply susceptible to contamination, and in the late 1860s this seems to have given rise to a serious outbreak of 'enteric fever' (typhoid) among staff and patients. Dadd was struck with this in 1868, lost three stone in weight and was slower in his work thereafter. In that year the casenotes record that he 'Appears to be rather desponding [regarding] his health, and says he is breaking up and that "it is quite time".'[54] There was no further medical crisis until mid-1885 when, complaining of feeling unwell, he was moved to the Infirmary on the ground floor of Block Three. It was the classic asylum killer, tuberculosis, and Dadd declined gradually before succumbing early in the new year. The companion of his last hours, the casenotes record, was attendant Samuel Smith, himself a Broadmoor lifer. Smith had joined the staff in 1874 and rose through the ranks to become eventually the asylum's Chief Attendant, retiring in 1919. Dadd was buried in the cemetery that, as a journalist had observed, gave the finishing touch to Broadmoor's aspirations to self-sufficiency.

It proved hard to find any surviving member of Dadd's family to receive his belongings, or indeed to have anything to do with the asylum's efforts to achieve legal closure of Dadd's case. At first word came from Aberdeen, where Dadd's sister Maria was being cared for in the city's main asylum, that her daughter by the painter John Phillip 'is to claim Dadd's things as his heiress'.[55] But this must have come to nothing, for correspondence in the Broadmoor archives speaks, as late as 1897, of the family showing 'some amount of indifference towards the whole business' and of the need to find alternative means of achieving 'settlement of a long pending question unfortunately neglected by members of the deceased's family'.[56] If the specialists were now claiming that madness was all in the genes, then this reluctance is understandable: Dadd's relatives must have feared that they may have already received an inheritance of an unwelcome kind. Meanwhile, the journeys of Dadd's paintings and drawings (which must have been the only things of interest among the belongings he left) into portfolios, collections and museums around the country and beyond were already well under way. The story of their life after Dadd's death is the subject of the last chapter.

6 The Asylum Speaks Back

If it is not too much of an exaggeration to speak of a modest upsurge of interest in Dadd during the last years of his life, then there is scant evidence that this was sustained into the early twentieth century. The narrative of Dadd's posthumous critical fortune should in theory be an intriguing story. Through it, one imagines being able to plot the shifting relationships between theories of art and madness through the periods of Symbolism, Expressionism and Art Brut. But it is a history that will never be written, because the blunt truth is that, until the 1960s, no one had much to say about Dadd. His art was regularly found to be lovely and strange, and it was seen to have its rightful place in any broad survey or collection of British painting. But Dadd and his work can only be said to have taken on a dynamic significance in cultural history – that is, he only became *useful* to those promoting certain cultural arguments – once the psychiatric profession that had overseen his life at Bethlem and Broadmoor underwent a profound crisis. But before turning to the 1960s, let us review what can be said of Dadd's reputation in the preceding decades.[1]

While his early career fell from public memory fairly quickly, the British art world never forgot Dadd or his extraordinary story: it was just that they did not know what to do with it.[2] The whole of his asylum work – more than forty years' worth of it – appeared like some grotesquely extended eccentric late phase of a brilliant career. The work could not be criticised by conventional canons, yet it was evidently professional in quality.[3] When, during the 1840s and 1850s, there were opportunities to see Dadd's work at public exhibitions, any press criticism tended

simply to claim to be able to identify traits of insanity. Immediately after the murder, Dadd had two pictures on show at the Liverpool exhibition that appeared to the local press to be beautiful and 'evidently the result of a highly embellished but erratic mind'.[4] Dadd's case was regularly compared to that of William Blake, now gradually being rehabilitated as a noble visionary after long being seen as merely an extreme eccentric or madman. The appearance of several works by each artist at the vast Manchester Art Treasures Exhibition of 1857 prompted the *Manchester Guardian* to ponder the difference between them. While both may have been in some degree liberated as artists by their loss of connection to the world around them, Blake lived and died immersed in beautiful thoughts, whereas Dadd really was mad, lost in confused and horrible mental states.[5] The picture of Dadd's which, during his asylum years, had the most success among connoisseurs was his *Water Carriers* 1843 (fig.32, p.62). Praised at the Art Treasures exhibition as having a biblical gravitas, by the 1870s this Palestinian subject was in the distinguished London collection of John Heugh, hanging alongside classic Victorian religious paintings including Holman Hunt's *Scapegoat* 1854–5 and Millais's *Christ in the House of His Parents* 1849–50.[6] The public had various chances to see Dadd's work at Christie's when such collections were broken up, although the only dealer who apparently made a point of buying up his pictures, William Cox, evidently failed to turn them to profit, for by 1884 his stock was itself auctioned off following his bankruptcy.[7]

Towards the end of the nineteenth century, first-hand memories of Dadd were fading. William Frith was still around to tell stories of how Dickens would lead friends to the spot in Cobham Park where Robert Dadd met his death, and in 1888, once he was sure Richard was dead, Frith himself included a chapter on his old friend in the last volume of his memoirs.[8] But there was nowhere obvious for potential Dadd fans to go for information. The books at Bethlem and Broadmoor containing details of Dadd's life were still being used for other patients and were not yet part of any kind of accessible archive. Dadd's family, as we have seen, were desperate to move on from what had happened long ago in the 1840s. Although the sons of Richard's brother Robert were now artists themselves – Frank a prolific illustrator and painter of historical genre, and Stephen a specialist in canine humour – the more material, genetic understanding of madness current from the late nineteenth century cannot have encouraged them to want to associate themselves with their once-famous uncle. The 1890s was of course also the period in which half-digested medical theories of genetic damage were turned into ammunition in cultural battles, as 'degeneration' – racial backsliding – was attributed to apparent signs of *fin de siècle* decadence. I claimed at the end of the last chapter that British asylum doctors had little diagnostic interest in their patients' art. But many other people looking for evidence that 'sane' culture was going mad took a lively interest in 'the art of the insane', for any parallel between asylum art and these critics' mainstream targets would help their cause. Paradoxically, then, psychiatrists with artistically talented patients found themselves, despite their disavowal of such art's medical interest, drawn into cultural battlefields.

THE SANITY OF THE INSANE: WORK BY MAD ARTISTS, AT "BEDLAM."

PHOTOGRAPHS BY ILLUSTRATIONS BUREAU.

1. A HEAD SUGGESTING A STUDY OF A JAPANESE: A DRAWING BY A MAD ARTIST.

2. ILLUSTRATING "THE PASSIONS—AGONY—RAVING MADNESS": A SKETCH BY A "BEDLAMITE."

3. MORE ECCENTRIC THAN VERY MANY OF THOSE SHOWN WITH IT: A LUNATIC'S DRAWING OF A HEAD—WITH AN EXAGGERATED NECK.

4. APPARENTLY INFLUENCED BY JAPANESE ART: A MADMAN'S SKETCH OF BIRDS AND TREES AND WATER.

5. THE CLASSIC AS IMAGINED BY A MADMAN: A CHARIOT-RACE IN OLD ROME.

6. THE MODERN SEEN BY A MADMAN: HOUNDS AND FOLLOWERS OF THE HOUNDS.

7. SHOWING THE HEAD OF THE FISH EMERGING FROM THE WATER: "CATCHING A FISH."

"The Exhibition of pictures and drawings by insane people lately held at the Bethlem Royal Hospital proved, at least, one thing," the "Times" points out—"namely, that a great deal of nonsense has been talked about the art of the insane and about the connection between art and insanity. There are, for instance, people who wish to believe that artists, whose work they dislike, are mad. For their purpose this exhibition proved either too much or too little. It contained one drawing at least that might be called Cubist . . . but then it also contained many works executed in a sound Academy style. . . . One thing at least is clear from it—namely, that lunatics have no one style of art peculiar to themselves. They vary both in style and in merit, just like sane people. Some have accomplishment and some have none ; and some know how to make use of their accomplishment, while others do not. Even where madness shows itself in their work . . . it sometimes seems to be a hindrance to them and sometimes a help."

Bethlem's Superintendent at the turn of the twentieth century, Theophilus Hyslop, was exceptional in that he evidently enjoyed this new role. An amateur artist himself, and deeply reactionary, he agreed with the Hungarian Zionist Max Nordau in seeing degeneracy everywhere in modern European culture. Above all he hated Modernist art – the Post-Impressionism famously introduced to London in two exhibitions curated by Roger Fry in 1910 and 1912 – which was regularly compared to the art of the insane. Hyslop wrote that truly mad artists made pictures compulsively and seriously; the Cubists and Expressionists however were shamming their insanity, as the critics who championed them must have known. Hyslop borrowed the term 'mattoid' from the Italian psychiatrist Cesare Lombroso to describe a 'borderland' of weak people living somewhere between madness and sanity.[9] Whether one should assist such biologically unfit types to survive, or whether the promoters of 'degenerate art' should be encouraged to perish was, concluded Hyslop, a difficult question.

In 1913 one of Hyslop's predecessors as Bethlem Superintendent, George Henry Savage, instigated an exhibition at the hospital (as part of a huge London medical conference) that returned to the question of modern art's relationship to degeneracy.[10] Savage had left Bethlem in the 1880s for private practice, and had apparently amassed a collection of patient art from various sources. Together with works lent by other doctors, and along with a selection of children's art (another supposed equivalent of Modernist painting), in 1913 this formed part of a widely reviewed display that, it seems to have been assumed, was intended to allow the question of modern art's parallels with the art of the insane to be properly debated. On these terms the exhibition was a success, even making the front cover of the *Daily Mirror*, where one of Dadd's *Passions* watercolours – *Agony – Raving Madness* (fig.70, p.129) – was reproduced, alongside works by other patients evidently selected on the basis of their superficial resemblance to various strands of European avant-garde painting.[11] With regard to Dadd, the more considered reviews of the exhibition simply observed how little his fundamental technique had been altered by his illness.

In this extraordinary exhibition we can see the roots of what was eventually to become known as Outsider Art. At Heidelberg a few years later, the German psychiatrist and art historian Hans Prinzhorn began to assemble his famous collection of psychiatric patient art, intrigued again by its apparent parallels with modernist practice.[12] Lombroso, as early as the 1880s, had sought to identify general characteristics within the art of the insane, classifying it on its own terms and in effect pathologising certain supposed graphic or compositional tendencies, a line of interpretation that became commonplace from around the time of the Second World War. But Dadd never came near matching these supposed 'symptoms', that now hackneyed list including obsessive pattern-making, the use of symbols and calligraphy, and the invention of creatures amalgamated from human and animal parts.[13] On the contrary, his asylum art did not seem to say much about his condition. I think that the experiment of closely comparing 'the art of the insane' with Modernist painting pointed up sharply Dadd's

difference from both. He remained a thoroughly trained academic artist whose works belonged in museums. As we have noted, the British Museum began its collection of Dadds in 1876 with *Recklessness* (fig.99), a drawing described at the time as being a model of good technique, manifesting the 'utmost refinement and … a freedom of handling that is now rare'.[14] By 1919 the curator of the Print Room, Campbell Dodgson, even wrote a note for the *Burlington Magazine* celebrating his receipt of *Port Stragglin* (fig.55, p.105). This had been a bequest from Robert Ross, the art dealer and intimate of Oscar Wilde (one of Nordau's *bêtes noires*), who had become deeply interested in Dadd and made some effort to begin research into his life.[15]

For most of the twentieth century, discussion of Dadd's work shrank to a focus on a single picture: *The Fairy Feller's Master-Stroke* (fig.74, p.137), painted, as we saw, at Bethlem for G.H. Haydon. It was acquired around the time of Haydon's death by the omnivorous collector, Alfred Morrison, who had already bought Dadd's *Contradiction* (fig.68, pp.124–5) at Hood's sale in 1870.[16] For some time, the two pictures hung together as pendants at Morrison's Wiltshire seat, Fonthill House, built over the remains of William Beckford's Gothic Revival extravaganza, Fonthill Abbey. The *Fairy Feller* passed to Morrison's daughter, Lady Gatty, who gave it to the poet Siegfried Sassoon around the time of his marriage to her daughter in 1933. Sassoon was of course famous as a poet of the trenches of World War One, when among his closest comrades had been Julian Dadd, the son of Stephen Dadd (the dog artist). Julian, whose two brothers were both killed during the war, was himself shot in the throat and later suffered a severe breakdown.[17] Sassoon recalled taking Julian to meet the Richard Dadd enthusiast Robbie Ross (it must have been during the war), but apparently even then Richard's illness was never mentioned, so taboo a subject had it become in the family.[18] Later, in the 1930s, Sassoon was able to show Julian the *Fairy Feller*, but sadly not long after this Julian took his own life.

For a few years in the later 1930s, Sassoon lent the *Fairy Feller* to the Ashmolean Museum in Oxford. There it was admired by, among others, the poet E.H.W. Meyerstein, who was inspired to write a rather poor sonnet on Dadd, and Laurence Binyon, another poet and art historian who had succeeded Dodgson at the British Museum Print Room.[19] Binyon wrote a brief article on Dadd for the American *Magazine of Art* in 1937, reproducing the *Fairy Feller*, but was unable to do much more than note the existence of some other works by Dadd in public collections and remark on the apparent parallels between Dadd's imagery and Surrealism. The same year saw, in Sacheverell Sitwell's *Narrative Pictures*, another expression of admiration frustrated by the lack of any further available information. Sitwell, who himself owned Dadd's *Flight Out of Egypt* (fig.46, p.93), wrote that Dadd 'was one of the two or three most interesting of our painters during the nineteenth century' and that he now held 'an especial appeal to the most recent fashions in painting', by which he must again have meant Surrealism.[20] It was not, however, until 1970 that a Surrealist – if we can thus label the Mexican writer Octavio Paz – eventually wrote about Dadd. Paz had seen the *Fairy Feller* at the Tate Gallery while staying in Britain, and the picture makes an appearance in his wonderful 1974

99
Sketch to Illustrate the Passions: Recklessness
1855
Watercolour on paper
35.8 x 25.9
British Museum,
London

Sketch to illustrate the Passions. The Recklessness.
by Richard Dadd Bethlehem Hospital London March 19th
A.D. 1855

book *The Monkey Grammarian*. The painting had arrived at the Tate in 1963, given by Sassoon 'in memory of his friend and fellow officer Julian Dadd, a great-nephew of the artist, and of his two brothers who gave their lives in the First World War'. The elderly Sassoon had rescued it in the nick of time from a London auction to which the picture had been consigned in his name by an unscrupulous dealer, to whom it had been entrusted for valuation.[21]

The appearance of the *Fairy Feller*, perhaps Dadd's most ambitious painting, in Britain's most popular art gallery, marked the beginning of his thorough reappraisal and renewed fame. The picture quickly became a favourite among visitors, and before long posters of it were to be seen in homes around the country. By any standards it was of course a fabulous work of art, but also the timing of its arrival could not have been better. The early 1960s saw the decisive turning of policy-makers against the asylum, while intellectuals began to be seduced by the idea that all psychiatry was corrupt, even that mental illness itself was a function of societal repression, not a disease appearing in an individual's brain. In just one year, 1961, there had appeared Foucault's radical re-reading of the history of the asylum, *Folie et Déraison: Histoire de la Folie à l'Age Classique*, Erving Gofmann's *Asylums: Essays on the Social Situation of Mental Patients and other Inmates* and Thomas Szasz's *The Myth of Mental Illness*. In Britain in that year, the Minister for Health, Enoch Powell, announced in the most dramatic terms that he intended to set 'the torch to the funeral pyre' of the Victorian asylums.[22] A consensus embracing, so it seemed, just about everyone from Maoists to the Conservative Party was forming against the arrogance of psychiatry and its abusive institutions. The tide of feeling that gathered to tear down the asylum was worthy of the similar swell of emotion upon which it had been built.

Here at last was a role for Dadd. Surely he was the hero of the new Victorian asylum story – the artist who had maintained his integrity despite being put away for decades, an outrageous imagination that refused to be eclipsed. And he had yet further credentials as a prospective icon of what was by the later 1960s being called the 'anti-psychiatry movement'.[23] He had killed his father and had gone mad while being pressed into service as an Orientalist. This suggested his potential relevance to R.D. Laing's Oedipal interpretation of schizophrenia as a reaction to the impossibility of family life, and to the connections made, for instance by Frantz Fanon, between mental illness and the psychic violence of racism and colonialism. As the anti-psychiatry movement allied itself to anti-colonialism, and to the revolution that once again seemed possible in France, 'the schizo' could be fondly imagined, as he was by the philosopher and psychiatrist double-act Deleuze and Guattari, as a new type of person freed from the shackles of all oppressive ideologies.[24] Could Dadd stand as their ancestor? A start was certainly made in the process of promoting him to this position. A review of Jeremy Maas's pioneering textbook on *Victorian Painters* in the left-wing *New Statesman* (titled 'Turn me on, Dadd') suggested that the revival of interest in all things Victorian would remain a tasteful affectation unless the suppressed sex and violence of the age, as manifested in Dadd, were acknowledged.[25] In 1971 the notorious counter-culture magazine *Oz*

ran an article on Dadd ('The Daddy of Them All') that sat alongside an interview with a pornstar with an erotic interest in pigs and a review of the *Anarchist Cookbook*, the DIY urban warrior handbook. The piece rehearsed the clichés of old Bedlam with its vicious doctors and filthy conditions, and ended in imploring the reader to 'join the crowd of children and freaks who make the pilgrimage to the Tate basement and stand mesmerised in front of the Fairy Feller's Master Stroke'.[26]

The time was ripe for a major book about Dadd, maybe along the lines of Foucault's enthralling 1973 study of another nineteenth-century parricide, Pierre Rivière, in which a single well-documented case was used to tease out the professional boundary disputes between medicine and the law. But the study of Dadd remained badly hampered by a lack of facts, and these were only ever going to come from two possible sources: the art market, with its contacts among the private collections in which Dadd's surviving works were hidden, and the hospitals in which he had been a patient. It was an auction house expert, John Rickett of Sotheby's, who made the first serious, if brief, effort to break the stalemate with his well-researched article of 1964. Sotheby's had recently sold both *Titania Sleeping* (fig.10, pp.22–3) and *Contradiction* (and very nearly the *Fairy Feller*), while Rickett himself owned several works by Dadd including *Puck* (fig.13, p.28) and *Come Unto These Yellow Sands* (fig.15, pp.32–3). Sadly his early death in 1970 prevented his research being taken further, until his papers were made available to what was now emerging as the centre of Dadd studies: the new archive and museum at the Bethlem Royal Hospital.[27]

Bethlem had left Lambeth for its present home at Monks Orchard near Croydon in 1930, and in 1948 had been absorbed into the new National Health Service. The ancient foundation mitigated its consequent loss of independence by uniting itself with a teaching hospital, the Maudsley, and by starting to trumpet more loudly its own history.[28] Bethlem's history was indeed a long and rich one, and already in the nineteenth century the hospital had made use of it – initially in order to point up change, as in Hood's comparison of his own casenotes with the inadequate ones of earlier years, and the display of disused iron manacles in the vestibule, again to suggest how far the bad old days had been left behind.[29] Later in the nineteenth and at the beginning of the twentieth centuries, entirely confident now in its professional security, Bethlem's historicising became more antiquarian, Daniel Hack Tuke seeking to reconstruct the architecture of the original Bishopsgate building, while the Revd Edward O'Donoghue, Chaplain from 1892, assembled a huge collection of lantern slides to illustrate his regular talks on the hospital's history, which complemented his book of 1914, *The Story of Bethlehem Hospital from its Foundation in 1247*.[30] John Hamilton, the last of Bethlem's Physician-Superintendents, stayed on at the hospital after the merger of 1948, becoming in effect O'Donoghue's successor as the institution's unofficial chronicler, and it was only on his death in 1967 that for the first time a professional archivist was employed at Bethlem to care for and interpret its centuries of records.[31] Laing and other anti-psychiatrists had championed the patient's right to speak back to the discourses of medicine, their right to a narrative of their own. Now, with the

asylum's reputation decidedly on the back foot, Bethlem itself was in a position to speak back in turn.

Thus it was that those wanting to give or receive information about Dadd now had a place to go. The archivist, Patricia Allderidge, made the first of her many contributions to the study of the artist in 1970 when she published his Bethlem casenotes. A proposal made in that year to the Tate Gallery to mount a full Dadd retrospective was eagerly accepted, resulting in the indispensible catalogue – in effect a catalogue raisonné – of 1974. (This immediately superseded David Greysmith's less thorough book on Dadd of the previous year.) Allderidge's book is so well documented (by the standards of what was available at the time) and so complete in its listing of known and recorded works that, unintentionally, it gave the impression of being the last word on the subject, and the study of Dadd appeared to stop at this point. Now queries about Dadd had to be addressed to Bethlem. Anyone making comments about any aspect of Bethlem without going through the archive risked a severe reproach, especially anyone minded to raise the question of its past cruelties without getting their facts straight.[32] Art historians, perhaps not the most determined of archive-botherers in any case, learned to leave the subject of Dadd alone. He belonged, once again, to Bethlem, and any prospect of a Foucault-inspired book on Dadd as a case study with which to deconstruct the discourses of enlightened progress within asylum medicine faded away.

It was therefore left to creative writers to interpret Dadd, who has indeed become the most fictionalised of any British artist. Angela Carter's radio play *Come Unto These Yellow Sands* (1979) and Michael Hofmann's poem 'The Late Richard Dadd' (1986) are both based on extracts from Allderidge's 1974 Tate catalogue. (Freddie Mercury's lyrics to the rock band Queen's 1974 song *The Fairy Feller's Master-Stroke* must have been based on lines from the *Elimination* manuscript published by Greysmith the previous year.) More ambitious have been the attempts to imagine Dadd's interior life, inventing his memoirs, an idea taken up in books by Isaure de Saint Pierre and Jennifer Higgie, both wonderfully sensitive evocations of Dadd's travels and brave attempts to render his interior life convincingly. Dadd and the *Fairy Feller* have made appearances in many other novels and short stories – those by Terry Pratchett and Robert Rankin are perhaps the best known – while the Dadd family plays a minor background role in Pat Barker's great *Regeneration* First World War trilogy.[33] Dadd continues also to be adopted as the subject of plays for radio and stage. Artists on the other hand have not entered Dadd's world with anything like the enthusiasm of writers.[34] His biography perhaps requires ventriloquising, but his art must speak for itself or not at all.

Elimination of a Picture & its subject – called The Feller's Master Stroke

This poem fills all the rectos of the twenty-four leaves of a small notebook now in the Bethlem archives, the writing getting suddenly smaller towards the end; the text is reproduced here exactly as in the manuscript, with page breaks marked. The poem is discussed in Chapter 4. Here it is illustrated with relevant details from Dadd's painting (see fig.74, p.137)

[1] Half twelve, that's six, 'tis more
Perhaps, exact that's gone before
Behoves not here to say,
How many years away
Have welled up and flowed on
Slow passing till they're gone.
But some such time has fled
Since regular business led
To where a canvas glowed
With fays, a leafy node
Encircling wild about.
Their differences they let out
About an Indian boy,
Whom for a toy
To while the time
Or teach to mime
Or verse in fairy tricks,
A mighty King his eyes did fix
Upon with covetous regard;
When met upon the sward,
[2] Near Athens' learned seat[1]
His Queen had set her feet
Thrice happy green – business
Led, an official person to this sight
Who with the picture pleased
As 't'were a jewel bright,
His mind of burden eased,
To have the like
Of which did strike,
At fancy's shrine well meant.
If 't'was not so, then I may say
'T'was this perhaps, that west away
Some friend he had, who wrote in verse
About the fairies, sense as terse
As poets jam into a measured line
And gives such extra value I opine
To Heliconian jest.[2] So of his rhymes
Possessed, he wished to see
A little sketch, slight as may be
To illuminate the same –
Some stanzas shewed as game
Or point from which to throw
[3] As much as to need enow
Illumes
I had a cloth myself prepared
Oft it had idly on me stared
By license of the Muse to say I mean,
As 'gainst the wall I saw it lean.
By paint smeared o'er & fit for use
Not smooth but of a texture loose,
A homely business on a frame

Strained & for such, not very lame.
The tint was cloudy – as I say
The cloth being roughish in the web
And thus fell so – my stead
To suit the stanzas, what mun I do?
As Yorkshire lad, in Lunnun[3] new
Come up, might ask his sen[4]
So I – no subject in it then,
Defined! – But waiting for
That flight of fancy wild
Artists are oft compelled to draw –
– so mild – A flight unseen by him
Who has it now just pat
Or thinks he has
[4] Sees nothing clearly as his hat
Blackly impositive and soon
Makes it as clear as sunny noon
That he has not –
Waiting this heavenly gift
I thought on nought – a shift
As good perhaps as thinking hard.
Fancy was not to be evoked
From her etherial realms
Or if so, then her purpose cloaked
And nuzzling the cloth, on which
The cloudy shades not rich,
Indefinite almost unseen
Lay vacant entities of chance,
Lent forms unto my careless glance
Without intent, pure fancy 'tis I mean
Design and composition thus –
Now minus and just here perhaps –
– plus –
Grew in this way – and so – or thus,
That fairly wrought they stand in
view.
A fairy band, much as I say, just so
'tis true.
[5] Part from the shades designed
Part a vain fancy, all inclined
A common end to gain
Of nothing something still
To stand before, the sight to fill
Something we have, having, we
yet have not.
Be it so or nay, why care a jot?
But there they are – and now
They stand a theme – a field to plough
And silent reap what any choose
Judiciously or not to loose.
All, the significance may give

They surely think in this doth live
As Nature's Pages open spread
By erudite or fools are read,
To this one seems the world a den
While that a paradise in it doth ken
In the same place, 'tis lore
Preacquisite, the wise man's store
Gives oft a value rich & full
To that sprung from a sense so dull
It does not half appreciate
Upon the which it doth dilate
[6] Dilatory, dull, absorbing, rapt
In the sort of a kind of a –
something mapped
While struggling reason roams
away
Nor will in such dull fetters stay
But leaves the author out of himself
To make his fame or gain his pelf[5]
If so he may or can –
But to the common mind
The meaning thus, let's find –
For idle pastime hither led
Fays, gnomes, and elves and
suchlike fled
To fix some dubious point to fairies
only
Known to exist, or to the lonely
Thoughtful man recluse
Of power a potent spell to loose
Which binds the better slave to worse
Swindles soul, body, goods & purse
T'unlock the secret cells of dark
abyss
The power which never doth its
victim miss
But may egorge when truth appears
When fail or guns or swords or spears
[7] For some such end we may suppose
They've met since day hath made
its close
Night's moon time haply extra bright
By fairie power made all so light
Doubtful if night or day might reign
To certain be in mind resolve again
And say that common nature is not
true
Precisely to what fairie opes to view
Comme ça for the effect, if you should
doubt
If you've not been there, perhaps you

mought

Make a fresh bend; we'll now advance

These folk displayed as in a trance

Have not the dexter[6] object here

But the same might be sinister

For saintly doubtless it is rare

To call a goblin elf, the lair

He loves, or any thing or sprite

That in the name of fairy doth delight

Or e'en the land itself

Laden with unimpossible wealth

To the mutton says Monsieur Crapaud[7]

This meet unto the Patriarch owed

Say its conclave – and here to shew

His triple crown of subtle might

Weird in its form & shining bright

An arch magician whose large little

club

[8] Of some hard heavy wood is but a stubb

And might be loaded in its larger butt

Force to add when to use 'tis just

But even without no fairy skull

Resist it might however thick or dull

A little bit of wood just a mere twig

For which a plodding mortal less than

a fig

Cares – but to an elf it has

A power as fatal as the Upas.[8]

If on a sudden it descends

On fairy sconce, its revel ends

And then you know poor little fart

Unto another private realm he will

depart.

"Don't want to hurt poor little fa-er-ee"

Appeals the rogue unto the powers that be

The arch-fiend sees no dodge illicit

'Bout younker[9] caught,—is not explicit

Or he might say "Don't let me catch

you here again

Or perhaps you'll meet with far too

much sharp pain

And stunning effects the same to

follow – Which will not leave you

time to holloa!" ————

Beneath his wide spread crown

He casts a glance adown

Dim vistas of the pregnant coming bustle

To note if there is aught to stay or hustle

[9] The incident peculiar here

Inciding edge incising clear

Or so to do.

His right hand raised, seems to declare

"Except I tell you when, strike if you

dare – For all the powers of skill or chance

Fairies can use before my glance –

are bare"

'Tis so – no doubt, but even Almighty

Power

Suffers defeat each day & every hour

As unforeseen some little trifling thing

Cheats of a stave, another song we sing

His glance means likely too

If t'other is not much ado

He with one blow, another turn will

serve

If from the aim's intent it doth not

swerve

Left to its time & how to do

To split, for Mab perchance a chariot

new. 'Tis all the skill there is for

such a deed

Happen, happening in faërie for fairy's

need

See – 'tis fay woodman holds aloft the axe

Whose double edge virtue now they tax

To do it single & make single double

Featly and neatly – equal without

trouble

'Tis not yet done – yet there he stands

[10] Try if he'll do it – for your own commands

He knows the axe to use on fairy trees

And fairy common sense embodies

if you please

If that your fancy you can strain so
far. As to suppose the same & yet not mar
Your mental method and decorum
Where all things shew them quasi coram[10]
He's clothed in leather note from top
to toe. All of one colour you may
mark also. The colour of his money
you might say. Good or bad adding
lack-a-day. How can I tell ? –
Splitting is either good or bad
For not so the same terms are had.
And that's his money so to speak
Merely tho' tis about a freak.
As to the colour this we'll add
Tis warm enough for fairy mad
But fairy leather comes from victims
small. Tho' if they're cattle fed in
field or stall. I know not –
A bat's wings dyed to suit the taste
But to the next one let us haste.
The ostler from the fairy inn
Knowing his air, the curate of the binn[11]
Hands to his knees and body bent
[11] On the nut's destiny is all intent
With well spurred heel can ride amain
Stirrup or saddle recks not to maintain
His seat the which so well he knows
Secure the menage that around him grows
That is a look of mastery as 'twere to say
There is no dodge to me doth lay
Concealed where asses dogs or varmint[12]
be, I am a doctor veterinaree
They call me night or moon as't ere
I am – price –
I know full well of beasts & in a trice
Your Servant Sir your ass I'll groom
And show you to the fairy inn's
best room. What are you at there?
Steady ho!!! – Do you think his gaze
will help the blow.
Next a dwarf monk with shaven crown
On the bank's brink hath cast adown
His wide sleeved arms & rests his chin
Partly his face his hands conceal – I
put him in –
For why? because I may reply
Monks beatific mount they say on
high.
[12] But as historians do aver
About their manners some demur

Checks the free access unto Heaven
And then, of that to speak with leaven
Of circumspection, unto a nether region
they adhere. Not holding on to it very
tight I fear. And where there is but
little wine or beer.
For wandering habits also tis well known
Led the same blades about from town
to town And this with inns & ostlers
too. Familiarly acquainted grew.
Says he's a rogue & to the next,
'Tis varhma's[13] ploughman claims
the text. He has a twinkle in his eye
Bespeaks good humour you'll descry
Of cows & sheep & crops can talk
Quite wonderful & see him walk
With lounging stride across the fields
Just turned afresh to raise the crop
that yields. Ample return for all his
labour. That wants no sound of pipe
& tabour. His doubtful speech he hath
addressed. To waggoner will beside
[13] him lest The sage remark quite lost
should be. But how indifferent will
is – see. 'Come hither.' Woah is more
to him Than such a speculative whim
Above Clod-hopper sits and like the
sod – He's brown in colour also he's
well shod. A satyr's head has,
buckles in his shoes. Nurses one foot
upon his knee amuse with him

Yourself he's modern fay. So gives
his garb & decent sylvan he Is not
stark naked & so proud might be
A foot and not a hoof to own. But
can he put a hat upon his crown?
His horns forbid – say that it slid
From off his pate & fell
Where! he nor I can tell!
There let it be ———
The Politician next, with senatorial
pipe. For argument or his opinion
ripe. A First chop Englishman
at that sort of chaff. To hear him
talk, Lord! how 't'would make you
laugh. For fairy politics differ so
[14] very wide From human governments
complete divide. He's pondering
matters now as if his vote Ought to
be given ere 't'is smote. The nut –
I mean – Next him observe one
clad in green. An unknown character
some fairy dandy. Making a break
as sweet as candy. To faery nymph
like him so quaint. They are poor
ones clearly and attaint. The present
case, because 't'is queer, And like
themselves – yet no small beer.
They deem of their own station.
Behind them elves quite wide awake
Notes of the doings here to take
And to their fellows bye and bye
Tell all without a word of a lie.
Below a pedagogue appears. A
Critic up to sneers & jeers, And
by his faun-like ears he's wild
Untamed himself, each fairy child
He tames with many a look severe
But if his glance is there or here
'T'is hard to say. He squints to note
[15] You may. But he'll not meddle
with a work so sharp. Waits in sus-
pense and doth not carp. His business
is to teach to do. Do it himself?
Oh no! tis you. Next come two
wenches rather smart. From lady's
chamber where each art. Of fairy
luxury they the care, At madams
need can well prepare. This holds
a mirror in her hand so tiny. A
magic surface polished bright &
shiny. While that a broom to sweep

away. The fairy rubbish lack-a-day
Holds in her left hand on her right
A favourite hawk moth doth alight.
They've got good legs and feet so
small. Bavaria Flanders Germany
and all. Can shew no more fan-
tastic limb. Critics are severe 't'is
therefore that I beg. You'll not in-
form that fay, that under the leg
Of one of those maids, behind his
back. A satyr peeps; at what, it
[16] doth not lack, An explanation. At
such a book, His right to look, I care
not to dispute. Such secrets surely
some must know. All are not saints
on earth below. Or if they are they know
the same. Or are shut out from natures
game. Banished from natures book
of life, Because some angel in the
strife Had got the worser fate. And
they close their eyes, that gate By
which reminders enter. And in a
paradise of fools contented live. Fays
also are not saints, so I must believe
That this and similar frolics they
achieve. The truth is not for all you'll
say. But that eternal seal it
bear, One might say nay. Who are
the Victims of that cruel fate False
secrecy, that sometimes 't'is too late.
To find – lost to their race for ever they
In other spheres can understand the
light of day ——— Next Lubin[14] bending
o'er his flame. Chloe or Phyllis[15] hard
to tame. With wooden sabots round
about she'll clatter. Churn fairy butter
or some such matter. As to the dairy
[17] doth belong. Whiling and charming
time with song. They're rustic Lovers
rustic in manner. And Lubin happen
is a fairy tanner, Tanned woodman's
leather coat and cap, His leggins, all
their boots mayhap. Except his sweethearts
they are of wood. He'd do them too to oblige
her if he could. They are curious in this
business you see plainly. See also next
below, two dwarfs – ungainly? No
for the sake of rhyme it fits so well –
We'll write it down – and after tell
That 'tis deformity approaches near
The truth about this couple here. A

fairy conjuror he who knows a trick
Or two at cards and in the nick – Of
time, can well deceive. Thus, of your
reason you take leave. Then 'tis that
he will do the clever dodge. Which puz-
zles many a clownish varhma Hodge.[16]
You think perhaps you don't do so. The
prayer book so affirms I know. ———
Just now he offers out to let. 'T'will or
't'will not be surely split. Some odds
perhaps will give. What fairy coin is
true as I live. I can't inform – nor if they
[18] betted. And if they did, the profits netted
The spider near his web hath left.
Dropt down upon them from some cleft
Where he spread his wide snare for game
One that detains yet doth not maim
Perhaps he's an offer when they have
done. To supply with gossamer webbs
all, every one. A master weaver he in
whose employ The lesser spinners may
enjoy, Profits & learn to make account
Of those who wish aloft to mount. And
sail away upon the wind. From Europe
p'raps to furthest Ind. They've only
wind to ask for – 't is the weather. That
in this case saves the expense of leather
And pilgrimages ——— let's make one
To the opposite side – That is, objection
if you've none. Two braves we see –
Sir gallantry – who by their wits can
live. Can sing or play – Fight, run a-
way. Or entertainment give. Your fairy
man upon the town. That can clean out
a swell or clown. And if there's need
can let you down – A peg or two – so
high they fly. Hawking while talking
all my eye ——— Next to the Patriarch's
Crown attend. And mark the motes
[19] that there descend. Dancing and sing
ing there they go. With their fal lal
the rah and huy gee wohe. The dress
is Spanish tis in use, At present time
if I abuse, Not memory of the source
From which I borrowed {them it of course
Call cottagers, no bloods are, these;
As on a tight rope they to please
I represented – when in the play – One is
dressed like to Duvernay.[17] Balancing
these on the other side. Queen Mab
in Car of State doth ride. Some

atomies the poet says[18] did draw
A gnat gives to them coachman's law
I never saw the famed Queen Mab
or might, Had it been so contributed
delight. The atomies are, no doubt,
a dubious theme. Like tiny female
centaurs here do seem. Half beast &
half a woman yoked are. With wings
to soar away in regions far. Under
the coachman standing nigh. Two
little pages you may spy. Cupid &
Psyche they enact. Fairies no doubt
possess the tact. To imitate like mortal
[20] players. I know not if at theatres or
fairs. It needs must be so ———
Fairies tis said shun all display
And most affect the pale moon's ray
Sol's potent ray soon drives them off
He'd instant find whereat to spurn
and scoff – Just so it was with folk
in olden time, Whose practices were
held to be a crime. They fled the powers
that held despotic sway – Poor little
fairies! why not also they? Fancy
this pair aught else 't'will do, But
male and female they are plain to view
Next to the Queen you here behind may
count, Some strapping fairy footmen
mount And garde chemin no doubt
they well do serve. Tiny in size but
lusty in the nerve, as every footman

should be ———
Above in attitude of fondest love
King Oberon & his Queen approve
The sport else why should they repair
To this sequestered spot the same to share
Merely perhaps to note the way things
went. And how many chops were useless
made anent. Pulling of straws out from
a stack of wheat. Is for a pastime not
[21] more meet. And such the Old Lady in
the Scarlet Cloak, might now be fancying
true – no joke. Is it true for me or even
you – true if you care not – this is true.
Her nose and chin will never crack
The monster nuts & many a whack
From club or shining axe will want
Ere the chance fatal lights upon't
Above the harridan some whose names
Serve schoolboys turn when at their games
They of the future calling prophecy
With boisterous laugh and ecstacy. Of
childish mirth, nor want they perhaps a
forced imposed belief. In soldier and
sailor, tinker or tailor ploughboy
apothecary, thief. Counting their buttons
down the vest, A name to each – the last
doth rest The fated trade – soon from
the thoughts tis laid Aside and fairy
prophecy forgot. Here let me say my
let of this same lot ———
The ragged soldier sure is mad. Made

so by wounds, debauch and glad But
hard earned victory. Being fay, I've not
the history. I made it so but not from
spite. Else he'd find reason to requite
But ragamuffins to enlist. He's a brave
[22] spirit to assist. Knows when he does he'll
be Commander The chief one or a Sala-
mander. A real fire eater like the Sun
By his own bravery surely won
The sailor keeps a pleasure yacht
Has nought to do but live on what
The smiling elements that never frown
Freely disclose as up and down For
pleasure merely roam about. The fleets
of vessels of which he'll take Entire com-
mand for the nation's sake, Nor cares
he where to move or swim. Till death
commands to dowse the glim. Some
other oceans then he'll try, Rolling
eternal in the sky ———
The tinker next with barrow trig
Knows every wandering gypsy rig
Where does he lodge? tis hard to say
Whether a house or stack of hay
Serves the poor outcast for his rest
He's butt howe'er for many a jest
Lives in a world of nether pose
Mysterious obscure your senses lose
Or cast aside as nothing worth
Nor length it has no breadth or girth
Just now he marks the filbert big
Stript of its natural russet wig
How would he here his skill to prove?
[23] He'd grind it p'raps? Not so by Jove
Clumsily skilful though he be
He knows too much for that d'ye see
Around the fairy villages he'll stray
Knives scizzors to grind might bawl
each day. Knows well the tailor reg'lar grinds
his shears. Ah! that's a tailor brave that
knows no fears. Nine fairy tailors would
not make a man Tho' they might queer
him, you know well they can. But this
one seems disposed to queer, The plough-
boy that is standing to him near Shewing
him a coat neat made and very strong
T'would last the lad his fairy life time
long. But while he doubts the same to
buy, The Thief his craft on him doth
try. Loosens his handkerchief so gay.
Too artful he to snatch away. The doc

fold Unto the picture brings grace which else was wanting to its face But tied at length unto a stem Shews or should do finitam rem[20] – The size the nuts do here display. Forgive, nor make me forfeit pay Having the benefit of doubt Of what the fairies grow without The reach of human ken or will And needs not now that I instil Into your mind, what here I've said from fancy's wing A sense supporting at my need You may deny – say – no such thing Tis all wrong every bit indeed. Well, to your judgment I must bow Freely its exercise allow you perhaps to such are more inured. Your notions may be more endured But whether it be or be not so You can afford to let this go For nought as nothing it explains And nothing from nothing nothing gains – R[d] Dadd. Broadmoor, Jan[y]. 1865.

tor in his thoughts reserved. The trick below hath not observed, But with his sounding pestle beats, The drugs that he to fairy metes. His mortar would not hold the nut. But holds enough for fairy gut. A nostrum or a panacea At any price we'll say, not dear. Next to the Soldier on his right, a Dragon Fly exerts his skill & might, Sounds the [24] long notes 'long the long tube that wind and in the fairy hollows echoes find. To assist this gaudy long legged trumpeter a tatterdemalion & a junketer Holiday folk that tends upon, Like a Postilion[19] if you con Each blows his brazen tube no doubt in tune with Dragon Fly that rests his leg abuve The jutting stone on which they sit Expecting company that soon will flit slanting along the Lunar ray Like boys & girls come out to play – Now behind these last named two an elfin takes a peeping view not at the nut but the spectator Happen to mark if arbitrator He in this re-markable fudge Or humbug gives the fatal nudge. Peeper is wildest of the crew Cares nought for them or I or you. You from his cap with me perchance agree Of the Chinese Small Foot Societee, He's a small member. But if Confucius sent him Now I can't remember. Turn to the Patriarch & behold Long pendents from his crown are rolled, In winding figures circle round. The grass and such upon the mound, They represent vagary wild and mental aberration styled. Now unto nature clinging close Now wildly out away they toss, Like a cyclone uncontroll'd sweeping around with chance-born

NOTES

1 *A Midsummer Night's Dream* is set in and around Athens.
2 Mount Helicon in Greece was sacred to the muses and emblematic of poetic inspiration.
3 Lunnun: London.
4 Sen: sense.
5 Pelf: money, reward, spoils.
6 Dexter: to the right; cf. sinister (in next line): to the left.
7 Monsieur Crapaud: type of a Frenchman.
8 The Upas tree was a legendary source of poison for arrows.
9 Younker: youngster.
10 Quasi coram: as if present.
11 Binn (Gaelic): verdict, judgement.
12 Varmint: vermin.
13 Varhma: farmer.
14 Lubin: type of a simple, honest peasant – best known from John Clare's poem 'The Village Minstrel' (1821).
15 Chloe or Phyllis: Classical female names – both appear, for example, in Horace's *Odes*.
16 Hodge: type of the illiterate English farmer.
17 The dancer Pauline Duvernay made her name with the Cachucha – a stylized Spanish dance, originally from Cuba – in London in 1836.
18 The poet: Shakespeare – cf. *Romeo and Juliet*, Act I, scene 4, line 57.
19 Postilion: boy riding one of the horses pulling a coach.
20 Finitam rem: the completed thing or the end of the thing.

Dadd's Casenotes

Complete transcriptions of the casenotes made by doctors in the three asylums to which Dadd was admitted. The Clermont notes are partially published in Klemenz 2010; the Bethlem notes were published in their entirety by Allderidge 1970; the Broadmoor notes are published here for the first time.

Clermont

Dadd was admitted to the Maison d'Aliénés de Clermont, Oise, on 20 September 1843 and discharged to British authorities on 26 July 1844. Author: Eugène-Joseph Woillez. Source: Centre Hospitalier Interdépartemental de Clermont, Archives Q16.

[Original text in French]

Dadd Richard
Artiste peintre
Agé de 26 ans, né à Chatam, Comté de Kent, Angleterre
Domicilié ordinairement à Londres
Non interdit
Entré le 20 7bre 1843
Placé par arrêté de M. Le Préfet de Seine & Marne du 14 7bre 1843

Copie du Certificat délivré en vertu de l'art. 8 de la loi du 30 juin 1838 :
par Mr. Woillez médecin de l'Etablissement Clermont Oise le 21 7bre 1843

Nous, soussigné, docteur en médecine etc: Certifions que le nommé Dadd Richard, habitant précédemment Londres et admis récemment par arrêté de Mr. Le Préfet de Seine et Marne en date du 14 Septembre courant est affecté d'une aliénation mentale caracterisée par une fixitée d'idées (manie partielle) qui paraît le porter au meurtre.

Copie du Certificat délivré en vertu de l'art. 11 de la loi du 30 juin 1838 :
par Mr. Woillez médecin de l'Etablissement Clermont Oise le 5 Octobre 1843

Nous, soussigné, docteur en médecine etc: Certifions que le nommé Dadd Richard, anglais de nation, admis par arrêté de Mr. Le Préfet de Seine et Marne, est affecté de monomanie homicide. Ce jeune homme a commis un meurtre en Angleterre; il se croit inspiré et obligé d'ôter la vie à certaines personnes au moment de ses inspirations. Il est calme depuis son admission et paraît préoccupé constamment de ses idées fixes.

Notes Mensuelles

Octobre
Dadd est un jeune artiste distingué de l'Angleterre chez qui l'excès du travail (souvent aux dépens de son sommeil) des déceptions inattendues et un séjour assez prolongé sous le ciel brillant du Levant paraissent avoir produit une manie partielle caractérisée par des conceptions délirantes singulières qui l'ont porté à l'homicide. Sa première victime a été son malheureux père, qu'il renie au reste comme tel, et à qui il a dû donner la mort, dit-il, poussé par une impulsion intérieure irrésistible. C'était un diable, comme beaucoup d'autres qu'il devra tuer. La prononciation française est très difficile à Dadd, et on le comprend seulement à force de questions. Ainsi il nous a appris qu'il se croyait le fils du soleil, qu'il passe, en effet, des journées presque entières à fixer sans aucun clignotement des paupières (la pupille reste alors médiocrement contracté) et sans que la vue en épreuve d'autres troubles qu'une coloration rougeâtre des objets. Il a des inspirations du ciel auxquelles il ne pourrait en aucune façon résister; cette voix *intérieure* est celle qui le force à mettre à mort tous les diables (tous ceux qui l'entourent). Ces diables entrent dans son corps et il est souvent furieux parce qu'il est obligé de les cracher – il en voit dans la salive. La santé physique est d'ailleurs bonne.

Novembre et Décembre
Même état mental et physique que précédemment. Les bains avec diffusions d'eau froide ne produisent aucune amélioration.

1844 Janvier
Dadd a été séquestré parce qu'il a tenté, dans les environs de Fontainebleau, de couper la gorge, dans une diligence, à un voyageur qui s'y trouvait avec lui. Son état ne varie pas en janvier: l'incurabilité nous paraît hors de doute.

Février and mois suivants
Etat stationnaire

Dadd, réclamé par le gouvernement anglais, est dirigé, non guéri, vers Londres, le 26 juillet (1844).

[English translation]

Dadd, Richard
Artist painter
Aged 26, born at Chatham, Kent, England
Usually resident in London
Non interdit [not legally certified as mentally incapacitated]
Admitted 20 September 1843
Referred by an order of the Prefect of Seine & Marne of 14 September 1843

Copy of the Certificate submitted in accordance with Article 8 of the Law of 30 June 1838 by Mr Woillez, House Physician at Clermont, Oise, 21 September 1843:

We, the undersigned, Doctor of Medicine, etc., certify that the said Richard Dadd, formerly resident in London and recently admitted by order of the Prefect of Seine & Marne dated 14 September last, is suffering from a mental derangement characterised by a delusion (partial insanity) which appears to lead him to commit murder.

Copy of the Certificate submitted in accordance with Article 11 of the Law of 30 June 1838 by Mr Woillez, House Physician at Clermont, Oise, 5 October 1843:

We, the undersigned, Doctor of Medicine, etc., certify that the said Richard Dadd, of British nationality, admitted by order of the Prefect of Seine & Marne, is suffering from homicidal monomania. This young man committed a murder in England; he feels inspired and obliged to take the lives of certain people at the time of his inspirations. He has been calm since his admission and appears constantly preoccupied with his delusions.

Monthly Notes

October

Dadd is a distinguished young artist from England in whom overwork (often at the expense of sleep), unexpected disappointments and a fairly long period under the brilliant sky of the Levant seem to have produced a partial insanity characterised by extraordinary delirious notions which led him to commit homicide. His first victim was his unfortunate father, whom he however did not recognise as such, and whom he had to kill, he says, being driven by an irresistible inner compulsion. He was a devil, like many others he will have to kill. Dadd finds speaking French very difficult and it was only possible to understand him through repeated questioning. Thus he explained that he believed himself to be the son of the sun, at which he indeed spends entire days staring without blinking (so that the pupil remains slightly contracted) and without his vision experiencing any other trouble than a reddish colouring to objects. He receives inspirations from above which he could not resist by any means; it is this *interior* voice which compels him to put to death all devils (all those around him). These devils enter his body and he is often enraged because he is obliged to spit them out – he can see them in his saliva. His physical health is otherwise good.

November and December

Same mental and physical state as previously. Baths with diffusions of cold water do not produce any improvement.

1844 January

Dadd was confined because he attempted, near Fontainebleau, to cut the throat, in a coach, of a traveller who was there with him. His condition has not changed during January: incurability seems to me beyond doubt.

February and following months

Condition unchanged

Dadd, claimed by the British government, was removed, uncured, to London, 26 July (1844).

Bethlem

Dadd was admitted to the State Criminal Lunatic Department of Bethlem Hospital, London, on 22 August 1844 and was transferred to Broadmoor on 23 July 1864. Author: W. Charles Hood. Source: BRH Criminal Lunatics, 1816-50, p.83 and Criminal Lunatics Supplementary Volume, p.120.

21 March 1854

For some years after his admission he was considered a violent and dangerous patient, for he would jump up and strike a violent blow without any aggravation, and then beg pardon for the deed. This arose from some vague idea that filled his mind and still does so to a certain extent that certain spirits have the power of possessing a man's body and compelling him to adopt a particular course whether he will or no. When he talks on this subject and on any other at all associated with the motives that influenced him to commit the crime for which he is confined here, he frequently becomes excited in his manner of speaking, and soon rambles from the subject and becomes quite

unintelligible. He is very eccentric and glories that he is not influenced by motives that other men pride themselves in possessing – thus he pays no sort of attention to decency in his acts or words, if he feels the least inclination to be otherwise; he is perfectly a sensual being, a thorough animal, he will gorge himself with food till he actually vomits, and then again return to the meal. With all these disgusting points in his conduct he can be a very sensible and agreeable companion, and shew in conversation, a mind once well educated and thoroughly informed in all the particulars of his profession in which he still shines and would it is thought have pre-eminently excelled had circumstances not opposed. He killed his father in Cobham Park without any discoverable reason, and escaped to France with the intention he has said of killing the Emperor of Austria; but whilst on a Diligence the temptation came on him strongly to commence operations on a fellow passenger and he attacked him with a knife or razor and seriously wounded him but was prevented actually destroying life. For this crime he was confined 12 months in France and on his release was taken in charge by English authority and subsequently brought to this Hospital. He has said that he once when he was in a public place in Rome with the Pope, felt a strong inclination to assault him, but that on second thoughts the Pope was so well protected that he felt he should come off second best, and therefore he overcame the desire. After he killed his father, his rooms were searched and a portfolio was found containing likenesses of many of his friends all with their throats cut. He had been travelling in the East and was abroad at the time his peculiarities were first noticed.

[Thereafter, at roughly monthly intervals, only 'No change' *is added until 1860 when, as Allderidge observes, 'the need to begin a new book suggested an opportunity for further comment']*

10 January 1860

No alteration in this man's symptoms have occurred since the last note was made in the No.1 Case Book. He still employs himself daily with his brush, but he is slower in completing any work he takes in hand. He associates very little with other patients, but is generally civil and well behaved to them. His mind is full of delusions.

Broadmoor

Dadd was admitted to the Broadmoor Criminal Lunatic Asylum, Crowthorne, Berkshire, on 23 July 1864 and died there on 8 January 1886. Author: William Orange. Source: Broadmoor

Archive, Berkshire Record Office, Reading, D/H14 D2/1/1/1 Patients Case Book, 1864-1903 (patient no.130) and D/H14 D2/1/3/1 Patients Case Book Supplementary Volume, 1865–1915, fo.26.
[*includes transcript of Bethlem casenotes, 1854 and 1860*]

29 July 1864

Tongue broad & flabby, pulse regular. Heart's action normal, Lungs resonant, breath sounds good. Has never had syphilis. Still believes himself to be a marked man under the influence of an evil spirit. Makes laboured attempts at justification of the two criminal assaults saying it was in 'justification of the Deity'.

7 November 1864

Employs himself generally in painting and is at present engaged on a water colour fairy scene which he is executing with great care. He is unable to converse for long without introducing fanciful ideas connected with spiritual agency and in explaining his idea he becomes much excited and occasionally his eyes have a singularly wild appearance. As examples of his thoughts he told me (Mr. Orange) this afternoon that the power some people have of playing chess without the board was probably due to their having a familiar spirit and that towards some people the chess pieces were evidently unfriendly and that this unfriendliness might be due to the antiquity of the game.

31 May 1865

Has been very orderly, employs himself in painting.

28 September 1865

Continues much the same is very quiet and orderly, never becomes excited, generally paints every day, but mostly associates with some of the most weak minded of his fellow patients.

24 October 1865

No change.

11 December 1865

Suffering from slight puffiness under eyes. Urine not albuminous. Took Tinct. Ferri [tincture of iron] for a week is now convalescing.

23 February 1866

Little change. Still occupies much of his time in painting. Makes no complaints and seems pretty contented.

11 July 1866

No change.

30 October 1866

The same.

30 January 1867

Occupied in painting, is quiet and well behaved. Is sometimes a little incoherent in his conversation. His bodily health is good.

25 May 1867

No change.

5 September 1867

Much as last.

17 February 1868

Is about as usual. The principal attendant says he is very much longer in completing any work lately than he used to be. Is now painting the Royal Arms on some fire buckets. Sprained his arm last month from an accidental fall.

25 February 1868

A sharp attack of Podagra [gout] came on, on the 22nd but is now getting better though the great toe of left foot is still red, swollen and hot.

28 February 1868

Redness & swelling now gone.

29 July 1868

Has had no return of the gout since last report; takes Claret & Brandy, otherwise he is in the same condition as previous reports; still works hard.

14 August 1868

His conversation has more or less reference to spirits. The weather has been recently very hot, and he says he thinks that mad people suffer more from the sun than others because they have no spirit to intercede for them, and shelter them from the sun's rays. Appears to be rather desponding his health, and says he is breaking up and that 'it is quite time'.

23 August 1868

Removed to the Infirmary ward on the 18th. Has an attack of fever; pains in limbs and stomach. Headache; great weakness; bowels relaxed from time to time; tongue furred; breath offensive; pulse 84.

3 September 1868

The motions from the bowels this day, after ol. Ricini [castor oil] are light brown and fluid, and yeasty in appearance.

15 September 1868

Still confined to bed, tongue sticky, pulse 76, stomach distended, bowels open this morning darker coloured motion.

18 September 1868

Very feeble. Has frequent eructations, bowels less distended, stomach tympanitic. Bowels acted twice the day before yesterday. Is taking milk & Brandy and very small quantities of strong beef tea when his stomach will bear it. Has numerous strange delusions. Says that there is an animal inside him which devours all the food he takes & leaves him only faecal matter in his stomach.

19 September 1868

Passed a yellow yeasty motion with blood intermixed; is taking milk & brandy but is troubled with great nausea and foetid eructation; ordered charcoal biscuits.

2 October 1868

Much better; no action of bowels from 18th Septr. till 30th Septr. when they were relieved by a simple water Enema.

28 October 1868

Convalescent; occupies his old room. Bowels act fairly well and with little or no pain; Takes meat daily.

11 January 1869

Gaining flesh and strength, but still requires special diet. Takes meat occasionally.

20 April 1869

Going on very well; numerous delusions.

26 June 1869

No change.

29 January 1870

Is on special diet (chop & Claret); has lost nearly 3 stone in weight since 1868; has not been under treatment lately; no change in mental condition.

8 April 1870

No change in mental condition; bodily health poor, but probably from his appearance, improving.

26 January 1871

Suffering from acute Rheumatism for some days past; elbows and wrists most affected, then the knees; considerable fever; delusions very prominent and curious – a sort of insane connection of ideas – reasons about why the joints should be worse on purpose; heart sounds clear, slight irregularity of first sound; dullness not increased.

30 June 1872

Has been going on very well. For some months past has been employed painting scenery for the stage in the central hall and is allowed a good deal of liberty when so occupied; steady supervision considered unnecessary. At this work he has taken considerable interest. Has the use of his own room in B3. Mentally there is no change. Although very quiet usually when he begins to talk will go on from one idea to another in an insane and incoherent manner. Bodily health at present good.

28 September 1872

In his usual mental condition; health of body feeble, but he is able to amuse himself painting, carving wood & in reading.

31 January 1873

No change; is still very feeble.

4 October 1873

Delusions that spirits enter his mouth, and he sometimes tries to cough or splutter them out; is unable to hold any lengthened conversation without becoming rambling and incoherent.

6 June 1874

No change; bodily health improved.

25 November 1874

Employs himself as usual; no change.

24 May 1875

In moderately good health.

5 October 1875

Rather more rambling in talk and enfeebled in mind than formerly but in his usual health.

20 December 1876

Goes on very quietly. Keeps to himself & does some painting & reading. Talks in a mysterious way about the myths of past age. Health only moderately good.

14 May 1877

Much as usual. Told me that his father was a chemist near Chatham & migrated to London when he (Dadd) became acquainted with someone in the British Museum through whose influence he was enabled to study the Elgin Marbles. He afterwards went travelling abroad.

Describing the scene of patricide, he said he was impelled to the act of killing his father ("if he was his father" he said) by a feeling that some such sacrifice was demanded by the gods & spirits above. He said that they were walking side by side in Cobham Park when Richard suddenly sprang upon his father & stabbed him in the left side. When his father fell, Dadd (posing himself with upstretched arm), thus apostrophised the starry bodies "Go," said he "& tell the great god Osiris that I have done the deed which is to set him free."

On going to France, he felt constrained to kill a fellow passenger inside a conveyance – but lost his opportunity. Later on travelling on a diligence the same feeling came over him with regard to a person sitting next to him & he consulted the stars - & observing two stars in the "Ursa Major" move a little towards each other, he thought the sacrifice was demanded. He got out a razor & was about to kill the victim but was overpowered & ultimately taken to a lunatic asylum.

20 October 1877

Very insane & rambles into all sorts of weird talk. Health indifferent.

5 April 1878

Goes on quietly, sometimes coherent & at others wandering & disjointed in his conversation. His bodily health is not good. Occupies himself reading the classics & painting.

1 August 1878

Able to get about & go to the cricket field – where he takes an interest in the game & players.

26 November 1878

No alteration in his state. Bodily health moderately good – but he is physically rather weakly.

11 June 1885

Yesterday complained of feeling unwell – was put to bed at once, and afterwards removed to the Infirmary (B.3.). A few high-pitched notes were to be heard over the bases of the lungs posteriorly, but his temperature was normal, and pulse not markedly quickened.

20 June 1885

Is better, but still in bed. Takes food well.

6 July 1885

Better – gets up daily. Still in infirmary.

14 August 1885

Physical examination shows harsh breathing over apex of left lung posteriorly, with a few very fine crepitations – takes food well and is up daily. Still in infirmary.

20 September 1885

Takes food fairly well but is failing in health.

25 October 1885

In infirmary ward & is getting gradually weaker, though he still takes his food well.

26 November 1885

The lung mischief makes progress – is gradually failing in strength.

29 December 1885

Has taken to his bed getting much weaker. Still takes food fairly well but is too weak to get about.

2 January 1886

Gradually getting weaker expectoration becomes more profuse cough more troublesome. Appetite not so good.

4 January 1886

Getting much more feeble.

8 January 1886

Today for the first time refused all food. Only by much pressing can he be induced to take a little milk or beef tea. Has had several severe fainting fits, hands cold, lips blue. Died this day at 7.30pm in the presence of Att. Samuel Smith.

Notes

Abbreviations
BA Broadmoor Archives (recently transferred to the Berkshire Record Office)
BRH Archives and Museum of the Bethlem Royal Hospital, London
References to published works are given in abbreviated form; see Bibliography for full citations.

Preface

1 Alldridge 1974. Mainstream art critics were admiring of this project, but could not see where Dadd might be taken next. The *Burlington Magazine* reviewer wrote that 'The paranoid schizophrenia from which he apparently suffered undoubtedly gives Dadd's work an edge. But behind that edge there is a blank' (Roberts 1974).
2 But see Lippincott 1988, Bown 1999, Fraser Stansbie 2006 and Klemenz 2010.
3 See the introduction to Andrews and Digby 2004 on this point.
4 See the introduction to Shorter 1997.
5 Williamson 2006, p.187. Despite attempts to define schizophrenia neurologically, 'No biological differences have been found that have any diagnostic validity' (Nettle 2001, p.32).
6 See Zeki 2003 and his critics, especially Hyman 2006.

Fairytopia

1 Chatham and Rochester Philosophical and Literary Institution, *First Annual Report*, 1828, p.25. Fernando Po was an island off the coast of Equatorial Guinea.
2 Dickens 1988, pp.14–15.
3 Truth 1828, p.2.
4 Dickens 1988, p.2.
5 Anon. 1828, p.11.
6 Robert Dadd was an occasional lecturer at the Geological Society in London (*Gentleman's Magazine*, June 1833, p.546).
7 Annual Reports of the Rochester Mechanics' Institute, and catalogue of the sale of the property of the Philosophical and Literary Institution held by Thomas Burr at Rochester, 17 July 1844. Robert's obituary in the *Kentish Independent* (2 September 1843: copied in several national papers) mistakenly claimed he was closely involved in the Mechanics' Institute, which was not established until after he had moved to London.
8 In his will of 1837 (National Archives, Kew), Robert requested to be interred in the burial ground of the Unitarian and General Baptist Chapel at Chatham. However, this document was not discovered until after his funeral and he was buried in the parish church at Gillingham.
9 See Alldridge 1974, p.150 for a family tree.
10 The school was at this point apparently at the nadir of a long period of decline (Greysmith 1973, pp.12–13). Richard's education was no doubt continued by his father.
11 A local drawing master, William Dadson, may also have been involved in Dadd's early studies.
12 *Economist*, 2 September 1843; Dadd 1843, p.267. The business was taken over from André Picnot, a relation of Robert's first wife.
13 There was even a movement, led by the reforming MP Joseph Hume, to turn the SBA into a National Institute of Art for the general public.
14 Dadd was also – again conventionally – studying the Parthenon sculptures at the British Museum at this time, where the keeper of the print room, Henry Josi, had become a friend.
15 According to the reminiscences of the engineer John Imray, who had been friendly with the Clique as a young man: Imray 1898; the quotations are from *A Midsummer Night's Dream* and *Julius Caesar*.
16 Ibid.
17 Anna Jameson in the *Monthly Chronicle*, June 1838, p.354.
18 See Vaughan 1979.
19 See Barlow 1989.
20 See King 1985; Morris 2002.
21 Alldridge 1974, p.66.
22 Dadd 1843, p.267; Hall 1864; Imray 1898; *Survey of London* 1980, pp.117–66. Dadd's panels were presumably removed and subsequently dispersed when the family's lease on the house expired in 1887.

23 *Manfred* has as its motto Hamlet's lines 'There are more things in heaven and earth, Horatio,/ Than are dreamt of in your philosophy', which Adams also borrowed in his 'Walpurgis Night' (f.35r).
24 *Cleave's Penny Gazette*, 28 October 1843.
25 E.g. Frith 1887–8: vol.1, p.62; vol.3, p.182.
26 Scott 1892: vol.1, p.111.
27 On Huskisson, see Martineau 1997, no.29; Alldridge 1974, no.248.
28 Carter 1997, p.59; Stewart 1993, p.112.
29 Nicola Bown writes that mid-Victorian fairy images 'function mainly as consolations for the anxieties produced by scientific progress, but they do this partly by representing the objects of the scientific gaze turned into fairies and fairyland' (2001, pp.107–8).
30 Hazlitt, *Characters of Shakespear's Plays*, 1817.
31 Forster 1896, p.65.
32 *The Times*, 17 November 1840, p.4. For further reviews see Griffiths 1996, pp.21ff.
33 Dadd may have been encouraged by those critics who felt that these stage extravaganzas could offer only 'The material attractions of a pageant', which, 'however gorgeous, are no substitute for spiritual essence' (*Athenaeum*, 21 November 1840).
34 Williams 1997, p.98.
35 E.g. *Blackwood's Edinburgh Magazine*, 50 (September 1841), p.348.
36 *Morning Chronicle*, 16 August 1841.
37 See Mannings and Postle 2000, no.2142 for the Reynolds; and Halliwell 1845, sect.6 for the Kentish version of Puck's biography.
38 Jay 2004.
39 *Art-Union*, April 1841, p.68.
40 Two versions of this composition survive: they were formerly identified as the two versions of the *Haunt of the Fairies* in the Cox sale (1884), but see following note.
41 *Art-Union*, October 1841, p.171. *Fairies Assembling at Sunset* was probably the painting, later known as the *Fairy's Haunt*, sold to the Manchester collector Samuel Ashton by Agnew's (he soon swapped it for *Titania Sleeping*: Agnew 1967, p.16 and Agnew's archives); and again probably identical to the *Haunt of the Fairies* in the Reeves and Cox collections. Its appearance in the Cox sale of 1884 along with a slighter picture with the same title led to the confusion with *A Fairy – Sunset* mentioned in the previous note. But the dimensions of the picture, when in the Reeves sale, were given as 27½ x 35½in (70 x 90cm), larger than any other recorded fairy picture by Dadd.
42 *A Midsummer Night's Dream*, Act 1, Scene 1, lines 121–34.
43 *Blackwood's Edinburgh Magazine*, 52 (July 1842), p.34; Martineau 1997, p.49.
44 *Art-Union*, July 1842, p.161.
45 *Art-Union*, October 1842, p.235.
46 *Titania* was in the sale of Samuel Hammond, flax spinner, of Low Folds Mills, Leeds, in 1854, and sold by Agnew's to Ashton of Oaklands, Cheshire, later the same year.
47 Meigh 1847, p.43 no.151; cf. *Art-Union*, December 1845, pp.366–7. Birchall lent *Puck* and three Dadd watercolours to the Manchester Art Treasures Exhibition in 1857.
48 *Art-Union*, February 1844, p.47; Dudgeon owned the painting by 1854 when he lent it to the Royal Scottish Academy exhibition in Edinburgh (*Art Journal*, April 1854, p.109). Dudgeon was, incidentally, for many years a trustee of his local asylum, the Crichton Royal Institution, where Dr W.A.F. Browne pioneered the encouragement of painting among his patients (Park 2010).
49 Reeves was so discreet a figure that he passes under the radar even of so specialist a study as Coan 1980; he is mentioned in passing in *Edgbastonia* (March 1889), p.35. A modest local philanthropist, Reeves lived at Hawthorne House, Bristol Street. His other favourite artists were local boy David Cox and Cox's friend William Müller.
50 Foster's auctioneers, 29 March to 1 April 1865.
51 For a detailed reading of Phillips's politics, see Williams 2003.
52 See Jones 1999.
53 Phillips 1849, p.50.

Orientalist and Assassin

1 Guiterman and Llewellyn 1986; Tromans 2008.
2 Alldridge 1974, no.251.
3 Morgan 1892, p.178.
4 My references to the V&A sketchbook are in the form

of 'S.' followed by the page number/s as separately accessioned by the V&A in 1892. Dadd wrote three long letters to David Roberts while abroad: from Athens, 4 September 1842; from Damascus, 5 November 1842; and from Malta, 24 February 1843. Edited versions of these were published in the *Art-Union* (Dadd 1843). References to the letters here are to the originals now at Bethlem Royal Hospital (BRH), and are identified in my notes simply by the place whence the letter is dated.
5 Damascus letter.
6 It is possible, and to my mind plausible, that the few known independent pencil studies from the tour (e.g. Alldridge 1974, nos.77, 79, 82) are pages from this untraced (broken up?) larger sketchbook.
7 Athens letter. The conjectured word in square brackets has been mostly torn from the manuscript.
8 See Behdad 1994.
9 Phillips to his brother, Athens, 3 September 1842: quoted Alldridge 1974, under no.251.
10 Both quotations from Athens letter.
11 Later, at Bethlem in the 1850s, Dadd wrote of the dangers of looking too closely into the details or texture of a thing, a curiosity that might 'make us too knowing and we should become dissatisfied: those details might prove humbugging – like Mohamed's veil &c.' (annotations to Haydon's *Lectures*, p.301: see Chapter 3, n.32).
12 Fellows wrote as if he were a real explorer, mapping the region for the first time (Fellows 1839, pp.221, 249; Fellows 1841).
13 Damascus letter.
14 Ibid.
15 See Hardwick 1990.
16 See Cook 2005, pp.5–6; the slabs sketched by Dadd are Cook nos.1, 3, 12, 182. Dadd's now lost drawings were passed via Stratford to the aristocratic traveller Walter Devereux, who had copies of them crudely lithographed (in Devereux 1847). Devereux's copies surfaced at Christie's, 14 July 1987 (lot 7).
17 Damascus letter.
18 Ibid.
19 Slatter 1994, p.345, n.10.
20 See Hoskyn 1842 and Spratt and Forbes 1847. Hoskyn eventually became Chief Draughtsman to the Hydographic Survey. On Spratt see Dawson 1885, pp.41ff. and Deacon 1978.
21 On the Hydrographic Survey, see Day 1967. Many British Navy boats switched between military, surveying and archaeological roles; for example the *Beacon* became a survey ship in 1832, having originally been launched in 1823 as the bomb vessel *Meteor*.
22 Fraser Stansbie 2006, p.108.
23 Frith 1887–8: vol.3, p.188.
24 Damascus letter.
25 Frith 1887-8: vol.3, p.187.
26 Frith (1887–8: vol.3, p.190) mistakenly reads 'Venom' for *Vernon*, a 50-gun frigate launched in 1832.
27 Ibid. p.189.
28 Ibid. p.187.
29 Malta letter.
30 Lepsius 1853, p.416; Lippincott 1988, p.90.
31 Malta letter.
32 Dadd himself, at least in Syria, wore a fez with two handkerchiefs tied around it; he also grew a beard and moustache (Frith 1887–8: vol.3, p.183).
33 Malta letter. In fact Lewis only returned from Cairo to London in 1851.
34 Malta letter.
35 Alldridge 1993, pp.206–7.
36 Dadd's Bethlem casenotes, 1854 (BRH).
37 Anon. 1877, p.13. The same source has it that, on the crossing to Malta, Dadd had seen Phillips playing cards with the captain of the ship (itself unlikely), 'nominally for small moneys, but really for the captain's soul'. Another account suggested that even before the tour, some had begun to think Dadd 'had grown "very strange"' (Hall 1843, p.45).
38 BRH sketchbook, fol.15v.
39 Dadd 1843, p.268.
40 Ibid.
41 Scott 1892: vol.1, p.172.
42 Frith 1887–8: vol.3, pp.179ff.; Alldridge 1974, p.23. Another of the stories offered in the *World* feature (Anon. 1877) was that during this period Dadd had cut a birthmark from his head because it 'had been imprinted on him by the devil': this would explain the 'two scars on forehead' later noticed in the Broadmoor *Patients' Description Book* (BA D1/4/1). He was also said to have secretly prepared 'a paper …

containing outline portraits of all the artists … with a dash of red paint across the throat of each' (Hall 1883: vol.1, pp.188–9; this story was repeated by Dr Hood in the Bethlem casenotes).

43 Dadd 1843, p.267; *The Times*, 6 September 1843, p.3.
44 For the story about Dadd's diet see William Clements to Joseph Mayer, 11 September 1843 (Liverpool Central Library).
45 Frith 1887–8, p.181; cf. Goodall 1902, p.230.
46 Dadd 1843, p.267.
47 Phillips to David Roberts, 10 September 1843 (BRH).
48 Most press reports said that Robert Dadd ignored this advice, but others (e.g. *John Bull*, 4 September 1843, p.549) suggested that Richard was afterwards watched very closely.
49 As reported by Stephen Dadd, Richard's brother, to David Roberts, 2 September 1843 (BRH).
50 Dickens 1988, pp.123–4.
51 Broadmoor casenotes, BA D2/1/3/1 (14 May 1877).
52 Wood 1851, p.42.
53 My account is based on reports in the Kent local press of the inquest into Robert Dadd's death held at Cobham on 31 August. One of those questioned was a doctor from Gravesend who carried out a postmortem near the scene of the murder.
54 *Kentish Independent*, 2 September 1843.
55 Reports varied in their accounts of when the passport had been obtained – either on the very day of the murder or earlier (Dadd 1843, p.268; *The Times*, 11 September 1843, p.6).
56 Dadd's Bethlem casenotes (BRH).
57 Broadmoor casenotes, BA D2/1/3/1 (14 May 1877); cf. Anon. 1877, p.13.
58 *Le Siècle*, quoted by *The Times*, 12 September 1843, p.6.

Inside

1 *Sun*, 13 September 1843 and *Observer*, 18 September 1843. Dadd's examination was carried out by a Dr Leblanc.
2 Dadd was moved to the Hospice de Fontainebleau on 13 September and then in stages to Clermont, where he was admitted on 20 September.
3 See Woillez 1839 for a description of the asylum.
4 Goldstein 2001, p.165. It was Georget who commissioned Théodore Géricault's famous series of portrait studies of different types of monomania.
5 Woillez 1849, pp.48–9. Dadd's casenotes remain at the Centre Hospitalier Interdépartemental, Clermont (Archives, Q16). Thanks to the archivist for sending me photographs of the notes, extracts from which have been published in Klemenz 2010.
6 Dadd's tragedy was apparently made into a play at some of London's makeshift 'penny theatres' (Greysmith 1973, p.61).
7 William Clements to Joseph Mayer, 5 September 1843 (Liverpool Central Library); Hall in *Art-Union*, 5, 1843, pp.267, 295.
8 For example, *Art-Union*, May 1844, p.122; *Age and Argus*, 13 January 1844, p.5. Among those able to bring reports of Dadd from France to Britain would have been John Browne, a family friend who had travelled to see him in September (when Dadd was being held at Fontainebleau) in case any legal help might be needed (see Browne's affidavit of 3 January 1844, National Archives, Kew PROB 37/1274).
9 *Art-Union*, 5, 1843, pp.272, 295.
10 See May's report in National Archives, MEPO 3/47.
11 *Age and Argus*, 10 August 1844, p.2.
12 *Kentish Gazette*, 13 August 1844.
13 *Illustrated London News*, 10 August 1843, p.87. On the Act for making further provision for the confinement and maintenance of insane prisoners (3 & 4 Vic., cap.54, 1840), see Hood 1854, p.23 and Smith 1981, pp.21, 92. The Act allowed the Home Secretary to place in an asylum any prisoner (tried or untried) on the certification of their insanity by two JPs and two physicians.
14 For example, Thomas Mayo in his Croonian lectures to the Royal College of Physicians in 1853 considered that Dadd had got off very lightly (Mayo 1854, pp.22–3, 89–90); cf. Taylor 1865, pp.1096, 1107. Commenting on the same question, *Blackwood's Edinburgh Magazine* claimed that, although Dadd had efficiently planned the murder and his escape from the scene, 'nobody ever doubted that he was one of the maddest, if not the maddest, of the mad' (December 1850, p.712).
15 Allderidge 1985.
16 On the presence of Bethlem in eighteenth-century English literature, see Byrd 1974; Kromm 1985;

Ingram 2005.
17 Stevenson 2000, p.35.
18 Andrews *et al.* 1997, pp.454–5. In practice this meant a modest patient population (by later standards) but a large turnover of cases, which allowed the Bethlem doctors to become pioneers in Britain of the application of statistics to insanity (Macalpine and Hunter 1991, pp.297–8; Black 1810).
19 See Andrews *et al.* 1997: chapters 23–4.
20 *Journal of Mental Science* 1863, cited in Philo 2004, p.439.
21 Bethlem's total patient population, measured at specific points, was 184 in 1820; 228 in 1830; 359 in 1844.
22 Laurie 1838, p.14.
23 *Annual Report for 1844* (1845), pp.59–60.
24 Charity Commissioners 1840; Allderidge 1974, p.27; Andrews *et al.* 1997, p.409.
25 Charity Commissioners 1840, p.517.
26 Wynter 1857.
27 See Johnston's own account (1850) and *Journal of Psychological Medicine*, 6, 1853, pp.40ff.
28 See Hervey 1986.
29 Pearce 1851, pp.xiii, v–vi; *Journal of Psychological Medicine*, 4, 1851, p.231. Pearce was eventually discharged in 1859.
30 Wood 1851, pp.41–2.
31 Robert Dadd had borrowed from David Roberts the standard modern work on ancient Egypt, Wilkinson's *Manners and Customs of the Ancient Egyptians* (1841): see his letter to Roberts of 13 March 1843 (BRH; wrongly attributed to Richard himself in Allderidge 1974, p.39).
32 This passage comes from a copy of B.R. Haydon's *Lectures on Painting and Design* (1844), which Dadd annotated in Bethlem (MacGregor 1989, p.129; the book is now in a private collection). I will refer to these notes (whose punctuation I have tidied) as 'Annotations to Haydon's *Lectures*', with the relevant printed page number from Haydon 1844: the words just quoted in the main text are from p.41. *Suum cuique* means 'to each his own', i.e., in this context, unilateral thinking. Osiris also figured in the opium-fuelled revelries of Thomas De Quincey (Lippincott 1988, p.81).
33 Wilkinson 1841: vol.2, pp.289, 341. The principal ancient authors on the subject were Plutarch (*De Iside et Osiride*), Diodorus and Macrobius.
34 Bullen 1989 surveys this theme.
35 Bucknill 1854, p.74. His list includes examples of heterodox modern Christian movements abhorrent to the established Church.
36 Dadd's casenotes, 1854 (BRH).
37 Annotations to Haydon's *Lectures*, p.196; cf. Becker 1978, p.22.
38 One of Dadd's *Passions* watercolours, *Want* 1856 (V&A), has astrological symbols inscribed in the foreground (Allderidge 1974, no.157 identifies some of them).
39 Dadd quoted in Wood 1851, p.42: 'Now the author of this act is unknown to me, although, as being the cat's paw, I am held responsible. I do not extenuate my act; but as men are reasonable, or *capable of reason*, I think I have said enough to prove that I have no other concern than with an act of volition, blindly, it is true, but, as I thought, rightly accorded.'
40 The next step was for genius to become pathologised, which it began to be from the 1830s (Becker 1978, pp.28–9).
41 Trevelyan 1876: vol.2, p.355: 'Haydon was exactly the vulgar idea of a man of genius'; Lamb 1906.
42 See Berrios *et al.* 2003 for a basic history of the category.
43 For a thoroughgoing attempt to deconstruct the category, see Boyle 2002. Kraepelin's original description is still cited with approval by leading neuropsychiatrists such as Williamson (2006, pp.4ff).
44 Boyle 2002, p.71 and *passim*.
45 Fazel *et al.* 2009.
46 Howells 1991, p.xii; this collection is sympathetic to the line that historical ambiguities should not preclude the use of the category.
47 Among the authors of standard histories, Scull is contemptuous of the recency hypothesis (1993, pp.334–5n), but Shorter takes it surprisingly seriously (1997, pp.62ff).
48 Jamison 1993; for a survey concentrating upon art, see Clair 2005.
49 Jay 2003.
50 See Röske and Brand-Claussen 2006, pp.69ff.

51 Macalpine and Hunter 1956: Freud had already written on the case in the 1920s; see also Heinrichs 2003 on the eighteenth-century sculptor Franz Xavier Messerschmidt.
52 Winslow 1849, p.271.
53 Moral therapy had renounced restraint but remained attached to the use of opium and other sedatives and to water therapies.
54 See Winslow 1849; Clark 1988. It was said of Dadd that 'No living artist possessed a more vivid or delicate imagination; and there is no doubt that the excess of this quality predisposes to the disease which has triumphed over him' (*Art Journal*, 1864, p.130).
55 Nettle 2001, p.187.
56 Clements to Mayer, 5 September 1843 (Liverpool Central Library); Greysmith 1973, p.133.
57 George's casenotes are given in Allderidge 1970, p.313. A common feature of both brothers' behaviour was bulimia, accompanied in Richard's case by vomiting (see his casenotes quoted above).
58 Copies of casenotes at Aberdeen Art Gallery: thanks to Jennifer Melville for sharing these with me; the originals belong to the Grampian Health Board Archives. Maria died at the Royal Aberdeen Lunatic Asylum in 1893.
59 *The Times*, 16 October 1854, p.1.
60 Greysmith 1973, p.132.
61 Read 2004, p.228; Moffitt (1988) suggests (with his tongue somewhere near his cheek) that the age-old association of artists with mental illness may have to do with lead poisoning caused by their paints.
62 On sunstroke and psychiatry, see Fraser Stansbie 2006, pp.51–3.
63 *Quarterly Returns for the Criminal Department* (BRH).
64 Andrews *et al.* 1997, p.444.
65 *Art-Union*, May 1845, p.137.
66 *Manchester Guardian*, 23 April 1857, p.3.
67 Christie's, 23 February 1878; the drawings cannot be identified today.
68 On the iconography of the fishwives in Dadd's work, see Allderidge 1974, nos.102–3.
69 For Morison's career, see the chapter by Hervey in Scull *et al.* 1996.
70 Morison, *Diary* (Royal College of Physicians of Edinburgh), 21 April 1845, 4 September 1850. Thanks to Nick Hervey for providing some navigation through this epic document.
71 The study of physiognomy and the passions allowed for the retention of a place for the soul in science, in contrast to phrenology, which was generally perceived as a godless pursuit, associated at Bethlem with the disgraced Apothecary Edward Wright (Andrews *et al.* 1997, p.442).
72 There are some garbled anecdotes that suggest Dadd noticed Gow and Johnston at work (several of their sitters were from Bethlem's criminal blocks): *Art-Union*, 7, 1845, p.137; Frith 1887–8: vol.3, pp.97–9; Allderidge 1974, p.35.
73 From a letter – the details of which remain obscure – relating a visit to Morison: sold with Dadd's 1861 drawing *The Rabbit Hutch* at Christie's in 2001.
74 Sotheby's, 15 March 1878, lots 51–3. The other five watercolours were: *David Hiding in the Cave* (private collection), *The Murder of Henry VI* (Wellcome Collection) and three sheets now in the V&A: *The Flight of Jason and Medea, Christ Walking on the Water* and *A Fallen Warrior*.
75 *Diary*, 11 September 1850. The attendant is named as Kidd, who was keeper of No.2 Ward in the Criminal Department for many years until 1853.
76 See Pitman 1994. Among the Society's first members were Haslam, E.T. Monro and Alexander Sutherland.
77 *Art-Union*, May 1845, p.137.
78 Annotations to Haydon's *Lectures*, p.242.
79 Ibid. p.331.
80 Ibid. p.273; cf. p.170: 'True, the genius might for its own purposes supply the grandeur the artist was too lazy or incompetent to put in.'
81 Christie's, 14–16 April 1864, lot 21; an inscription, verso, shows it had left the hospital by 1847.
82 *Art-Union*, February 1848, p.66.
83 Frith 1887–8: vol.3, p.192. Lippincott (1988, p.86) makes some interesting connections between Dadd's rocky landscapes and the new geology of the 1840s, which opened up vastly expanded perspectives upon world history.
84 Andrews *et al.* 1997, p.439.
85 Ibid. chapter 25. The report was shown to the Bethlem authorities early in 1852 and published later the same year. The Lunacy Commission was empowered to

make regular inspections of Bethlem from 1853.

86 Ibid. p.477.

87 The only Bethlem officer to remain in post during all of Dadd's time there was the Visiting Surgeon, (Sir) William Lawrence of Barts (see fig.35). At least nominally on the staff from 1815 to his death in 1867, Lawrence's career moved from controversy over supposed atheistic tendencies shortly after his appointment at Bethlem to becoming President of the Royal College of Surgeons in the 1840s.

88 Scull *et al.* 1996, p.317 n.122.

89 See Smailes 1980.

90 An almost identical view of Anchorfield, drawn in 1830 by Georgiana McCrae, is now in the McCrae Homestead and Museum outside Melbourne: thanks to James Holloway for showing me a photograph of it.

Contradiction

1 The centrepiece was made by the firm of Hunt & Roskell. Conolly had been Visiting Physician to Hanwell since his resignation from the Superintendency in 1844.

2 Foucault 2001, chapter 9.

3 Allderidge (1974, no.105) compares the figures' postures to the Mausoleum frieze (see Chapter Two of this book and fig.24), Lippincott (1988) to ancient Egyptian art.

4 Busts were also obtained from the studio of the prolific portrait sculptor E.B. Stephens by G.H. Haydon (MacGregor 1989, p.128; O'Donoghue 1914, p.354).

5 Motley and Sommer 1999, p.299; cf. Sommer *et al.* 1998. But see Mundt 1990 for an attempt to persevere with pathography, or the diagnosis of illness from images.

6 I Samuel 26:7–12; see Lippincott 1988.

7 It would be intriguing to discover how Dadd treated the now untraced *Deluge* mentioned by Alexander Morison in his diary for 27 January 1859 (Royal College of Physicians of Edinburgh). Generally Dadd avoided explicitly Christian subjects, although there is a watercolour of *Jesus Christ Walking on the Sea* 1852 (V&A).

8 Wood 1851, p.42; Dadd's casenotes (BRH).

9 Sass 1992, p.149.

10 Cf. Bown's discussion (2001, pp.66ff.) on the massive and the miniaturised as mutually dependent aspects of the same newly dynamised ratios produced by Victorian technologies.

11 In taking this stand, Hood neatly split the two halves of the psychiatric profession, comprising, respectively, public and private practice. The former was represented by the Association of Medical Officers of Asylums and Hospitals for the Insane (established 1841, the ancestor of the present Royal College of Psychiatrists), whose *Asylum Journal* was hyperbolic in its praise of Hood (e.g. 2 July 1855, p.218). The voice of the private asylum, on the other hand, the *Journal of Psychological Medicine and Mental Pathology*, expressed amazement at Hood's appointment. Its editor, Forbes Winslow (fig.35), whose reputation as a leading forensic psychiatrist depended on his being able to tease out the hidden insanities of prisoners on trial, was appalled by Hood's rejection of monomania (*Journal of Psychological Medicine*, 1852, pp.407ff.).

12 *Phrenological Journal*, 10, 1837, p.697; on the art of Browne's patients, see Park 2010.

13 Scull *et al.* 1996, p.113. Compare the complaint of the outgoing Edward T. Monro in 1851: 'hardworking attention to minute particulars ... has never hitherto characterised the mental physician exercising a high profession in a liberal manner' (Andrews *et al.* 1997, p.477).

14 Suzuki 1999. Shorter (1997, pp.50–1) suggests that an important factor in the Victorian desire to put away so many 'lunatics' was the increasingly sentimental and emotional definition of the family circle into which it became harder to integrate a member suffering from mental illness.

15 *Annual Report for 1853*, 1854, pp.48–50.

16 For example Wynter (1857, pp.360–1) copies the comparison of casenotes.

17 Morley 1857, p.147. Note also the evangelical tone of Sala (1860, p.305): 'we all know that he [Hood] is on his Master's business.'

18 Andrews *et al.* 1997, pp.472, 492. This emphasis already characterised Bethlem's intake; when in 1857 Hood ceased accepting parish paupers he was formalising an established trend.

19 Wynter 1857, p.359.

20 Thompson's Bethlem casenotes copied into his Broadmoor file (patient no.24).

21 Hill 2007, chapter 41. Pugin was admitted in June 1852, removed the following month and died in September.

22 Wynter 1857, pp.361-2. This section of Wynter's article on the Bethlem Criminal Department was widely copied in the press (e.g. in the *Manchester Guardian*, 29 May 1857) and in the specialist journals (e.g. *Journal of Psychological Medicine*, July 1857, p.552).

23 Dadd's Bethlem casenotes are given in full in Allderidge 1970; the original documents remain at BRH. (See pp.195–196)

24 Ibid.

25 Hood believed that 'insanity is due more to moral than to physical causes' (Hood 1862, p.63), but his claim that this was now 'generally admitted' was an exaggeration.

26 Ibid. p.122. Beyond this, Hood's therapeutic philosophy was unoriginal: he believed in the retention of traditional mild purgatives, and sedatives such as opium, cold baths and the application of ice to the head (ibid. p.110).

27 *Annual Report for 1858*, 1859, p.35.

28 *Physician's Report for 1857*, 1858, pp.37–8. It was reported (*London Review*, 31 May 1862, p.502) that the new criminal ward was one of the best in the hospital. From the early 1880s, by which time Dadd had been transferred to Broadmoor, patients at Bethlem were encouraged to take part in executing decorative painting schemes in the wards (Guyatt 2004, p.56).

29 10 January 1860 (BRH).

30 *Quarterly Returns for the Criminal Department* (BRH).

31 This was the total in the sale of Hood's collection at Christie's, 28 March 1870.

32 Hering's photographs were one of the sources used to illustrate Conolly's series of articles on the application of photography to psychiatry, which had been pioneered by Hugh Welch Diamond at the Surrey County Asylum (see Conolly 1858, p.82; the Bethlem patient shown here can now be identified as Eliza Camplin: BRH, HPA-01). For the larger story, see Gilman 1996, chapter 14 (although this book was first published before Hering was identified as the author of the Bethlem photographs) and Green-Lewis 1996, chapter 5.

33 Letter from the Bethlem treasurer to Morison, 5 May 1856 (BRH); the previous year it had been resolved to restrict visiting hours in the Criminal wards.

34 MacGregor 1989, p.133. At Bethlem, one of the organised activities for the women patients was flower painting in watercolours (Sala 1860, p.304).

35 The three members of the series known only by name (*Despair, Ingratitude, Malice*) may turn out, if rediscovered, to have earlier or later dates.

36 Gauchet and Swain 1999, p.154, and chapter 5 generally, ibid., on the passions.

37 See, for example, the full title of Esquirol 1805.

38 Esquirol 1835, p.142.

39 Partridge 1953, p.74.

40 Hood 1862, p.53, table 8.

41 The only original works of art in Hood's 1870 sale were those by Dadd: these included three oil paintings – *Mercy* (fig.51), *Contradiction* (fig.68) and the untraced *Jael and Sisera*.

42 On the history of art therapy, see Hogan 2000.

43 The sitter may be Charles Neville, who had worked with Hood at Colney Hatch and followed him to Bethlem in 1853, where he was attendant in charge of the male criminal lunatics: compare Dadd's later portrait of him (Allderidge 1974, no.191); he would have been about thirty-one in 1853.

44 Tristan 1980, pp.160–1; Allderidge 1977.

45 *Journal of Psychological Medicine*, 1852, p.409.

46 For a full biography of Haydon, see Haydon 2007.

47 Spielmann 1895, pp.423, 502.

48 Haydon 2007, p.228.

49 Ibid. p.232.

50 Rossetti 1906: vol.1, pp.269–70; vol.2, p.497. For further evidence of a modest interest among the Rossetti circle in Dadd, see Dunn 1904, pp.58–9 (a garbled tale). There seems to be no evidence for the suggestion sometimes made that Samuel had been a particular friend of William Michael Rossetti, who visited Bethlem in 1863 and saw Dadd there.

51 See Chapter 3, n.32.

52 Annotations to Haydon's *Lectures*, p.196.

53 Ibid. p.171.

54 There is also a resemblance to some of the more exaggerated heroic faces to be found in German history painting of the period, as satirised in *Punch* in

1846 (Vaughan 1979, p.178, fig.107).

55 Allderidge 1974, pp.34, 156 n.60.

56 Annotations to Haydon's *Lectures*, p.201.

57 Ibid. p.245.

58 The pencil inscriptions, in Italian and English, are on the stretcher. I can just make out: 'Egli cosi ed egli [n]o facevano/ al[t]ro viene che non [cosi?] pensava/ ed altronde proviene che non mai certamente a vero'; and 'I deny/ Thou deniest/ He denies/ We may, can, would, should [be right?] to, deny.' Thanks to the owner of the picture for allowing its examination, and to Marcus and Marcella Leith for photography.

59 'Est suum cuique dunc dictum/ Transupra et ecce sinistrum/ Simile similibus addendum/ Daemoni date debendum m m m.' Allderidge (1974, no.184) makes a valiant attempt to translate the lines but they are surely more in the way of a constellation of phrases and sounds – as in the *Contradiction* inscriptions – rather than continuous verse. See also Schiff 1983.

60 See Allderidge 1974, nos.248, 250; Martineau 1997, nos.28–9 (Huskisson); and Schindler 1990 (Paton).

61 On the aesthetics of microscopy, see Seibold-Bultmann 2000. The ovoid shape of *Contradiction* might also bring to mind the projected image of a magic lantern, one of which Hood introduced to Bethlem in 1852 (Andrews *et al.* 1997, p.489), a connection possibly referred to by Dadd himself when he described *Contradiction* as a canvas that 'glowed' (*Elimination*).

62 Frith 1887–8:, vol.3, p.185.

63 At least one of Dadd's sisters had worked unhappily as a governess, for his friend Frith.

64 Allderidge 1974, p.112.

65 The artist and diarist Joseph Farington recorded early in the nineteenth century the belief at that time that the majority of female cases in Bethlem were due to broken hearts, while the majority of male cases were due to aggravated pineal glands (1979, p.2288; 2 April 1804).

66 For example: *Dymphna Martyr* (fig.52), *Splendour and Wealth* (represented by Cleopatra: Newport Museum and Art Gallery), *Lucretia* (BRH) and *The Flight of Medea* (V&A).

67 On Ophelia as a Victorian type of madness, see Showalter 1987, p.90; and on Bethlem as an archive of living models for painters of Ophelia, see Rhodes 2008, p.153.

68 *A Midsummer Night's Dream*, Act 2, Scene 1, lines 106–17.

69 *Romeo and Juliet*, Act 1, Scene 4, lines 53–98.

70 Bucknill 1859; Conolly 1863.

71 Stewart 1993, pp.46, 48.

72 Quotations from *Elimination* in the text have been minimally altered in punctuation to more closely resemble the standard lines of poetry that the rhymes suggest.

73 Gere in Martineau 1997, p.70.

74 There exists a second copy of the *Elimination* manuscript, made by someone other than Dadd after his original, which descended in the Haydon family (private collection).

75 Haydon to Charles Darwin, 12 September 1881 (Cambridge University Library; cited Haydon 2007, p.304).

76 Bown 1999, p.134.

77 Cf. Paz 1989, pp.121–6.

78 This process sounds strikingly close to the 'blot' method of instinctively composing landscape watercolours on the basis of random stains on a sheet of paper proposed by Alexander Cozens (see Cramer 1997). Cozens' son John Robert became one of the most original British artists of the 1790s but died young after falling into insanity: he was a patient of Dr Thomas Monro of Bethlem.

79 The lines also of course recall Lear's advice to Cordelia: 'Nothing can come of nothing' (*King Lear*, Act 1, Scene 1, line 92); cf. Annotations to Haydon's *Lectures*, p.170. Eleanor Fraser Stansbie suggests an altogether more heroic interpretation of Dadd and the *Fairy Feller* which she sees as 'a surreptitious defence of his secret self', a 'retort to the threat to his identity posed by the clinical and observing gaze of his physicians' and 'a covert critique of the institution in which he was held captive' (2010, pp.95, 104). I think the most that can be said along these lines is that Dadd 'eliminated' the meaning of the picture by explaining it away as 'nothing' and thereby deprived his doctors of any ownership of his thoughts.

Pleasure Men: Dadd at Broadmoor

1 Bethlem's modern history is described in Andrews *et al.* 1997, Part 4.

2 Broadmoor has been poorly served by historians, but see Partridge 1953, Hamilton 1980 and Weiner 2007. For this chapter I have depended on the Broadmoor Archives (BA), recently transferred to the Berkshire Record Office (D/H14).

3 By 1858 there were 134 male and female criminal lunatics at Bethlem. When Broadmoor opened in 1863, the women patients were moved first; 112 male patients, Dadd among them, followed the next year.

4 Philo 2004, pp.606–7; Hood 1854, p.139.

5 The image of Broadmoor as the home of sadistic butchers began early: in 1867 the *Illustrated London News* (24 August, pp.208–9) described it housing 'such notorious cases as the young artist Dadds [sic], who cut off his father's head'. On Broadmoor in the more recent popular imagination, see Cohen 1981; Jenks and Lorentzen 1997.

6 For a summary of the legal and logistical background to the move, see Allderidge 1974a.

7 *Annual Report for 1864*, 1865, p.33.

8 BA D1/1/1/1 (Admission Register, 1863–71).

9 See Weiner 2007 for an account of the original building of the hospital.

10 BA A1/1/1/1–2.

11 The popular perception persisted that escaping the gallows via a successful insanity plea was a luxury of the rich defendant with a smart lawyer, a notion angrily refuted by the medical statistician William Guy in a letter, in which he mentions Dadd's case, to *The Times*, 26 January 1872, p.6.

12 Blocks One and Six were described as being 'prison-like in their arrangements' by the Lunacy Commissioners, and at the turn of the century even the Chaplain was afraid to enter them (BA A1/2/7/1).

13 Soon enough the old dilemma returned and the Broadmoor authorities began seeking the exclusion of the convicts from their hospital: for a decade or so after 1875 they temporarily succeeded in this (Partridge 1953, p.78).

14 The description of the ward in which a journalist found Dadd in 1875 almost certainly describes Block Two: *Morning Post*, 27 December 1875.

15 Partridge 1953, p.139.

16 See Winchester 1998.

17 BA D3/3/2/1, fo.134.

18 BA D2/1/1/1 (28 September 1865; 7 November 1864).

19 Davis and Langdale 1994, no.23.

20 BA D2/2/1/174.

21 BA D2/2/1/858.

22 Anon. 1874, p.431.

23 BA A2/1/1/12: *Annual Report of the Superintendent for 1886*, 1887, pp.56–7, table 36.

24 BA D2/1/3/1 (30 June 1872). Orange had only taken his MD (Heidelberg) in 1868, and his first notes on Dadd are signed 'Mr. Orange'. See Nicolson 1917.

25 BA D2/1/1/1 (7 November 1864; 14 August 1868).

26 'Criminal Lunatics', *Morning Post*, 27 December 1875. Orange did, however, commission from Dadd a large mural of *Flora* for the Superintendent's Residence at Broadmoor (Allderidge 1974, no.214; destroyed).

27 Dodwell, another Block Two resident, was, until this attack, widely believed to be entirely sane (see berkshirerecordoffice.org.uk/documents/Henry_Dodwell.pdf).

28 Neville was scarcely in his new job a year before illness supposedly brought on by overwork forced his premature retirement.

29 See Pitman 1994.

30 On the traditional image of Mad Tom, wandering lonely over the fields in torn clothes, see MacDonald 1981, pp.131, 275 n.10. The 'before and after' pairing of Dadd's images recalls the practice of Henry Hering at Bethlem in the 1850s: in some cases he photographed the same patient both on admission and in convalescence.

31 BA A2/1/1/1: *Annual Report of the Superintendent for 1865*,1866, p.25.

32 *Echo*, 5 March 1877.

33 BA D2/1/3/1 (30 June 1872).

34 Anon. 1877, p.14.

35 Ibid. Dadd may have been recalling the great Vestris production of *A Midsummer Night's Dream* of 1840, which included one spectacular drop of Athens, 'looking up a long perspective of fanes [temples] to the Acropolis towering in the distance' (*Spectator*,

36 quoted by Williams 1997, p.99).

36 Adam 1908, p.156: 'he died at Broadmoor, leaving, as a legacy to that establishment, the many skilful though grotesque drawings which still adorn the walls of the entertainment-room.' The few works by Dadd remaining in Broadmoor's possession are presently on loan to Bethlem.

37 BA D2/1/3/1 (28 September 1872).

38 See Allderidge 1992. Another DIY frame may be that on *Leonidas and the Woodcutters* of 1873 (V&A).

39 BA D3/3/1/1.

40 The same years saw interest in Broadmoor from abroad: in 1878 Daniel Hack Tuke (co-author with J.C. Bucknill of the standard *Manual of Psychological Medicine*) travelled to Paris at the request of the Congrès International de Médecine Mentale to report on the hospital (see Tuke 1880).

41 *Echo*, 5 March 1877.

42 See Inglis 1987; Poynter's picture is presumed to have been destroyed.

43 There was ongoing debate among the Broadmoor officers over who should have access to the chapel, especially after the 1866 attack there on the Superintendent (Minutes of Council of Supervision, 4 June 1869, BA A1/2/1/1).

44 Patient no.45.

45 Scull 1993, pp.251ff.

46 See Nicolson 1878 (p.14 on Dadd); Orange 1883.

47 The epithet is Catharine Arnold's (2008, p.237). For Maudsley's career, see Turner 1988 and, on the foundation of his hospital, Allderidge 1991a.

48 See Clark 1981.

49 The importance of inheritance for insanity was of course scarcely a new idea: what was new was the primary focus upon it.

50 Skultans 1975, p.92.

51 Goodall 1902, p.231.

52 The same instruction appears – in English – on the 1878 watercolour version of Dadd's *Wandering Musicians* (Museum of the Shenandoah Valley, Winchester, VA).

53 Anon. 1879: thanks to Caroline Dakers for this reference. In 1880, William Michael Rossetti was reminded of Dadd when visiting Charles Bastian, who had been Assistant Medical Officer at Broadmoor in its first years (*Journal*, 3 October 1880, Library of the University of British Columbia).

54 BA D2/1/1/1 (14 August 1868).

55 See BA D2/2/1/130 for papers concerning the disposal of Dadd's effects.

56 By the 1890s, 'the deceased's family' meant, at least in Britain, Stephen Thomas Dadd and Frank Dadd, the sons of Richard's eldest brother, Robert, who had died in 1876.

The Asylum Speaks Back

1 MacGregor devotes a chapter to Dadd (1989, chapter 8), but only repeats his biography and has little to say about his 'discovery' by others.

2 In 1863 the *Art Journal* claimed that Dadd was 'an artist not now remembered save by fellow-labourers' (p.58).

3 Cf. the *Critic*, 15 March 1856: 'There is a mad painter in the criminal wards of Bedlam – one Dadd, who paints, with curious skill, strange and hideous phantasms such as a madman only could conceive … but no one ever dreams of quoting him as the chiefest of living painters.'

4 *Liverpool Chronicle*, 9 September 1843. Other opportunities to see Dadd's works at exhibition in this period included his contribution to the Palace of Westminster cartoons competition (Allderidge 1974, no.89), *Come Unto These Yellow Sands* (fig.15; shown in Edinburgh in 1854) and the several loans made by Richard Reeves to the annual Birmingham exhibitions.

5 [*Manchester Guardian*] 1857a, pp.12–14. The six works by Dadd shown at Manchester all came from collections in the Midlands or North of England. The comparison with Blake was also made by the collector James Hughes Anderdon on viewing Hood's sale at Christie's in 1870 (Royal Academy Library, Anderdon papers, vol.24, fo.40).

6 [*Manchester Guardian*] 1857, pp.126–7. The early fairy pictures also continued a limited afterlife: *Puck* (fig.13), also shown at Manchester, was engraved for the *Art Journal* in 1864.

7 Cox was, for example, the main buyer of Reeves's Dadds when they were sold off in 1865; his own sale was at Christie's, 8–9 and 15–18 February 1884. See also Maas 1975, p.217.

8 Hughes 1891, p.396; Frith 1887–8: vol.3, chapter 9.

9 Hyslop 1911: the term was given currency by the English translation of Lombroso's *Man of Genius* (1891), which described genius as a morbid degenerative condition.

10 The 1913 Bethlem exhibition was 'suggested' by Savage but actually 'organised' by Ralph Brown, the Junior Assistant Physician (*Report of the Resident Physician for … 1913*, London 1914, p.15; see further MacGregor 1989, pp.162ff). Also closely involved in organising the exhibition appears to have been Sir James Crichton-Browne, son of the Scottish alienist W.A.F. Browne. The patient art was shown without any information on case histories, a drawback pointed out by Savage himself in the *Journal of Mental Science*, 59, October 1913, p.657. The conference, the 17th International Congress of Medicine, also saw the Wellcome Collection of the history of medicine put on public show for the first time. An earlier exhibition of art at Bethlem, held in 1900, is far less well documented, but see the brief account in the hospital's in-house magazine, *Under the Dome*, December 1900, pp.244–6.

11 Apparently six works by Dadd were included in the exhibition, of which only *Agony* can be identified (Allderidge 1974, no.127).

12 See [Prinzhorn Collection] 1996, and for an updated attempt to calibrate Modernist practice against schizophrenia, Sass 1992. 'Outsider Art' was the English term invented for the title of Cardinal's book (1972) on Art Brut, the category defined by Jean Dubuffet in the 1940s as work made by untrained people outside the bounds of the art world, whether insane or not.

13 For such 'diagnoses' of pictures, see Reitman 1950 and Born 1946; the latter (pp.229–30) sees the *Fairy Feller* (fig.97) as typically schizophrenic in its incoherence and 'tendency toward "doodling"'.

14 *Academy*, 27 May 1876, p.520.

15 Dodgson 1919; Ross 1952, p.85. In 1919 the British Museum also bought from Ross's Carfax Gallery Dadd's *Crooked Path* (fig.93), which had been (so far as I know) the first of Dadd's works to be published photographically (in How 1893).

16 Anon. 1879.

17 Sassoon's poem 'A Whispered Tale' (in his *Old Huntsman* collection of 1917) is addressed to Julian; Julian and his brother Edmund subsequently appeared as 'Durley' and 'Edmunds' in Sassoon's *Memoirs of a Fox-Hunting Man* (1928; Wilson 2003, p.496). The third brother was named Stephen, a sculptor.

18 See correspondence in Tate Archives, 4/2/244/2.

19 Meyerstein 1939, p.43; Prance 1963.

20 Sitwell 1937, pp.73, 13.

21 Sotheby's, 29 May 1963, lot 37.

22 Shepherd 1997, pp.227–4. Powell of course recycled this apocalyptic language in his 'Rivers of blood' anti-immigration speech seven years later.

23 See Tantam 1991 and Kotowicz 1997 for, respectively, negative and positive readings of the movement's influence.

24 Deleuze and Guattari 2004.

25 MacBeth 1969: this author claims to be able to identify phallic imagery in many of Dadd's works, as does Fuller (1974) in his unintentionally funny attempt to reduce Dadd's life and work to an Oedipal scream. For further penis-hunting, see Fraser Stansbie 2006, pp.193–4.

26 Jones 1971.

27 For an obituary see *The Times*, 28 April 1970, p.12.

28 Andrews *et al.* 1997, chapters 29–30. Under the new NHS system, only teaching hospitals were allowed to report directly to government rather than submit to management by regional boards.

29 *Illustrated London News*, 25 March 1843, pp.207–8.

30 Tuke 1876; O'Donoghue 1914.

31 Andrews *et al.* 1997, p.626; Allderidge [1976?]; information from Colin Gale, the present Bethlem archivist, May 2010.

32 See, for example, Allderidge 1985, and the same author's letter to the *Psychiatric Bulletin*, 14: 8, 1990, p.498 (on the nineteenth-century patient Edward Oxford).

33 Pratchett 2003; Rankin 2003; Barker's *Regeneration* trilogy appeared between 1991 and 1995.

34 But see Polke 2004.

Bibliography

Ackroyd, Peter, *Dickens*, London: Sinclair Stevenson, 1990.

Adam, H.L., *The Story of Crime from the Cradle to the Grave*, London: Werner Laurie, [1908].

Agnew, Geoffrey, *Agnew's 1817–1967*, London: Agnew, 1967.

Allderidge, Patricia, 'Richard Dadd (1817–1886): Painter and Patient', *Medical History*, vol.14, no.3 (1970), pp.308–13.

Allderidge, Patricia, *The Late Richard Dadd*, exh. cat., London: Tate Gallery, 1974.

Allderidge, Patricia, 'Criminal Insanity: Bethlem to Broadmoor', *Proceedings of the Royal Society of Medicine*, vol.67, 1974a, pp.897–904.

Allderidge, Patricia, 'The Archives and Museum', in Robert Cawley and Margaret Myers (eds.), *The Bethlem Royal Hospital and The Maudsley Hospital Report 1970–75. Part I—Text* (n.p. [London]: n.d. [?1976]), pp.165–70.

[Allderidge, Patricia], *Cibber's Figures from the Gates of Bedlam*, London: V&A Publications, 1977.

Allderidge, Patricia, 'Bedlam: Fact or Fantasy?', in W.F. Bynum, Roy Porter and Michael Shepherd (eds.), *The Anatomy of Madness*, vol.2, 1985, pp.17–33.

Allderidge, Patricia, 'A cat, surpassing in beauty, and other therapeutic animals', *Psychiatric Bulletin*, vol.15, 1991, pp.759–62.

Allderidge, Patricia, 'The Foundation of the Maudsley Hospital', in G. Berrios and H. Freeman (eds.), *150 Years of British Psychiatry*, 1991a, pp.79–88.

Allderidge, Patricia, 'A Wayside Inn by Richard Dadd: A Landscape of the Mind', *NACF Review*, 1992, pp.67–9.

Allderidge, Patricia, 'Richard Dadd: Violence and Creativity in Victorian Bedlam', in Chris Thompson and Phil Cowen (eds.), *Violence: Basic and Clinical Science*, Oxford: Butterworth-Heinemann, 1993, pp.199–210.

Allderidge, Patricia, *Bethlem Hospital 1247–1997: A Pictorial Record*, Chichester: Phillimore, 1997.

Allderidge, Patricia, *Richard Dadd (1817–1886): Dreams of Fancy*, exh. cat., London: Andrew Clayton-Payne, 2008.

Allen, J.B.L. '"Mad Robin": Richard Dadd', *Art Quarterly*, vol.30, no.1, 1967, pp.18–30.

Andrews, Jonathan, Asa Briggs, Roy Porter, Penny Tucker and Keir Waddington, *The History of Bethlem*, London and New York: Routledge, 1997.

Andrews, Jonathan, and Anne Digby (eds.), *Sex and Seclusion, Class and Custody. Perspectives on Gender and Class in the History of British and Irish Psychiatry*, Amsterdam: Rodopi, 2004.

Anon., *April Fool Day. A True and Faithful Report of a Feast, and General Meeting of the Chatham and Rochester Philosophers*, Rochester: Epps, 1828.

Anon., 'Broadmoor Criminal Lunatic Asylum', *Illustrated London News*, 24 Aug. and 7 Sept. 1867, pp.208–9, 271, 273.

Anon., 'The Broadmoor Criminal Lunatic Asylum', *Journal of Mental Science*, vol.20, no.91, Oct. 1874, pp.431–5.

Anon., 'Her Majesty's Pleasure, The Parricide's Story', the *World*, 26 Dec. 1877, pp.13–14.

Anon., 'Treasure-Houses of Art (II)', *Magazine of Art*, vol.2, 1879, pp.206–11.

Anon., 'Minds in Splints', *Pan*, 27 Nov. 1880.

Anon., 'Art and Insanity. The Bethlem Hospital Exhibition', *The Times*, 14 Aug. 1913, p.8.

Anon., 'Art and Insanity', *British Medical Journal*, 30 Aug. 1913, pp.563–4.

Arnold, Catharine, *Bedlam. London and its Mad*, London: Simon and Schuster, 2008.

Barlow, Paul, '"The Backside of Nature": The Clique, Hogarthianism, and the Problem of Style in Victorian Painting', Ph.D. thesis, University of Sussex, 1989.

Becker, George, *The Mad Genius Controversy*, Beverley Hills, CA: Sage, 1978.

Behdad, Ali, *Belated Travellers*, Cork: Cork University Press, 1994.

Benjamin, Marina, 'Sliding Scales: Microphotography and the Victorian Obsession with the Miniscule', in Francis Spufford and Jenny Uglow (eds.), *Cultural Babbage: Technology, Time and Invention*, London: Faber, 1996, pp.99–122.

Berrios, German E. and Hugh Freeman (eds.), *150 Years of British Psychiatry, 1841–1991*, London: Gaskell, 1991.

Berrios, German E., Rogelio Luque and José M. Villagrán, 'Schizophrenia: A Conceptual History', *International Journal of Psychology and Psychological Therapy*, vol.3, no.2, 2003, pp.111–40.

Beveridge, Allan, 'A disquieting feeling of strangeness? The Art of the Mentally Ill', *Journal of the Royal Society of Medicine*, vol.94, 2001, pp.595–9.

Beveridge, Allan, 'What became of Arthur Conan Doyle's father? The last years of Charles Altamont Doyle', *Journal of the Royal College of Physicians of Edinburgh*, vol.36, 2006, pp.264–70.

Binyon, Laurence, 'A Note on Richard Dadd', *Magazine of Art*, vol.30, 1937, pp.106–7, 125, 128.

Black, William, *A Dissertation on Insanity: Illustrated with tables, extracted from between two and three thousand cases in Bedlam*, London: Ridgway, 1810.

Born, Wolfgang, 'The Art of the Insane', *Ciba Symposia*, vol.7, no.10, Jan. 1946.

Bowler, Anne, 'Asylum Art: The Social Construction of an Aesthetic Category', in Vera Zolberg and Joni Cherbo (eds.), *Outsider Art: Contesting Boundaries in Contemporary Culture*, Cambridge: Cambridge University Press, 1997, pp.11–36.

Bown, Nicola, '"Entangled banks": Robert Browning, Richard Dadd and the Darwinian grotesque', in Colin Trodd, Paul Barlow and David Amigoni (eds.), *Victorian Culture and the Idea of the Grotesque*, Aldershot: Ashgate, 1999, pp.119–39.

Bown, Nicola, *Fairies in Nineteenth-Century Art and Literature*, Cambridge: Cambridge University Press, 2001.

Bown, Nicola, 'What is the Stuff that Dreams are made of?', in Bown *et al.* (eds.), *The Victorian Supernatural*, Cambridge: Cambridge University Press, 2004, pp.151–72.

Boyle, Mary, *Schizophrenia: A Scientific Delusion?*, 2nd ed., London: Routledge, 2002.

Brand-Claussen, Bettina, and Thomas Röske (eds.), *Artists off the Rails*, exh. cat., Heidelberg: Prinzhorn Collection, 2008.

Bronkhurst, Judith, 'The Contemporary British Paintings at the Manchester Art-Treasures Exhibition', in Helen Rees Leahy (ed.), *Art, City, Spectacle: The 1857 Manchester Art-Treasures Exhibition Revisited*, Manchester: Rylands Library, 2009, pp.103–22.

Browne, W.A.F., *What Asylums Were, Are, and Ought to Be*, Edinburgh: Adam and Black, 1837.

[Browne, W.A.F.], 'Mad Artists', *Journal of Psychological Medicine and Mental Pathology*, vol.6, no.1, 1880, pp.33–75.

Bucknill, John Charles, *Unsoundness of Mind in Relation to Criminal Acts*, London: Highley, 1854.

Bucknill, John Charles, *The Psychology of Shakespeare*, London: Longman, 1859.

Bullen, J.B. (ed.), *The Sun is God. Painting, Literature and Mythology in the Nineteenth Century*, Oxford: Clarendon, 1989.

Bynum, W.F., Roy Porter and Michael Shepherd (eds.), *The Anatomy of Madness. Essays in the History of Psychiatry*, 3 vols, London: Tavistock, 1985–8.

Byrd, Max, *Visits to Bedlam. Madness and Literature in the Eighteenth Century*, Columbia, SC: University of South Carolina Press, 1974.

Cardinal, Roger, *Outsider Art*, London: Studio Vista, 1972.

Carter, Angela, 'Come Unto These Yellow Sands' [1979], in *The Curious Room: Collected Dramatic Works*, London: Vintage, 1997.

[Charity Commissioners] *Report of the Commissioners Appointed … to Continue the Inquiries Concerning Charities*, 32nd report, part 6, London: HMSO, 1840.

Chatham and Rochester Philosophical and Literary Institution, *Annual Reports*, 1828–41.

Chung, Man Cheung, K.W.M. Fulford and George Graham (eds.), *Reconceiving Schizophrenia*, Oxford: Oxford University Press, 2007.

Clair, Jean (ed.), *Mélancolie, génie et folie en occident*, exh. cat., Paris: Grand Palais, 2005.

Clark, Michael, 'The Rejection of Psychological Approaches to Mental Disorder in Late Nineteenth-Century British Psychiatry', in Andrew Scull (ed.), *Madhouses, Mad-Doctors and Madmen*, Philadelphia, PA: University of Pennsylvania Press, 1981, pp.271–312.

Clark, Michael, '"Morbid Introspection", Unsoundness of Mind and British Psychological Medicine, c.1830–1900', in Bynum, Porter and Shepherd (eds.), *The Anatomy of Madness*, vol.3, 1988, pp.71–101.

Coan, Catherine, 'Birmingham Patrons, Collectors, and Dealers 1830–1880', MA thesis, University of Birmingham, 1980.

Cohen, David, *Broadmoor*, London: Psychology News Press [1981].

[Commissioners in Lunacy] *Report of the Commissioners in Lunacy to the Secretary of State on Bethlem Hospital, and all correspondence thereon* in *Seventh Annual Report of the Lunacy Commissioners*, *Parliamentary Papers*, vol.49, London, 1852–3.

Conolly, John, 'The Physiognomy of Insanity. No.9—Religious Mania', *Medical Times and Gazette*, 24 July 1858, pp.81–3.

Conolly, John, *A Study of Hamlet*, London: Moxon, 1863.

Cook, B.F., Bernard Ashmole and Donald Strong, *Relief Sculpture of the Mausoleum at Halicarnassus*, Oxford: Oxford University Press, 2005.

Coombs, Katherine, *The Portrait Miniature in England*, London: V&A Publications, 1998.

Cramer, Charles A., 'Alexander Cozens's "New Method": The Blot and General Nature', *Art Bulletin*, vol.79, no.1, 1997, pp.112–29.

[Dadd, Richard] 'The Late Richard Dadd' [letters to David Roberts], *Art-Union*, Oct. 1843, pp.267–71.

[Davis and Langdale] *Richard Dadd (1817–1886). A Loan Exhibition* (with an introduction by Patricia Allderidge), exh. cat., New York: Davis and Langdale, 1994.

Dawson, L.S., *Memoirs of Hydrography, Part 2. – 1830–1885*, Eastbourne: Keay, 1885.

Day, Archibald, *The Admiralty Hydrographic Service 1795–1919*, London: HMSO, 1967.

Deacon, Margaret, *Vice-Admiral T.A.B. Spratt and the Development of Oceanography in the Mediterranean 1841–1873*, London: National Maritime Museum, 1978.

Deleuze, Gilles and Félix Guattari, *Anti-Oedipus: Capitalism and Schizophrenia* [1972], London: Continuum, 2004.

Devereux, Walter, *Views on the Shores of the Mediterranean*, London: Dickinson, 1847.

Dickens, Charles, *The Pickwick Papers* [1836–7], Oxford: Oxford University Press, 1988.

Dodgson, Campbell, 'Recent Acquisitions for Public Collections – XII', *Burlington Magazine*, vol.35, no.197, Aug. 1919, pp.61–3.

Donnelly, Michael, *Managing the Mind. A Study of Medical Psychology in Early Nineteenth-Century Britain*, London and New York: Tavistock, 1983.

Dunn, Henry Treffry (ed. Gale Pedrick), *Recollections of Dante Gabriel Rossetti and his Circle*, London: Mathews, 1904.

Eigen, Joel Peter, *Witnessing Insanity. Madness and Mad-Doctors in the English Court*, New Haven and London: Yale University Press, 1995.

Esquirol, J.-E.-D., *Des Passions considérées comme causes, symptômes, et moyens curatifs de l'aliénation mentale*, Paris: Didot, 1805.

Esquirol, J.-E.-D., 'Mémoire historique et statistique sur la maison royale de Charenton', *Annales d'hygiène publique et de médecine légale*, vol.13, 1835, pp.5–192.

Farington, Joseph, *Diary*, ed. Kenneth Garlick and Angus Macintyre, vol.6, New Haven and London: Yale University Press, 1979.

Fazel, Seena, *et al.*, 'Schizophrenia and Violence: Systematic Review and Meta-Analysis', *PLoS Medicine*, Aug. 2009.

Fellows, Charles, *A Journal Written During an Excursion in Asia Minor*, London: John Murray, 1839.

Fellows, Charles, *An Account of Discoveries in Lycia*, London: John Murray, 1841.

Ferrier, Jean-Louis, *Outsider Art*, Paris: Terrail, 1998.

Forbes, Duncan, '"The advantages of competition": the Art Union of London and state regulation in the 1840s', in Paul Barlow and Colin Trodd (eds.), *Governing Cultures: Art Institutions in Victorian London*, Aldershot: Ashgate, 2000, pp.128–41.

Forster, John, 'Macready's Production of "The Tempest"' [1838], in William Archer and Robert Lowe (eds.), *Dramatic Essays*, vol.3, London: Walter Scott, 1896, pp.65–72.

Foster, Hal, 'Blinded Insights: On the Modernist Reception of the Art of the Mentally Ill', *October*, vol.97, 2001, pp.3–30.

Foucault, Michel (ed.), *I, Pierre Rivière, having slaughtered my mother, my sister, and my brother* [1973], Lincoln: University of Nebraska Press, 1982.

Foucault, Michel, *Madness and Civilization: A History of Insanity in the Age of Reason* [French original 1961], trans. Richard Howard [1965], London: Routledge, 2001.

Fraser Stansbie, Eleanor, 'Richard Dadd: Art and the Nineteenth-Century Asylum', Ph.D. thesis, Birkbeck College, University of London, 2006.

Fraser Stansbie, Eleanor, 'A Victorian Picture Puzzle: Richard Dadd's *The Fairy Feller's Masterstroke*', in Albert D. Pionke and Denise Tischler Millstein (eds.), *Victorian Secrecy. Economies of Knowledge and Concealment*, Farnham: Ashgate, 2010, pp.95–114.

Frith, William Powell, *My Autobiography and Reminiscences*, 3 vols., London: Bentley, 1887–8.

Fuller, Peter, 'Richard Dadd: A Psychological Interpretation', *Connoisseur*, vol.186, July 1974, pp.170–7.

Gale, Colin and Robert Howard, *Presumed Curable: An Illustrated Casebook of Victorian Psychiatric Patients at Bethlem Hospital*, Petersfield: Wrightson, 2003.

Gauchet, Marcel and Gladys Swain, *Madness and Democracy. The Modern Psychiatric Universe* [1980], Princeton, NJ: Princeton University Press, 1999.

Gilman, Sander, *Seeing the Insane* [1982], Lincoln: University of Nebraska Press, 1996.

Goldstein, Jan, *Console and Classify. The French Psychiatric Profession in the Nineteenth Century* [1987], 2nd ed. Chicago: University of Chicago Press, 2001.

Goodall, Frederick, *The Reminiscences of Frederick Goodall, R.A.*, London: Walter Scott, 1902.

Gottesman, Irving I., *Schizophrenia Genesis. The Origins of Madness*, New York: Freeman, 1991.

Green-Lewis, Jennifer, *Framing the Victorians. Photography and the Culture of Realism*, Ithaca, NY: Cornell University Press, 1996.

Greenberg, Maurice *et al.*, *Narratives in Psychiatry*, London: Kingsley, 2003.

Greysmith, David, *Richard Dadd. The Rock and Castle of Seclusion*, London: Studio Vista, 1973.

Griffiths, Trevor R., *Shakespeare in Production. A Midsummer Night's Dream*, Cambridge: Cambridge University Press, 1996.

Guiterman, Helen and Briony Llewellyn (eds.), *David Roberts*, exh. cat., London: Barbican Art Gallery, 1986.

Guyatt, Mary, 'A Semblance of Home: Mental Asylum Interiors, 1880–1914', in Susie McKellar and Penny Sparke (eds.), *Interior Design and Identity*, Manchester: Manchester University Press, 2004, pp.48-71.

Hall, Samuel Carter (ed.), *The Book of British Ballads*, first series, London: How, 1842.

[Hall, Samuel Carter], 'The Latest Tragedy', *Pictorial Times*, 9 Sept. 1843, pp.45–6.

[Hall, Samuel Carter], 'Puck and the Fairies', *Art Journal*, May 1864, p.130.

Hall, Samuel Carter, *Retrospect of a Long Life: from 1815 to 1883*, 2 vols., London: Bentley, 1883.

[Hall, Samuel Carter and H.G. Adams], 'The Maniac Parricide', *Cleave's Penny Gazette*, 28 Oct. 1843, p.1.

Halliwell, James Orchard, *Illustrations of the Fairy Mythology of 'A Midsummer Night's Dream'*, London: Shakespeare Society, 1845.

Hamilton, John R., 'The Development of Broadmoor 1863–1980', *Psychiatric Bulletin*, vol.4, no.9, 1980, pp.130–3.

Hardwick, Lorna, 'Ancient Amazons – Heroes, Outsiders or Women', *Greece and Rome*, vol.37, no.1, 1990, pp.14–36.

Hare, E.H., 'Was Insanity on the Increase?', *British Journal of Psychiatry*, vol.142, 1983, pp.439–55.

Haydon, Benjamin Robert, *Lectures on Painting and Design*, London: Longman, 1844.

Haydon, Katharine, 'George Henry Haydon (1822–1891): An Anglo-Australian Life', Ph.D. thesis, King's College, London, 2007.

Heinrichs, R.W., 'Historical origins of schizophrenia: Two Early Madmen and Their Illness', *Journal of the History of the Behavioural Sciences*, vol.39, 2003, pp.349–63.

Hervey, Nicholas, 'Advocacy or Folly: The Alleged Lunatics' Friend Society, 1845–63', *Medical History*, vol.30, 1986, pp.245–75.

Higgie, Jennifer, *Bedlam*, New York: Sternberg, 2006.

Hill, Rosemary, *God's Architect: Pugin and the Building of Romantic Britain*, London: Allen Lane, 2007.

Hofmann, Michael, 'The Late Richard Dadd, 1817–1886' [1986], in Don Patterson and Charles Simic (eds.), *New British Poetry*, Saint Paul, MN: Graywolf, 2004, p.101.

Hogan, Susan, *Healing Arts. The History of Art Therapy*, London: Kingsley, 2000.

Hood, W. Charles, *Suggestions for the Future Provision of Criminal Lunatics*, London: Churchill, 1854.

Hood, W. Charles, *Criminal Lunatics; a letter to the Chairman of the Commissioners in Lunacy*, London: Churchill, 1860.

Hood, W. Charles, *Statistics of Insanity; embracing a report of Bethlem Hospital, from 1846 to 1860, inclusive*, London: Batten, 1862.

[Hood, W. Charles] Christie's auction catalogue, 26 and 28 March 1870, including works from Hood's collection.

Hoskyn, Richard, 'Narrative of a Survey of Part of the South Coast of Asia Minor; and of a Tour into the Interior of Lycia in 1840–41', *Journal of the Royal Geographical Society*, vol.12, 1842, pp.143–61.

How, Harry, 'Illustrated Interviews. XXII. Sir Robert Rawlinson, K.C.B.', *Strand Magazine*, May 1893, pp.513–17.

Howells, John G. (ed.), *The Concept of Schizophrenia: Historical Perspectives*, Washington, DC: American Psychiatric Press, 1991.

Hubbard, Hesketh, *An Outline History of the Royal Society of British Artists*, London: RSBA, 1937.

Hughes, William Richard, *A Week's Tramp in Dickens-Land*, London: Chapman and Hall, 1891.

Hyman, John, 'Art and Neuroscience', www. interdisciplines.org/artcognition/papers/15 (2006).

Hyslop, Theophilus B., 'Post-Illusionism and the Art of the Insane', *Nineteenth Century*, vol.69, Feb. 1911, pp.270–81.

Hyslop, Theophilus B., *Mental Handicaps in Art*, London: Baillière, Tindall and Cox, 1927.

Imray, John, 'A Reminiscence of Sixty Years Ago', *Art Journal*, 1898, p.202.

Inglis, Alison, 'Sir Edward Poynter and the Earl of Wharncliffe's Billiard Room', *Apollo*, vol.126, Oct. 1987, pp.249–55.

Ingram, Allan, with Michelle Faubert, *Cultural Constructions of Madness in Eighteenth-Century Writing: Representing the Insane*, Basingstoke: Palgrave, 2005.

Jamison, Kay R., *Touched with Fire: Manic-Depressive Illness and the Artistic Temperament*, New York: Free Press, 1993.

Jay, Mike, *Emperors of Dreams: Drugs in the Nineteenth Century*, Sawtry: Dedalus, 2000.

Jay, Mike, *The Air Loom Gang*, London: Bantam, 2003.

Jay, Mike, 'Psychedelica Victoriana', *Fortean Times*, Feb. 2004.

Jenks, Chris and Justin J. Lorentzen, 'The Kray Fascination', *Theory, Culture and Society*, vol.14, no.3, 1997, pp.87–107.

Johnston, George, *The Life of Captain Johnston, late Captain of the Ship Tory*, Liverpool 1850.

Jones, David J.V., *The Last Rising: The Newport Chartist Insurrection of 1839* [1985], Cardiff: University of Wales Press, 1999.

Jones, Peter, 'The Daddy of Them All', *Oz*, vol.33, 1971, pp.46–7.

Jouve, Michel, 'Richard Dadd et les ambiguïtés de la peinture de portrait', *Gazette des Beaux-Arts*, vol.111, 1988, pp.89–92.

Joy, Edward, 'The Royal Victorian Furniture-Makers, 1837–87', *Burlington Magazine*, vol.111, Nov. 1969, pp.677–87.

Kehler, Dorothea (ed.), *A Midsummer Night's Dream. Critical Essays*, New York and London: Garland, 1998.

King, Lyndel Saunders, *The Industrialization of Taste: Victorian England and the Art Union of London*, Ann Arbor, MI: UMI Research Press, 1985.

Klemenz, Hélène, 'Richard Dadd and his demons in France', *Burlington Magazine*, April 2010, p.227.

Kotowicz, Zbigniew, *R.D. Laing and the Paths of Anti-Psychiatry*, London: Routledge, 1997.

Kromm, Jane E., 'Hogarth's Madmen', *Journal of the Warburg and Courtauld Institutes*, vol.48, 1985, pp.238–42.

Lamb, Charles, 'Sanity of True Genius' [1826], in *Essays of Elia*, London: Dent, 1906, pp.219–21.

Laurie, Peter, *A Narrative of the Proceedings at the laying of the first stone of the new buildings at Bethlem Hospital*, London: Governors of Bridewell and Bethlem Hospitals, 1838.

Lepsius, Richard, *Letters from Egypt, Ethiopia, and the Peninsula of Sinai*, London: Bohn, 1853.

Lippincott, Louise, 'Murder and the Fine Arts; or, a reassessment of Richard Dadd', *J. Paul Getty Museum Journal*, vol.16, 1988, pp.75–94.

Macalpine, Ida and Richard Hunter, *Schizophrenia, 1677. A psychiatric study of an illustrated autobiographical record of demoniacal possession*, London: Dawson, 1956.

Macalpine, Ida and Richard Hunter, *George III and the Mad-Business* [1969], London: Pimlico, 1991.

MacBeth, George, 'Turn Me On, Dadd', *New Statesman*, 1 Aug. 1969, p.150.

MacDonald, Michael, *Mystical Bedlam. Madness, Anxiety, and Healing in Seventeenth-Century England*, Cambridge: Cambridge University Press, 1981.

MacDougall, Philip, *Chatham Dockyard 1815–65. The Industrial Transformation*, Farnham: Ashgate, 2009.

MacGregor, John M., *The Discovery of the Art of the Insane*, Princeton, NJ: Princeton University Press, 1989.

Maas, Jeremy, *Gambart: Prince of the Victorian Art World*, London: Barrie and Jenkins, 1975.

[*Manchester Guardian*] *A Handbook to the Gallery of British Paintings in the Art Treasures Exhibition*, London: Bradbury, 1857.

[*Manchester Guardian*] *A Handbook to the Water Colours, Drawings, and Engravings, in the Art Treasures Exhibition*, London: Bradbury and Evans, 1857a.

Mannings, David and Martin Postle, *Sir Joshua Reynolds. A Complete Catalogue of his Paintings*, New Haven and London: Yale University Press, 2000.

Martin, Francis Offley (ed.), *An Account of Bethlem Hospital* [abridged from 32nd report of the Charities Commissioners, 1837], London: Pickering, 1853.

Martineau, Jane (ed.), *Victorian Fairy Painting*, exh. cat., London: Royal Academy, 1997.

Mayo, Thomas, *Medical Testimony and Evidence in Case of Lunacy*, London: Parker, 1854.

Meigh, Charles, *Critical and Descriptive Catalogue of a Collection of Pictures at Grove House, Shelton*, Henley: Allbut, 1847.

Melling, Joseph and Bill Forsythe (eds.), *Insanity, Institutions and Society, 1800–1914*, London: Routledge, 1999.

Melling, Joseph and Bill Forsythe, *The Politics of Madness: The State, Insanity and Society in England, 1845–1914*, London: Routledge, 2006.

Meslay, Olivier, 'Féeries et parricide: "Titania endormie" de Richard Dadd', *Revue du Louvre*, vol.50, no.4, 2000, pp.70–5.

Meyerstein, E.H.W., *Sonnets. In Exitu Israel. Peace: An Ode*, Oxford: Oxford University Press, 1939.

Moffitt, John F., 'Painters "Born under Saturn": The Physiological Explanation', *Art History*, vol.11, no.2, 1988, pp.195–216.

Morgan, John, *Four Biographical Sketches: Bishop Ollivant, Bishop Thirlwall, Rev. Griffith Jones, Vicar of Llanddowror, and Sir Thomas Phillips, Q.C.*, London: Elliott Stock, 1892.

Morison, Alexander, *Outlines of Lectures on Mental Diseases*, Edinburgh 1825.

Morison, Alexander, *The Physiognomy of Mental Diseases*, London: Longman, 1840.

[Morley, Henry] 'The Star of Bethlehem', *Household Words*, vol.16, no.386, 15 Aug. 1857, pp.145–50.

Morris, Hazel, *Hand, Head and Heart: Samuel Carter Hall and the Art Journal*, Norwich: Michael Russell, 2002.

Motley, Jonathan C. and Robert Sommer, 'A Content Analysis of Richard Dadd's Art', *The Arts in Psychotherapy*, vol.26, no.5, 1999, pp.295–301.

Mundt, Christoph, 'Über Leben und Werk von Richard Dadd – Anmerkungen zur Pathographie eines Geisteskranken Malers', in Udo Benzenhöfer *et al.* (eds.), *Melancholie in Literatur und Kunst*, Hürtgenwald: Pressler, 1990, pp.127–61.

Nettle, Daniel, *Strong Imagination: Madness, Creativity and Human Nature*, Oxford: Oxford University Press, 2001.

Nicolson, David, 'A Chapter in the History of Criminal Lunacy in England', *Journal of Mental Science*, vol.23, 1877, pp.165–85.

Nicolson, David, 'The Measure of Individual and Social Responsibility in Criminal Cases', *Journal of Mental Science*, vol.24, 1878, pp.1–25, 249–73.

Nicolson, David, 'William Orange, C.B., M.D., F.R.C.P.' [obituary], *British Medical Journal*, 13 Jan. 1917, pp.67–9.

O'Donoghue, Edward, *The Story of Bethlehem Hospital from its Foundation in 1247*, London: Unwin, 1914.

Orange, William, 'Presidential Address', *Journal of Mental Science*, vol.29, no.127, Oct. 1883, pp.329–54.

Park, Maureen, *Art in Madness: Dr W.A.F. Browne's Collection of Patient Art at Crichton Royal Institution*, Dumfries and Galloway Health Board, 2010.

Partridge, Ralph, *Broadmoor. A History of Criminal Lunacy and its Problems*, London: Chatto and Windus, 1953.

Paz, Octavio, *The Monkey Grammarian* [1974], trans. Helen Lane, London: Owen, 1989.

Pearce, Arthur, *Poems by a Prisoner in Bethlehem*, ed. John Perceval, London: Effingham Wilson, 1851.

Phillips, Thomas, *Wales: The Language, Social Condition, Moral Character, and Religious Opinions of the People, Considered in their Relation to Education*, London: Parker, 1849.

Philo, Chris, *A Geographical History of Institutional Provision for the Insane from Medieval Times to the 1860s in England and Wales. The Space Reserved for Insanity*, Lampeter: Edwin Mellen, 2004.

Pitman, Joy, 'Papers of the Society for Improving the Conditions of the Insane', *Proceedings of the Royal College of Physicians of Edinburgh*, vol.24, 1994, pp.420–7.

Polke, Sigmar, 'Little World by the Wayside', *Tate Etc.*, vol.1, 2004, pp.48–51.

Prance, C.A., 'The Farringdon Road Bookstalls', *The Private Library*, vol.25, 1963, pp.86–90.

Pratchett, Terry, *The Wee Free Men*, London: Doubleday, 2003.

Prichard, James Cowles, *A Treatise on Insanity and other disorders affecting the mind*, London: Sherwood, 1835.

Prichard, James Cowles, *On the Different Forms of Insanity, in Relation to Jurisprudence*, London 1842.

[Prinzhorn Collection] *Beyond Reason. Art and Psychosis: Works from the Prinzhorn Collection*, exh. cat., London: Hayward Gallery, 1996.

Rankin, Robert, *The Witches of Chiswick*, London: Gollancz, 2003.

Read, John, Loren Mosher and Richard Bentall (eds.), *Models of Madness. Psychological, social and biological approaches to schizophrenia*, Hove and New York: Brunner-Routledge, 2004.

Reitman, Francis, *Psychotic Art*, London: Routledge, 1950.

Rhodes, Kimberly, *Ophelia and Victorian Visual Culture*, Aldershot: Ashgate, 2008.

Richards, Robert J., 'Rhapsodies on a Cat-Piano, or Johann Christian Reil and the Foundations of Romantic Psychiatry', *Critical Inquiry*, vol.24, no.3, 1998, pp.700–36.

Rickett, John, 'Rd. Dadd, Bethlem and Broadmoor. An attempt at a biography', *Ivory Hammer*, vol.2, 1964, pp.22–5.

Roberts, Keith [review of Allderidge 1974], *Burlington Magazine*, Aug. 1974, pp.487–8.

Röske, Thomas and Bettina Brand-Claussen (eds.), *The Air Loom and other dangerous influencing machines*, Prinzhorn Collection, Heidelberg 2006.

Ross, Margery (ed.), *Robert Ross: Friend of Friends*, London: Jonathan Cape, 1952.

Rossetti, William Michael, *Some Reminiscences*, 2 vols., London: Brown, 1906.

Russell, David, *Scenes from Bedlam. A history of caring for the mentally disordered at Bethlem Royal Hospital*, London: Baillière, 1996.

Saint Pierre, Isaure de, *Richard Dadd – His Journals* [1980], Henley-on-Thames: Ellis, 1984.

Sala, G.A., 'A Visit to the Royal Hospital of Bethlehem', *Illustrated London News*, 24 and 31 March 1860, pp.291–3, 304–5, 308.

Sass, Louis A., *Madness and Modernism: Insanity in the Light of Modern Art, Literature and Thought*, New York: Basic Books, 1992.

Schiff, Gert, 'A Bacchanalian Scene by Richard Dadd', *Source*, vol.3, no.1, 1983, pp.31–3.

Schindler, Richard, 'Joseph Noel Paton's Fairy Paintings: Fantasy Art as Victorian Narrative', *Scotia*, vol.14, 1990, pp.13–29.

Scott, William Bell, *Autobiographical Notes*, ed. W. Minto, 2 vols., London: Osgood and McIlvaine, 1892.

Scull, Andrew, *The Most Solitary of Afflictions: Madness and Society in Britain, 1700–1900*, New Haven and London: Yale University Press, 1993.

Scull, Andrew et al., *Masters of Bedlam: The Transformation of the Mad-Doctoring Trade*, Princeton NJ: Princeton University Press, 1996.

Seibold-Bultmann, Ursula, 'Monster Soup: The Microscope and Victorian Fantasy', *Interdisciplinary Science Review*, vol.25, no.3, 2000, pp.211–19.

Shepherd, Robert, *Enoch Powell: A Biography*, London: Pimlico, 1997.

Shorter, Edward, *A History of Psychiatry. From the Era of the Asylum to the Age of Prozac*, New York: Wiley, 1997.

Showalter, Elaine, *The Female Malady: Women, Madness and English Culture, 1830–1980* [1985], London: Virago, 1987.

Silver, Carole G., *Strange and Secret Peoples: Fairies and Victorian Consciousness*, New York and Oxford: Oxford University Press, 1999.

Sitwell, Sacheverell, *Narrative Pictures*, London: Batsford, 1937.

Skultans, Vieda (ed.), *Madness and Morals. Ideas on Insanity in the Nineteenth Century*, London: Routledge, 1975.

Slatter, Enid, *Xanthus. Travels of Discovery in Turkey*, London: Rubicon, 1994.

Smailes, Helen, *Method in Madness*, Scottish National Portrait Gallery, Edinburgh 1980.

Smith, Roger, *Trial by Medicine. Insanity and Responsibility in Victorian Trials*, Edinburgh: Edinburgh University Press, 1981.

Sommer, Robert, Jonathan Motley and Vincent Cassandro, 'Perceived Psychopathology in Richard Dadd's Art', *The Arts in Psychotherapy*, vol.25, no.5, 1998, pp.323–9.

Spielmann, M.H., *The History of Punch*, London: Cassell, 1895.

Spratt, Thomas and Edward Forbes, *Travels in Lycia, Milyas, and the Cibyratis*, 2 vols., London: Van Voorst, 1847.

Steptoe, Andrew (ed.), *Genius and the Mind: Studies of Creativity and Temperament*, Oxford: Oxford University Press, 1998.

Stevenson, Christine, *Medicine and Magnificence: British Hospital and Asylum Architecture, 1660–1815*, New Haven and London: Yale University Press, 2000.

Stewart, Susan, *On Longing*, Durham NC and London: Duke University Press, 1993.

Survey of London, vol.40: *The Grosvenor Estate in Mayfair, Part 2 (The Buildings)*, London: Athlone, 1980.

Suzuki, Akihito, 'Framing Psychiatric Subjectivity. Doctor, patient and record-keeping at Bethlem in the nineteenth century', in Melling and Forsyth 1999, pp.115–36.

Tantam, Digby, 'The Anti-Psychiatry Movement', in Berrios and Freeman 1991, pp.333–47.

Taylor, Alfred, *The Principles and Practice of Medical Jurisprudence*, London: Churchill, 1865.

Timbs, John, *Curiosities of London* [1855], London: Virtue, 1867.

Torrey, E. Fuller and Judy Miller, *The Invisible Plague. The rise of mental illness from 1750 to the present*, New Brunswick NJ and London: Rutgers University Press, 2001.

Trevelyan, G.O., *The Life and Letters of Lord Macaulay*, 2 vols., London: Longman, 1876.

Tristan, Flora, *Flora Tristan's London Journal: A Survey of London Life in the 1830s*, trans. Dennis Palmer and Giselle Pincetl, London: Prior, 1980.

Tromans, Nicholas (ed.), *The Lure of the East: British Orientalist Painting*, exh. cat., Tate Britain, London 2008.

[Truth, Timothy] *The First Book of the Chronicles of Folly. Written by Timothy Truth for the express purpose of handing down to posterity, the Philosophical Wisdom of the nineteenth century*, Rochester: Epps, 1828.

Tuke, Daniel Hack, 'Bethlem Royal Hospital', *Journal of Mental Science*, vol.22, July 1876, pp.201–21.

Tuke, Daniel Hack, *Broadmoor, l'asile d'Etat pour les aliénés criminels d'Angleterre*, Paris: Imprimerie Nationale, 1880.

Turner, Trevor, 'Henry Maudsley: Psychiatrist, Philosopher, and Entrepreneur', in Bynum, Porter and Shepherd (eds.), *The Anatomy of Madness*, vol.3, 1988, pp.151–89.

Vaughan, William, *German Romanticism and English Art*, New Haven and London: Yale University Press, 1979.

Weiner, Deborah, '"This coy and secluded dwelling": Broadmoor Asylum for the Criminally Insane', in Leslie Topp, James Moran and Jonathan Andrews (eds.), *Madness, Architecture and the Built Environment: Psychiatric Spaces in Historical Context*, London: Routledge, 2007, pp.131–49.

Wiener, Martin J., *Reconstructing the criminal: Culture, law, and policy in England, 1830–1914*, Cambridge: Cambridge University Press, 1990.

Wilkinson, John Gardner, *Manners and Customs of the Ancient Egyptians*, second series, 3 vols., London: Murray, 1841.

Williams, Chris, '"The great hero of the Newport Rising": Thomas Phillips, Reform and Chartism', *Welsh History Review*, vol.21, no.3, 2003, pp.481–511.

Williams, Gary Jay, *Our Moonlight Revels: 'A Midsummer Night's Dream' in the Theatre*, Iowa City: University of Iowa Press, 1997.

Williamson, Peter, *Mind, Brain, and Schizophrenia*, Oxford: Oxford University Press, 2006.

Wilson, Jean Moorcroft, *Siegfried Sassoon. The Journey from the Trenches*, London: Duckworth, 2003.

Winchester, Simon, *The Surgeon of Crowthorne*, Harmondsworth: Penguin, 1998.

Winslow, Forbes, 'The Insanity of Men of Genius', *Journal of Psychological Medicine and Mental Pathology*, vol.2, 1849, pp.262–91.

Woillez, Eugène-Joseph, *Essai historique, descriptif et statistique sur la maison d'aliénés de Clermont (Oise)*, Clermont: Danicourt, 1839.

Woillez, Eugène-Joseph, *De l'Amélioration du sort de l'homme aliéné considéré comme individualité sociale*, Paris: Masson, 1849.

Wood, William, *Remarks on the Plea of Insanity*, London: Longman, 1851.

[Wynter, Andrew] 'Lunatic Asylums', *Quarterly Review*, vol.101, April 1857, pp.353–93.

Youngquist, Paul, *Madness and Blake's Myth*, University Park PA: Pennsylvania State University Press, 1989.

Zeki, Semir, *Inner Vision. An Exploration of Art and the Brain*, Oxford: Oxford University Press, 2003.

Photographic Credits

Index